FOREVER
BEAUTIFUL

Rizzoli
NEW YORK

New York · Paris · London · Milan

FOREVER BEAUTIFUL

ALL-AMERICAN STYLE ALL YEAR LONG

MARK D. SIKES

PHOTOGRAPHY BY AMY NEUNSINGER
TEXT BY KATHRYN O'SHEA-EVANS

TO MICHAEL AND
OUR FAMILY OF DOGS,
PAST AND PRESENT—POPPY, LILY,
MAGGIE, AND GRACIE.
YOU'RE THE ONLY THINGS I LOVE
MORE THAN BEAUTY.

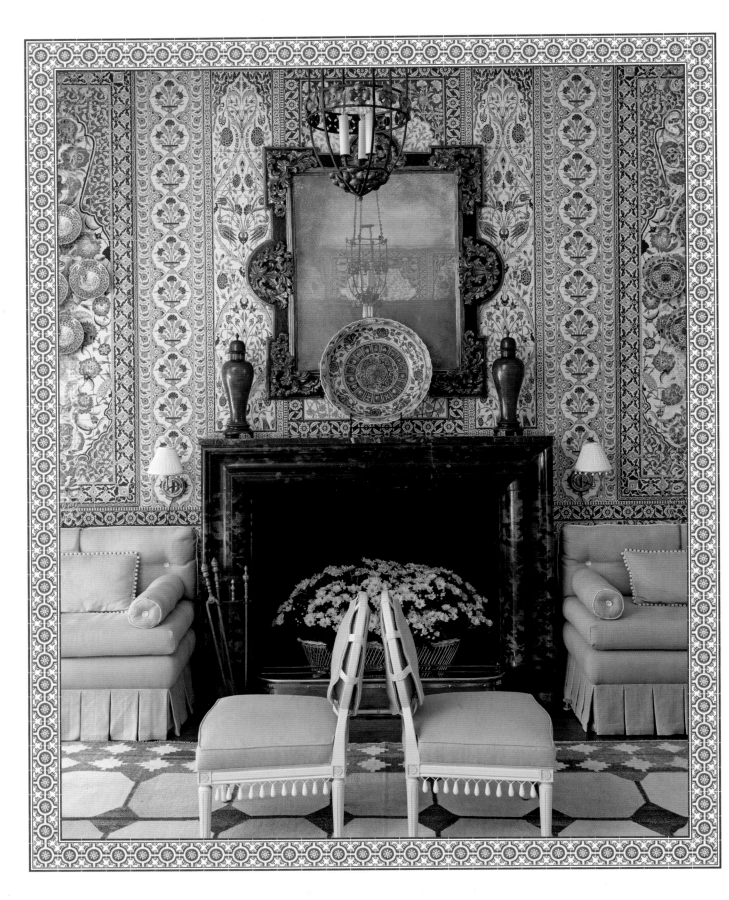

Contents

Introduction

Beauty can change the world. It's a bold statement, but I believe it. Like food and music, a kind smile or a good deed for a stranger, beautiful design can break down barriers between us. It unites people across cultures. And it can heal—raising otherwise flagging spirits like a warm, sunny morning after one-too-many days of rain.

When I first published *Beautiful* in 2016, I had no idea that it would become the first in a series. But you did. Readers crave beauty so much that the book—which was organized by color story, from timeless neutrals to blue and white—became a *New York Times* bestseller. *More Beautiful* continued the story in 2020 with homes we designed in varying vernaculars, like Country and Coastal, at a moment when we really needed the mental vacations.

This book, *Forever Beautiful*, is the third in the trilogy. Inside, you'll find twelve homes we've designed with wonderful teams in a multitude of styles all over the country and beyond. Among them is a sleek and modern mountain retreat in Vail, Colorado; a waterside Regency Revival estate in Bermuda; a

fairy-tale chalet in Sun Valley, Idaho; and a Mediterranean former horse stable in Hollywood that was once owned by a star of the silver screen. At a glance, each of these homes looks different, but they were all largely inspired by one thing: the natural beauty outside their doors.

Nature is the ideal muse. What would La Fiorentina in Cap Ferrat be if its architects hadn't designed it around terraced gardens that practically sashay to the Mediterranean below? Or the circa 1635 Rousham House in Oxfordshire, England, where the main salon is the color of grass—a timeless echo of its formal boxwood parterres and bowling green? Our surroundings are one of the most beautiful inspirations we can have.

So while the homes we included here encapsulate a range of our work, they were all inspired by their locales. You might find that reading through this book is like taking a journey because we arranged the chapters by the months of the year that best spoke to the projects within. Every season ushers in different types of light (beautifully captured by my longtime photographer and friend Amy Neunsinger, who shot nearly all of these projects), while each location brought with it a wonderful opportunity to work with people we had never collaborated with before—building relationships with vendors and workrooms in new regions, all with unusual and refreshing points of view. That's always a thrilling process; we learn so much from each other. You'll also see plenty of blue and white on these pages, but it's so much more than that! Just like anything in nature, each of these homes is wholly original and has its own color story.

It's hard to tell in photographs, but when you walk into these homes and spend time in them—really *feel* them—they talk to you. A home needs to have soul and substance to be truly beautiful. It should not only reflect who we are but also inspire us. That's how they become sanctuaries: they make you feel good.

Another thing that sets these homes apart are their artisanal details. Each house is uncompromisingly original; authenticity and customization are key. So you will see unexpected touches throughout, including decorative painting by trompe-l'oeil artist Joseph Steiert (who also painted the borders throughout this book) and custom furniture we designed to reflect the people that live in each home and the things they love. Everything we do is as unique as a snowflake. There's only one like it, and that makes it all the more beautiful.

January

SOUTH FOR THE WINTER

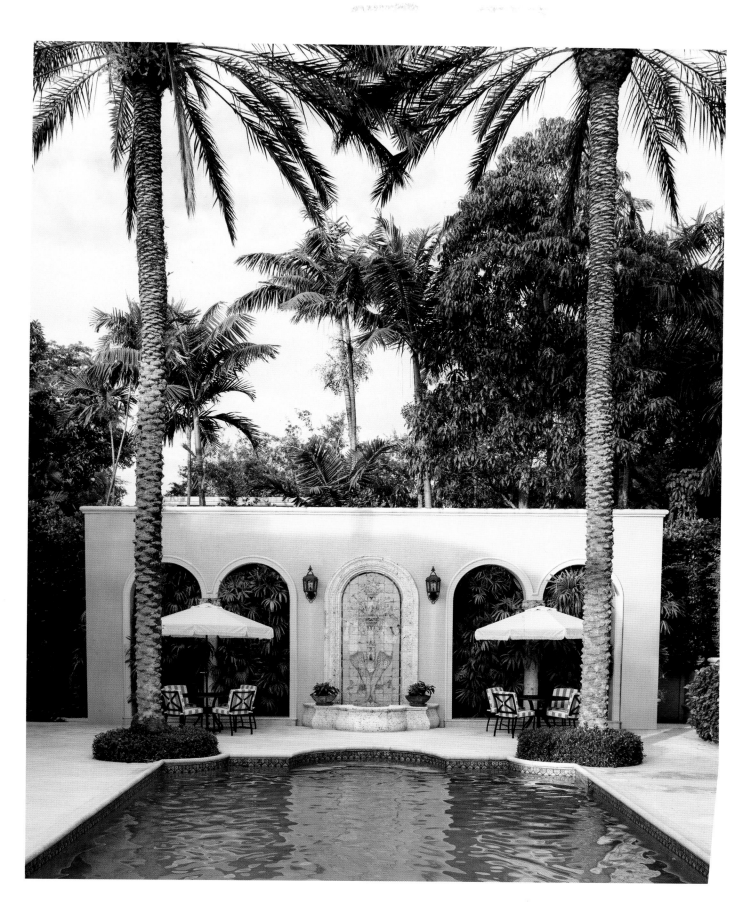

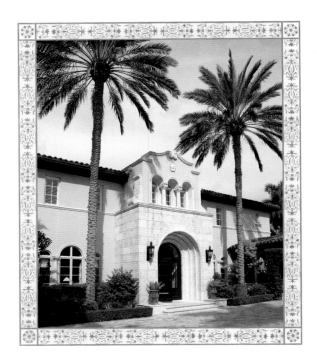

Although January may conjure visions of snow-swept landscapes, in the southernmost reaches of Florida, days often feel summery from dawn till dusk. Gardens are overgrown and exultant, living their best life. The air is warm and almost tropical, and often scented by salty marshes or citrus groves. No wonder some hummingbird species choose to winter here.

Located near Coral Gables, this house suits the scene. Built only a few decades ago, it reminded me instantly of Vizcaya, the circa 1914 Italian Renaissance villa that hugs the mangrove-dotted shoreline of Biscayne Bay. So we kept its existing travertine floors and columns intact and added even more touches of the Old World by referencing Italy throughout, including abundant Bonacina wicker furniture (handmade in Italy since 1889). We also enlisted artist Joseph Steiert to hand-stencil the home's cathedral-vaulted and coffered ceilings, echoing the motifs of the custom trim on the draperies. He took similar care in the primary bedroom's sitting room with its hand-painted palm leaves

PREVIOUS PAGE: Symmetry is forever beautiful—especially beside this mosaic-lined pool in Miami's Ponce-Davis neighborhood, where a pair of graceful wrought iron bistro tables and chairs topped with striped cushions suit the locale. ABOVE: The home has an inherent Mediterranean spirit. OPPOSITE: We kept the limestone floors intact for their historic feeling; they combine beautifully with the Bonacina wicker furniture and bullion-skirted table.

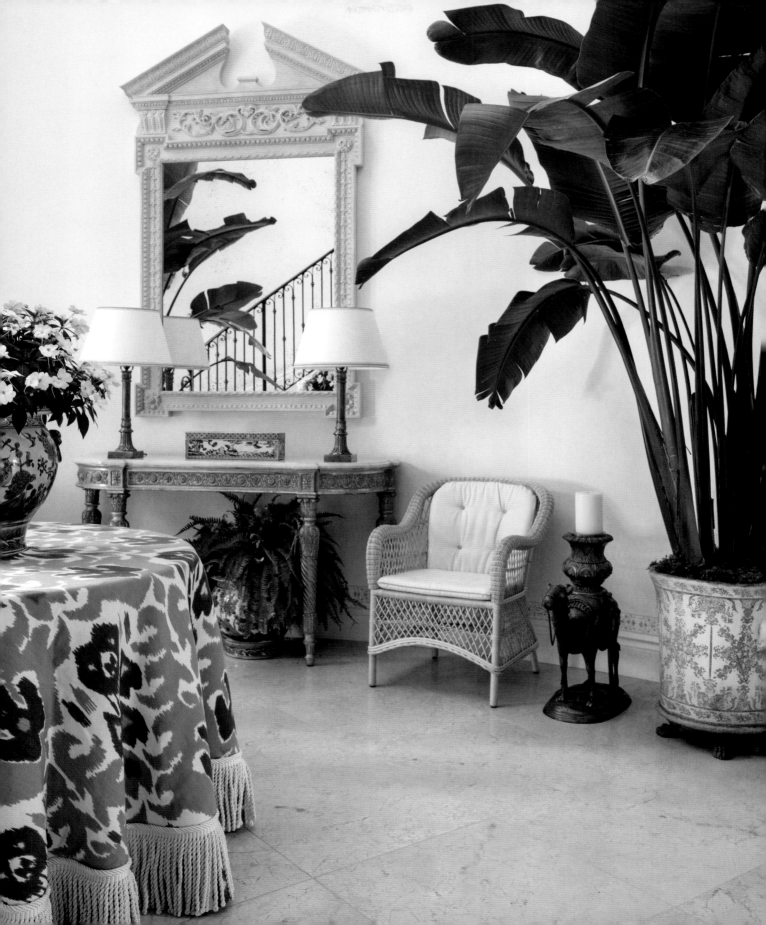

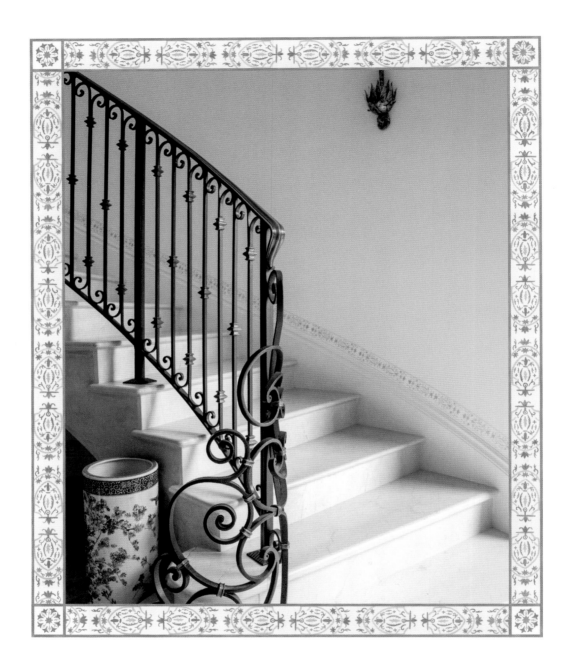

ABOVE: We recruited decorative painter Joseph Steiert to adorn the home with fanciful details, such as the delicate stenciling that now winds up the wall along the existing curved staircase and ironwork. OPPOSITE: The coffered ceiling was already eye-catching, but Steiert's motifs made it transfixing.

"Luxury is in each detail."

—Hubert de Givenchy

and even in the card room, where he painted the blue-and-white striped walls (which we then matched on the game tables, seat cushions, and lampshades).

Those little things always add up to a lot. We used Fortuny fabrics, highly detailed lampshades to add that hand of luxury, and a color palette of blues and greens. The wild peacocks that have taken up residence in this neighborhood stop by on occasion. We didn't know they existed when we planned the home's color scheme, but when one of them showed up, it was like kismet; there he was, strutting the grounds proudly in his iridescent blue-green plumage—and perfectly matching the interiors!

We couldn't help but bring some of the local flora inside: banana leaf trees, palms, and sword ferns not only supply lushness to the interior but also connect the indoors with the out. You'll notice many of them nestled on pedestals, which served to loft the plantings up a bit, thereby helping humanize the scale of such high ceilings. Much of the lighting feels like it was transported from a secret garden, thanks to the verdigris finish on many fixtures.

Most of the walls in the living spaces are ivory, which is what makes the two major departures—the dining room and library—so intoxicating. We painted the library a rich Kelly green, rolling in graceful furniture on casters, and softening it all with flouncy Roman and shirred lampshades. The dining room was already lovely, with its similar tray ceiling and lunette windows. But when we added hand-painted robin's-egg blue wallpaper to the walls and ceiling and a glimmering Murano chandelier, it became a portal into another world, much like this transporting winter escape.

OPPOSITE: In a room with such soaring ceilings, I always hang the window treatments high to encourage the eye to roam. Here, the custom embroidered trim on the draperies mirrors the stenciling on the hall arches and vaulted cathedral ceilings. FOLLOWING PAGES, FROM LEFT: The beauty is very much in the details. Modern art plays well with traditional lines. Plants on pedestals balance the towering ceilings.

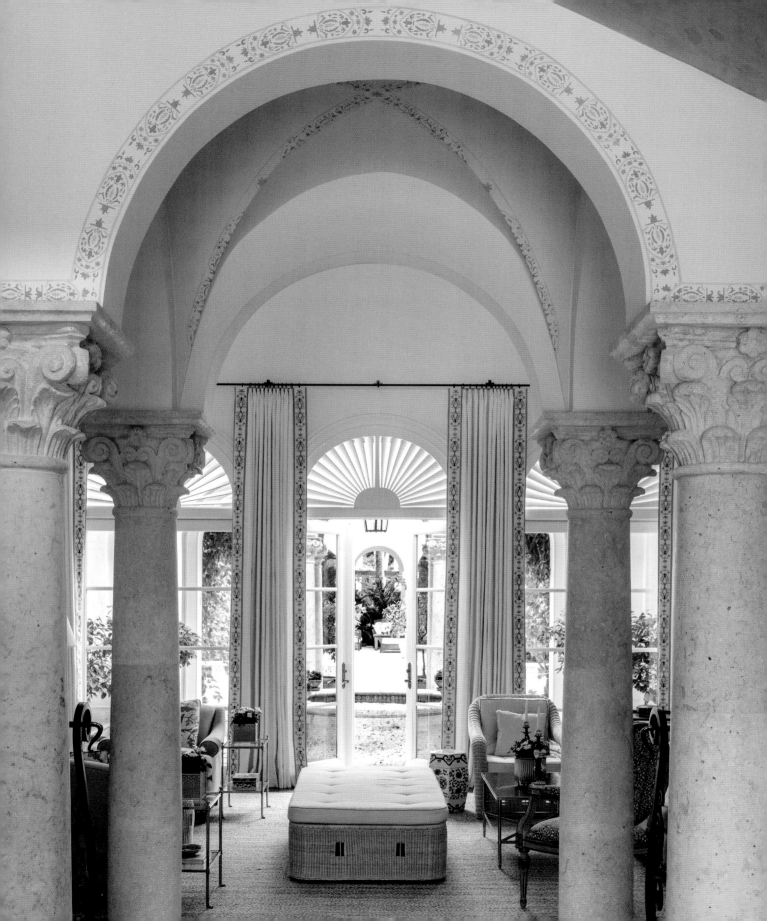

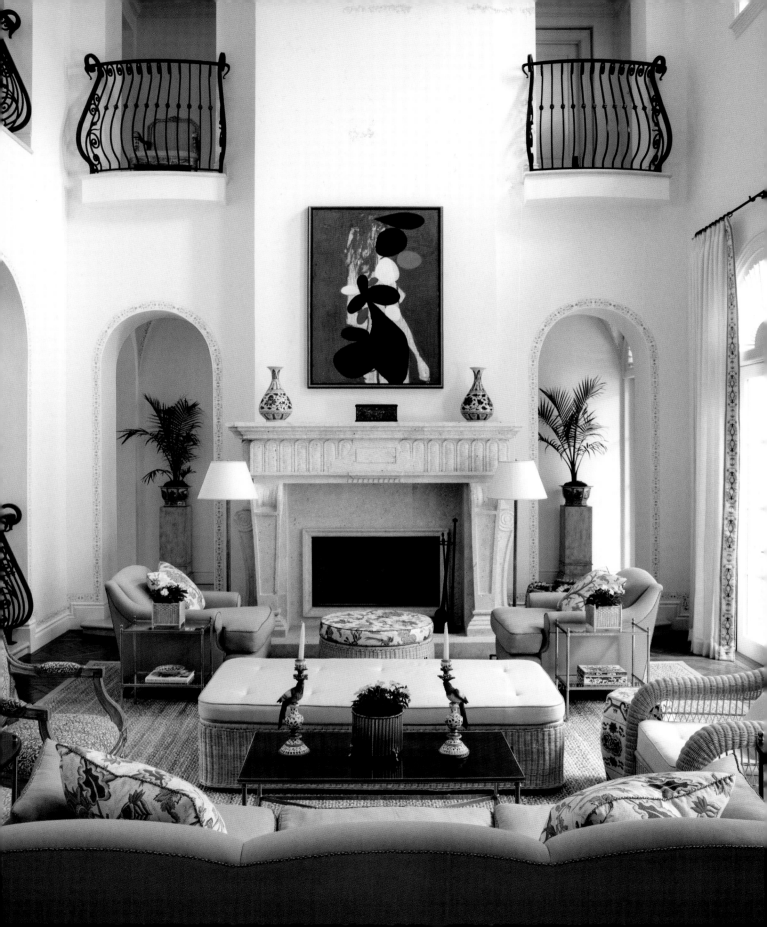

Sometimes it's the smallest, most imperceptible things that have the strongest impact.

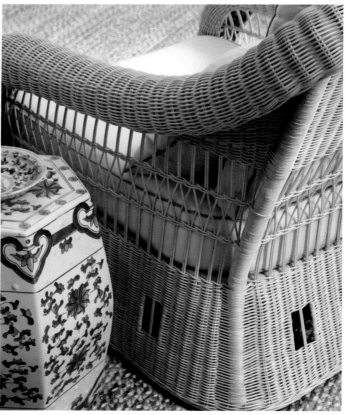

CLOCKWISE FROM TOP LEFT: Custom embroidered trim brings another layer of elegant texture. Bonacina wicker helps create an idyllic reading nook under the stairs. The matching cord on this sofa and throw pillows gives their different patterns a cohesive feel. A sisal rug balances the elegance of a Louis XVI armchair. Throughout, verdigris lanterns carry the romance of a garden indoors. Ceramic garden stools are ideal drinks tables—and provide pattern.

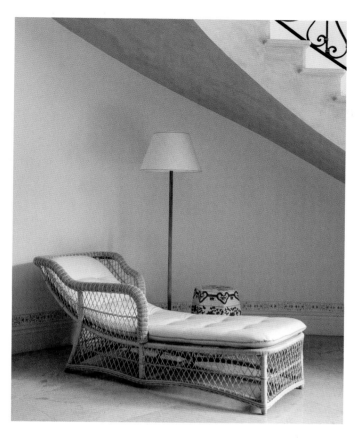

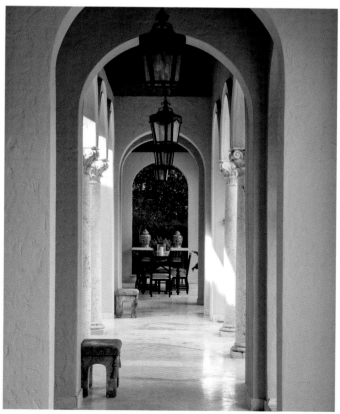
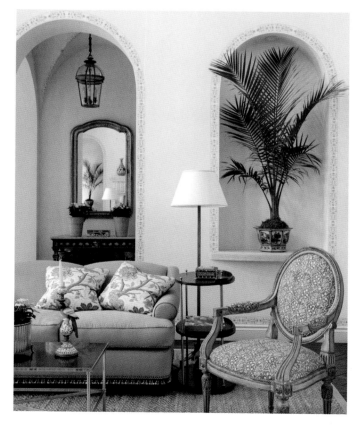

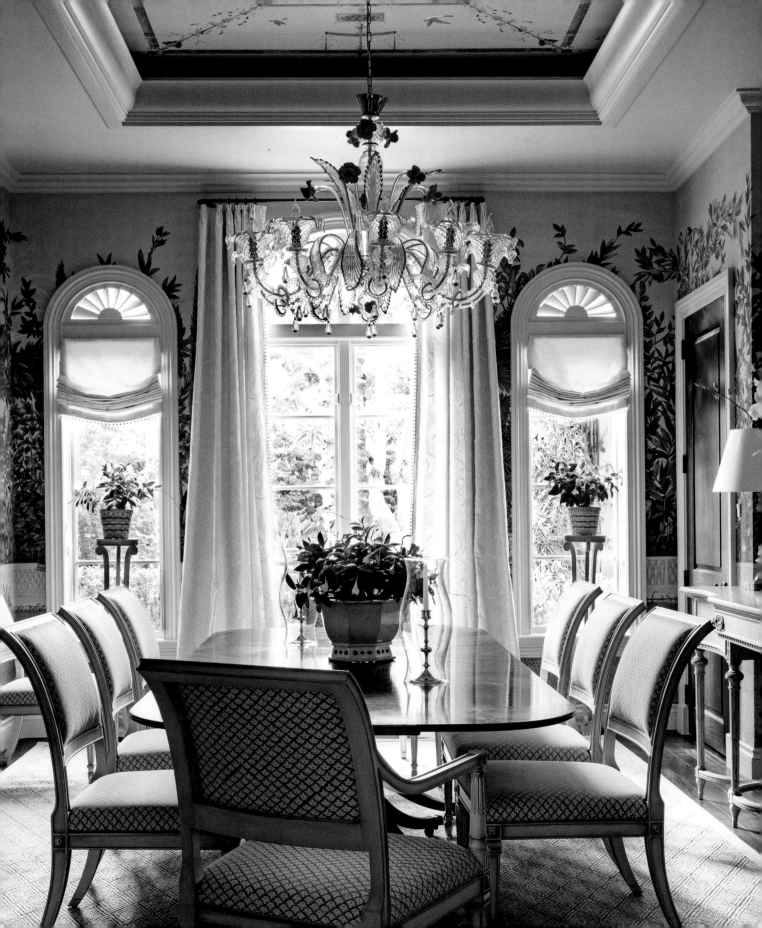

"One must maintain a little bit of summer, even in the middle of winter."

Henry David Thoreau

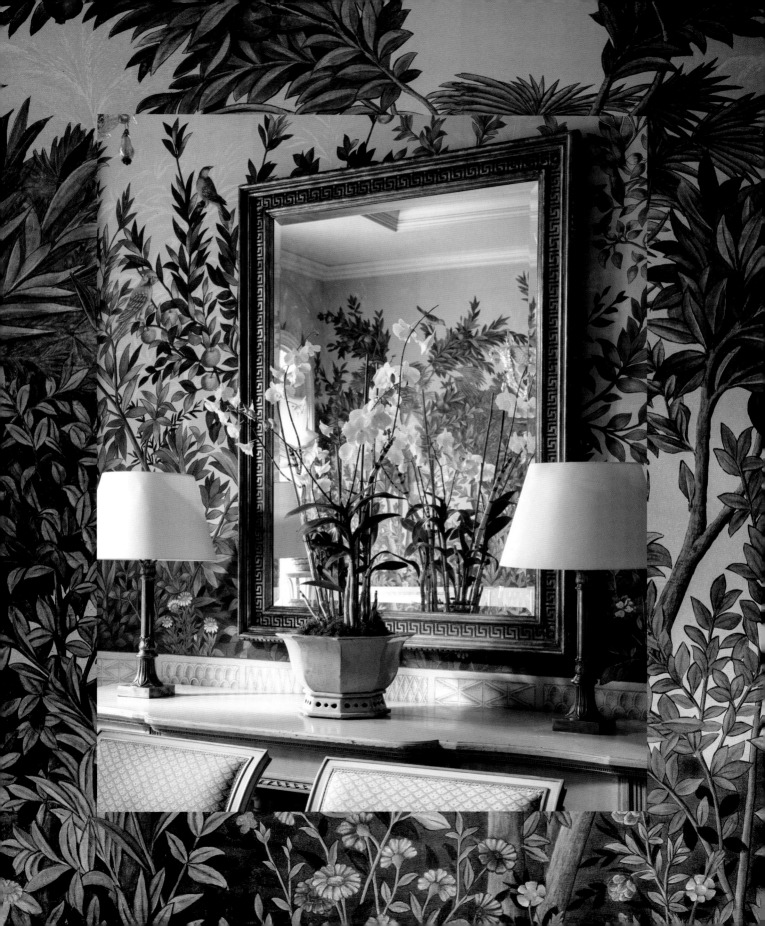

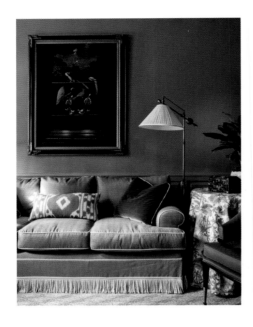
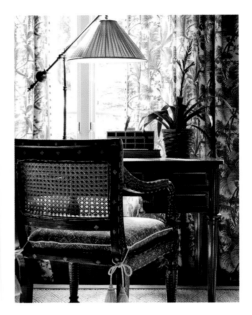

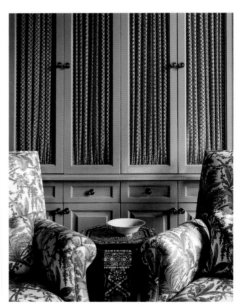

ABOVE, CLOCKWISE FROM TOP LEFT: A rich leaf green lends the library a studious air. The woven cane back adds additional texture to this bone-inlay armchair. Shirred fabric door panels bring extra pattern and softness to cabinetry. Silk tassel tiebacks on the cushions supply eternal charm. OPPOSITE: The custom lampshades throughout this home add to its timeless quality.

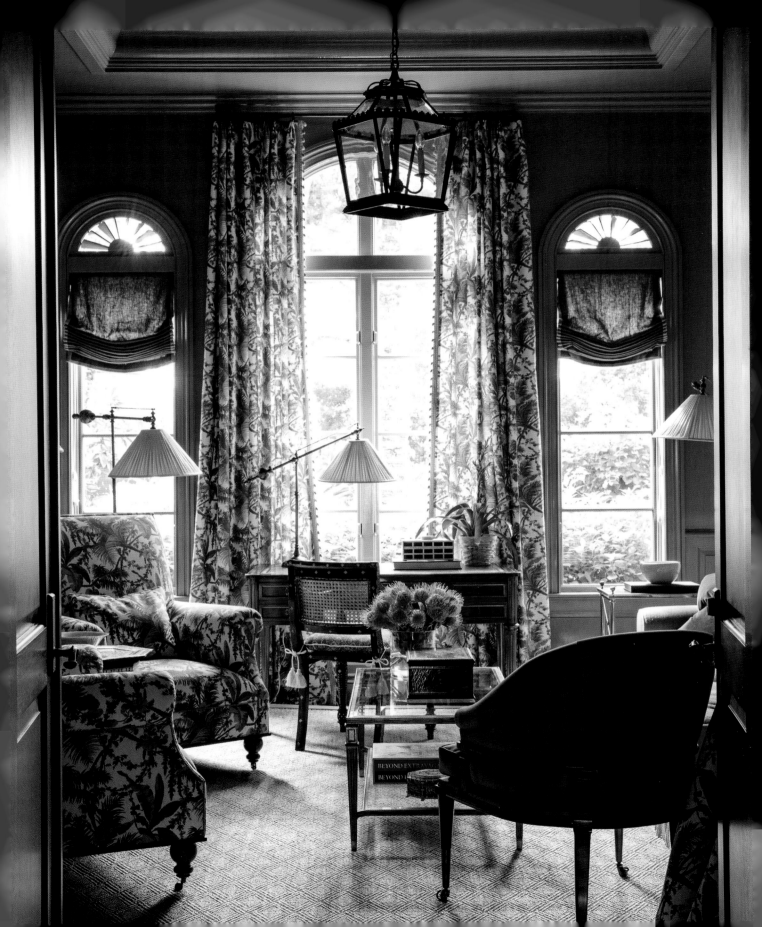

Blue-and-white hand-stenciling by Steiert creates a paneling effect in the family room. We had the ottoman poufs and blue-and-white dishes studding the walls custom-made; the paddle arm British lounge chairs are centuries-old antiques from the colonial era. Bringing in a sense of history is all but required for an enduring look.

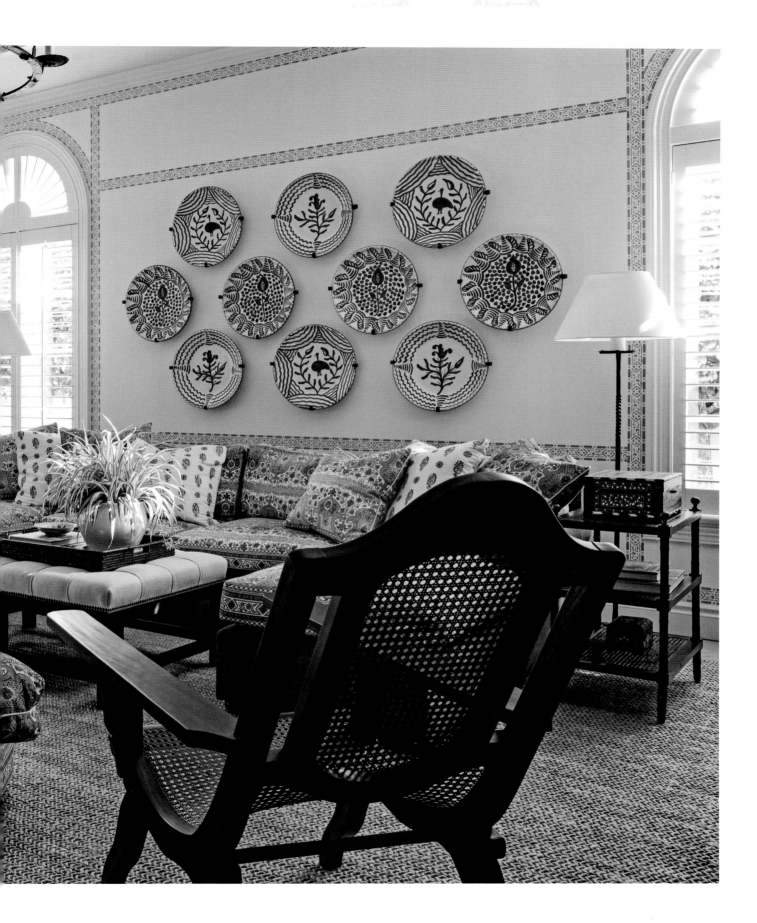

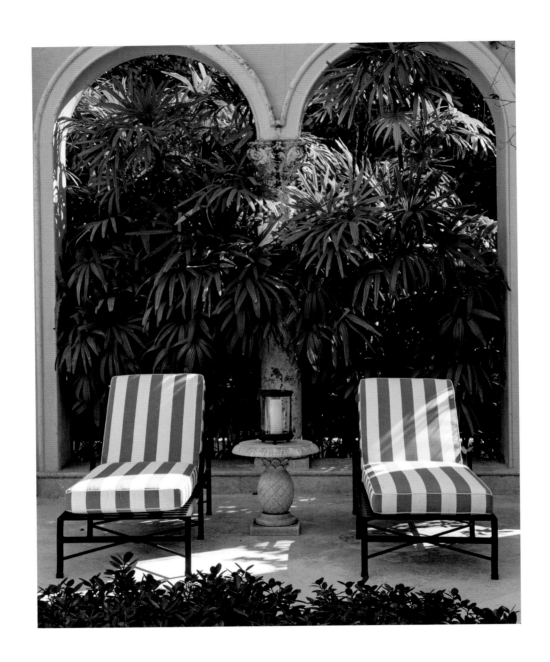

ABOVE: Blue-and-white striped chaises nod to Positano and the secret coves of Capri under a luxuriant wall of lady palms. OPPOSITE: In the card room, we embraced our love of stripes, employing the pattern on the walls, upholstered game tables, cushions, and shades on the pendant lights, too. Wicker chairs from the Bielecky Brothers add texture.

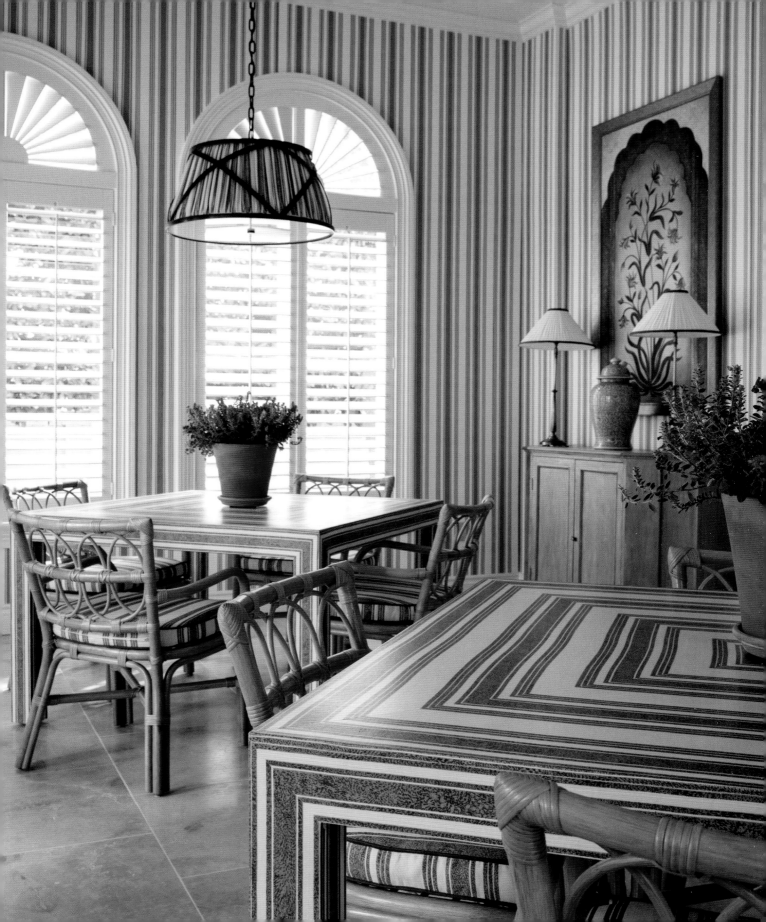

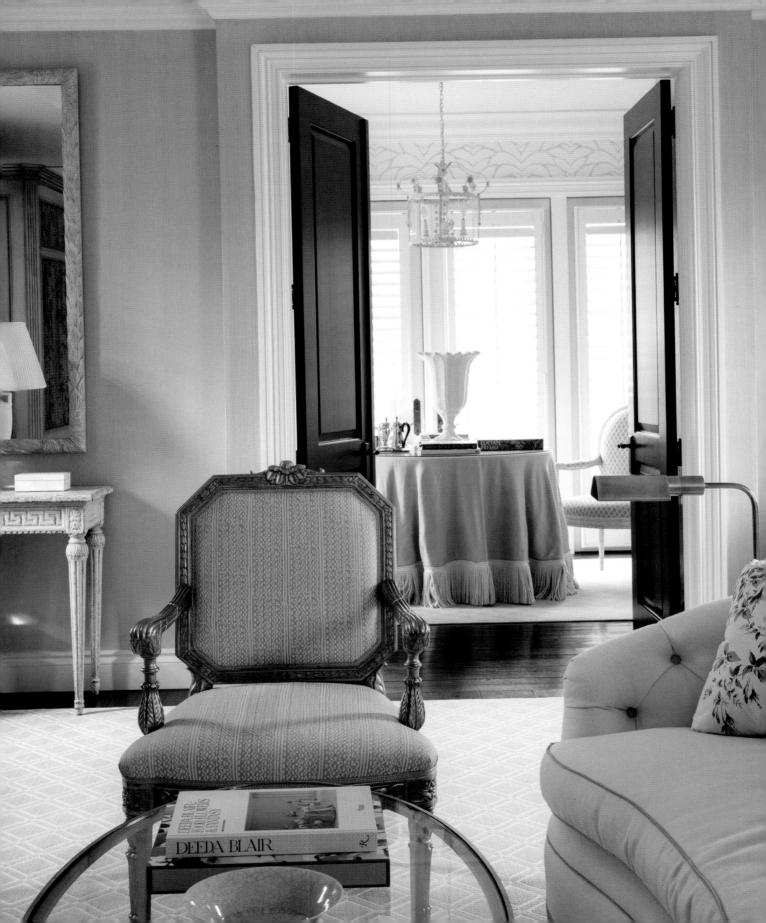

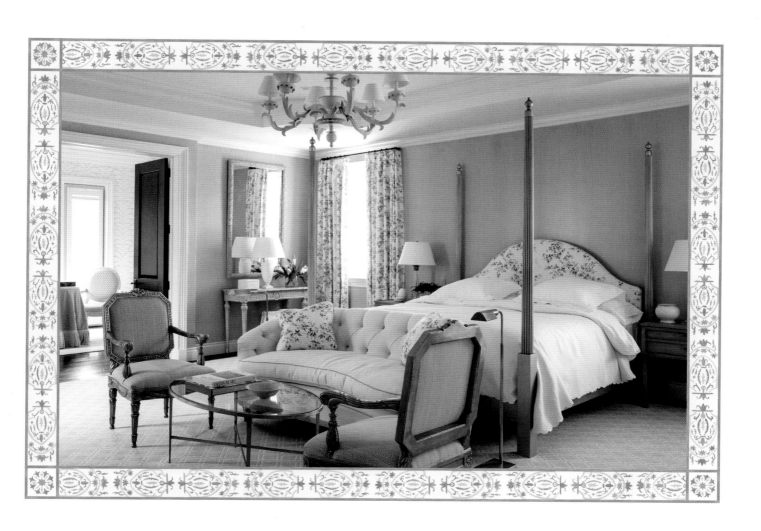

OPPOSITE AND ABOVE: In the primary bedroom, Fortuny fabrics and gilding on the hand-carved antique chairs bring an old-world touch. A sitting area at the foot of the bed is so civilized. Adjacent to the primary bedroom is the sitting room, an ideal place for a morning cup of coffee or afternoon tea.

Hand-painted details on the guest room's four-poster bed turned it into a showpiece.

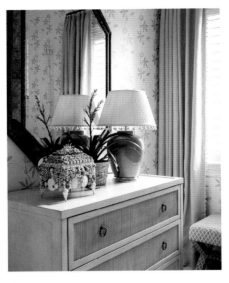

Shellwork is a must by the shore.

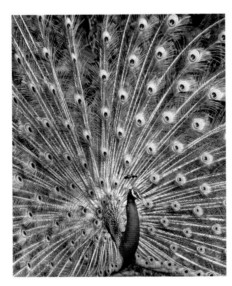

Wild peacocks roam the grounds.

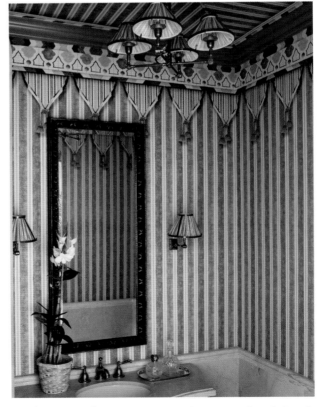

We matched the lampshades to the tented Iksel wallpaper in this powder room.

A wicker chaise and cotton cushion say "relax."

Palm trees are nature's fireworks.

Both the decoratively painted walls and vase echo a splay of palm fronds.

Mirrors reflect pretty details.

February

OLD HOLLYWOOD ROMANCE

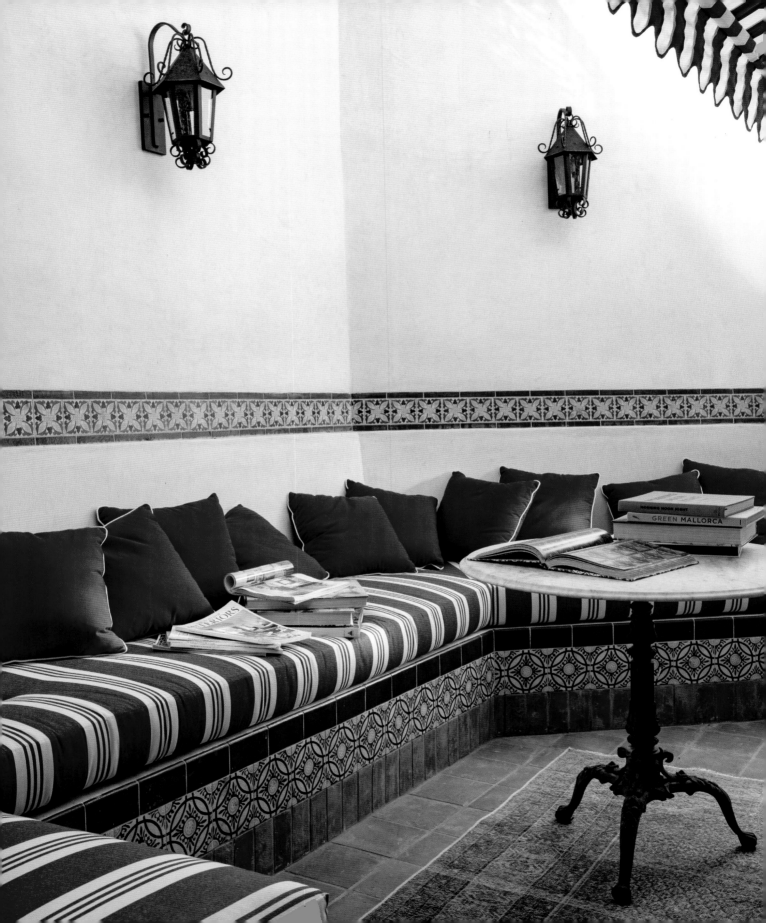

When the month of February appears, red and pink tokens of love are everywhere, bringing much-needed warmth to winter's last gasp. In California, camellias unfurl in early bloom—a symbol of new life. Occasionally, a morning marine layer brings in a misty fog as dramatic as an Old Hollywood stage set. Cue the romance!

Speaking of Old Hollywood: this guesthouse on my clients' Beverly Hills estate has a rich, bohemian backstory. The 1925 structure was once the horse stable where a silent film legend kept his Arabian stallions. I've always loved the Mediterranean sensibility that Hollywood embraced in the golden age, with its clay roofs, charming tile work, and striped awnings. Long before "indoor/outdoor living" became a catchphrase, they just *lived* it—maximizing courtyards and poolside cabanas and infusing every pocket of architecture with romance day and night, down to flickering wrought iron light fixtures and intricate tile work. Tucked in the foothills, this particular guesthouse has

PREVIOUS PAGE: Carmine red and white striped awnings and wrought iron details reference the glory days of Old Hollywood. OPPOSITE: We built a Mediterranean-inspired, intricately tiled outdoor banquette and topped it with a flurry of plush cushions and pillows for lazy afternoons. ABOVE: In this former horse stable in Beverly Hills, we kept the original stall doors intact.

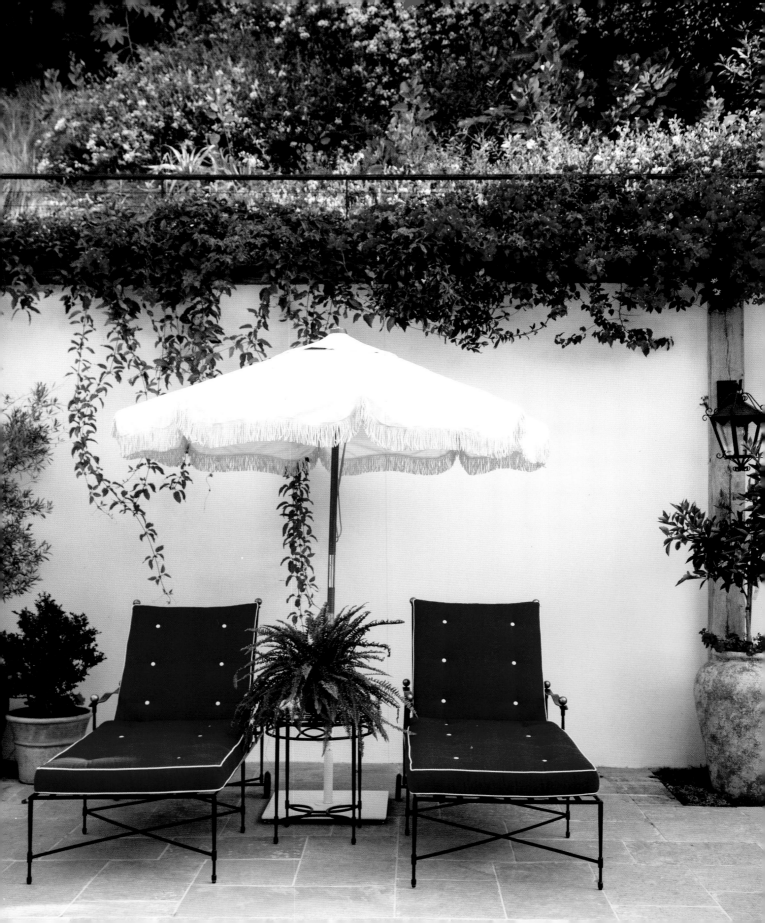

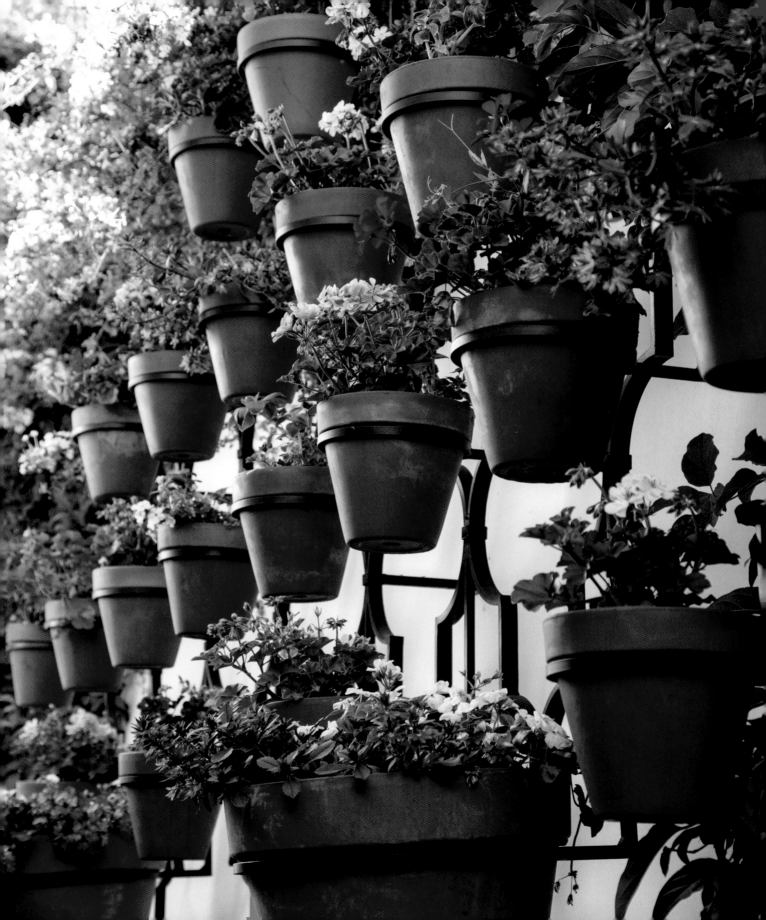

PREVIOUS PAGES: Ornamental bougainvillea, a trademark vine in Los Angeles gardens since the 1920s, helped kick off this romantic color palette. To lend Mediterranean allure to a retaining wall, we partnered with architect Marc Appleton and team to create a custom iron pot holder that now sings with geraniums. RIGHT: We imbued the sprawling main living area with artisanal details, such as a coffered ceiling with hand-stenciled beams and panels within.

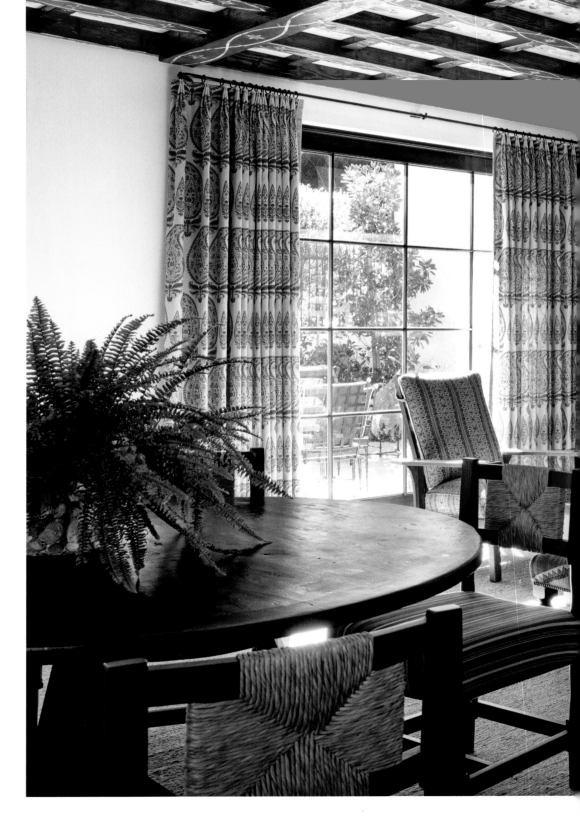

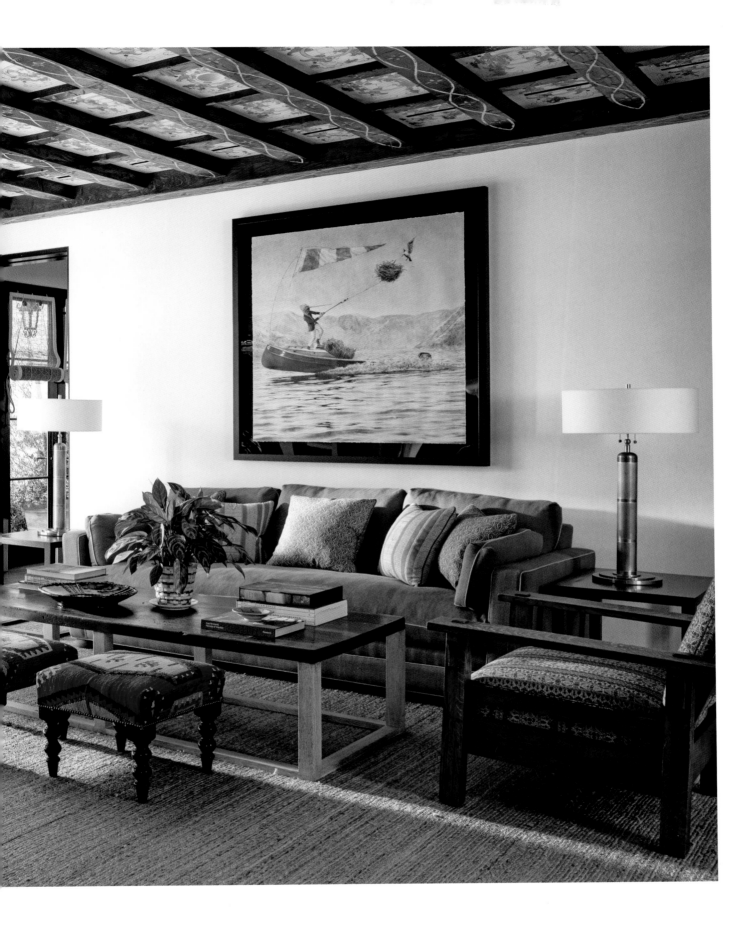

"Red is the ultimate cure for sadness."

Bill Blass

OPPOSITE: Rebuilding the fireplace surround with this shapely stucco helped it feel more authentic to the period. A round central table serves as this guest home's dining room and breaks up the expansive living space. Custom bronze sconces match the original fixtures.

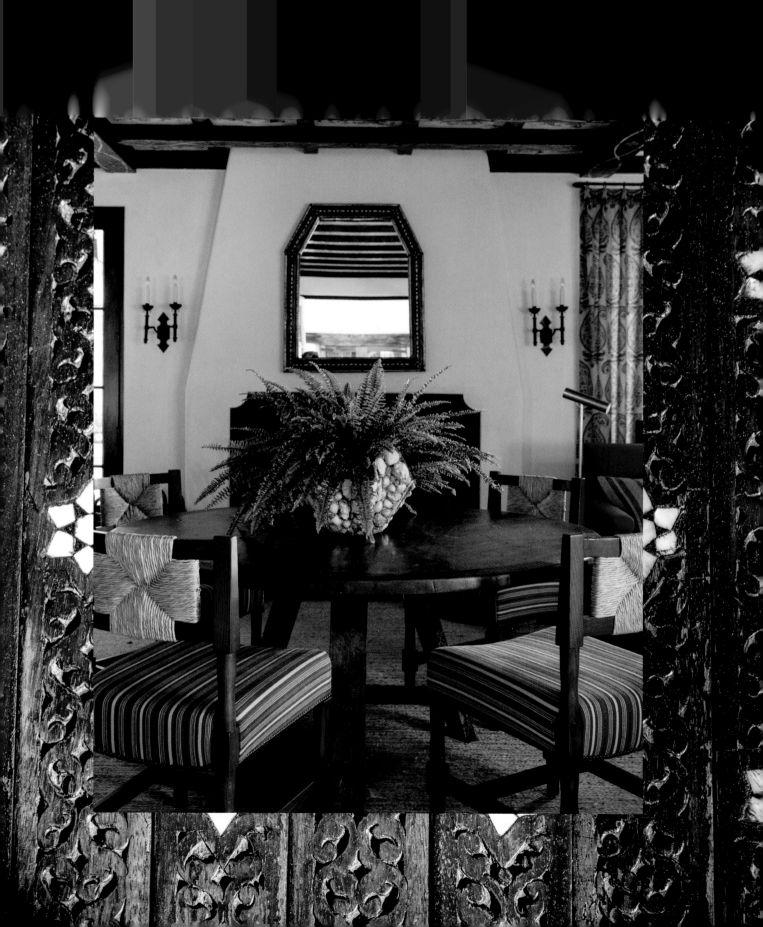

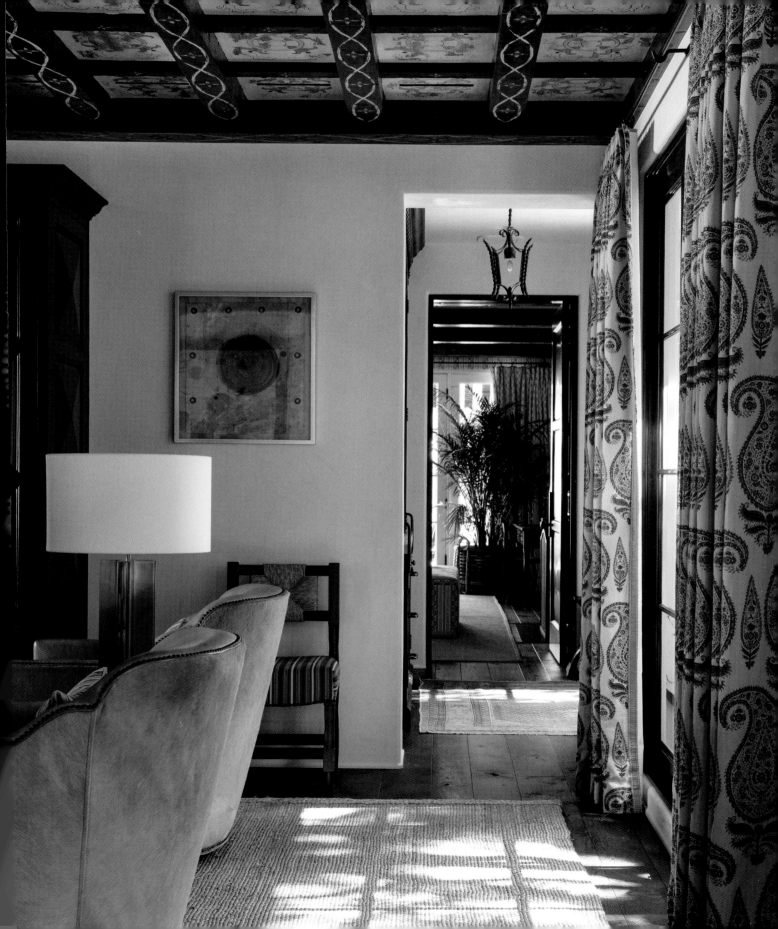

"To create something exceptional, your mindset must be relentlessly focused on the smallest detail."

—Giorgio Armani

all that, as well as layers of gardens and private walking trails. Still, it needed a bit of an upgrade—some good old-fashioned movie magic.

Thankfully, if you listen hard enough, historic houses tell you what to do. We worked tirelessly to authenticate the place, upping the ante on Spanish Colonial Revival style in an organic way that would feel original and idyllic. In short, everywhere we could add charm, we did. To match the thick mahogany stable doors that are nearly a century old, we created a coffered ceiling and hand-painted the beams and the planes of ceiling between them. We designed custom wrought iron light fixtures that echoed the lines of the existing 1920s ones; outdoors, we hung wrought iron trellises that—soon enough—will be veiled in fragrant bougainvillea.

Throughout the house, we used a carmine red color in ways big (the striped and scalloped awnings) and small (the piped outdoor cushions). The hue seemed to suit the place, which feels more like a creative studio than guest quarters. It's moody and lovely—a perfect pairing for the romantic architecture and design. When you walk in the doors, you get the feeling the person who lives here is very creative and needs a place to write and produce the art they're passionate about, whatever that may be. Call it a special effect.

PREVIOUS PAGES: Installing coffered box beams, then stenciling them (as well as the ceilings between) with paints in muted tones adds an aura of history above. The homeowner's leather chairs suit this guest home's equestrian roots. OPPOSITE: We added a few layered touches to the existing dark mahogany bar, including custom tiles and brass grilles in the upper cabinets.

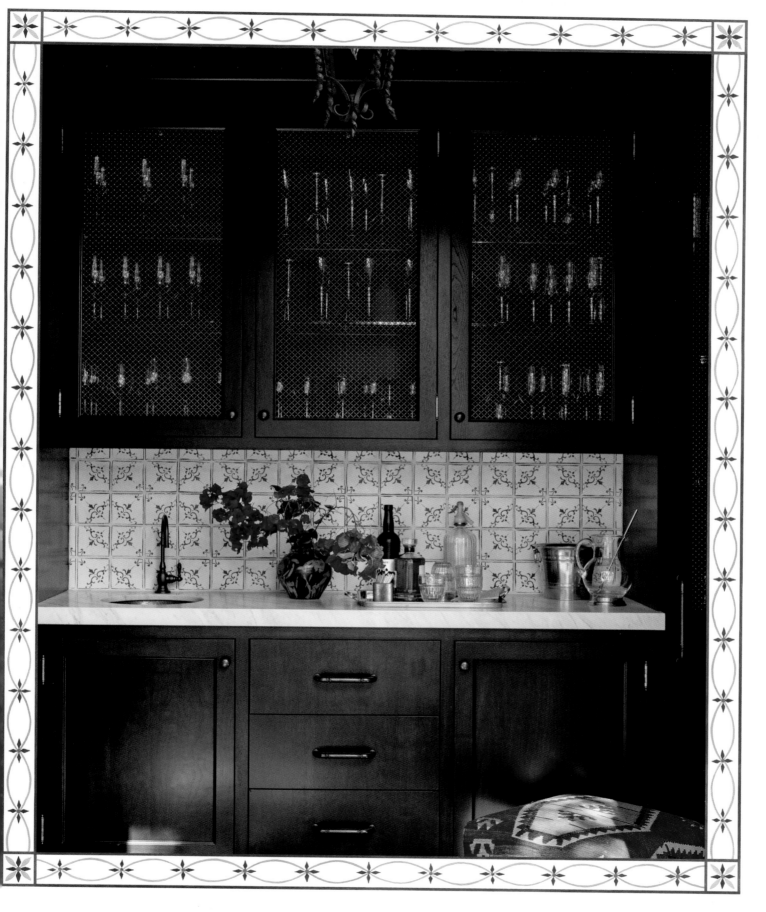

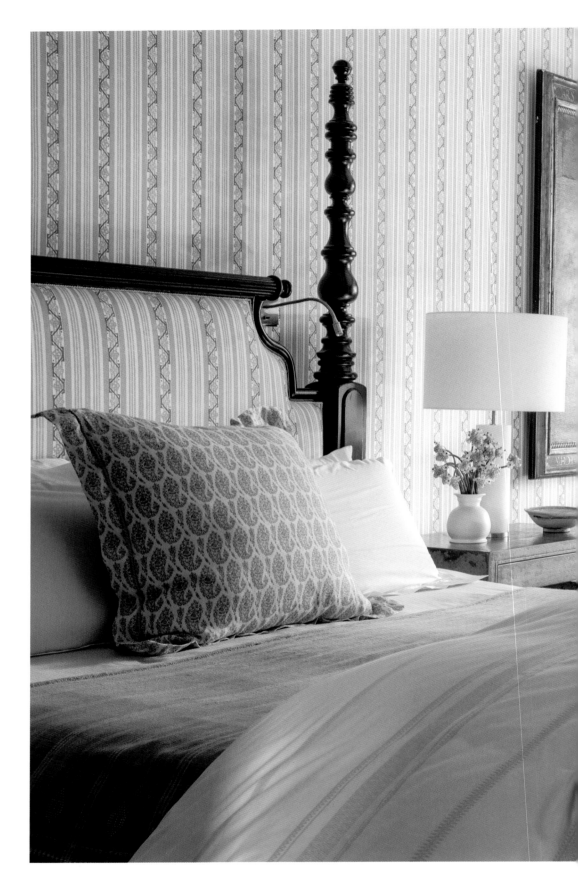

By matching the headboard upholstery on this turned post bed to the wallpaper and window treatments, the solid piece almost feels one with the architecture. The exposed beams are stenciled with a pattern inspired by the Carolina Irving fabric we employed in the room.

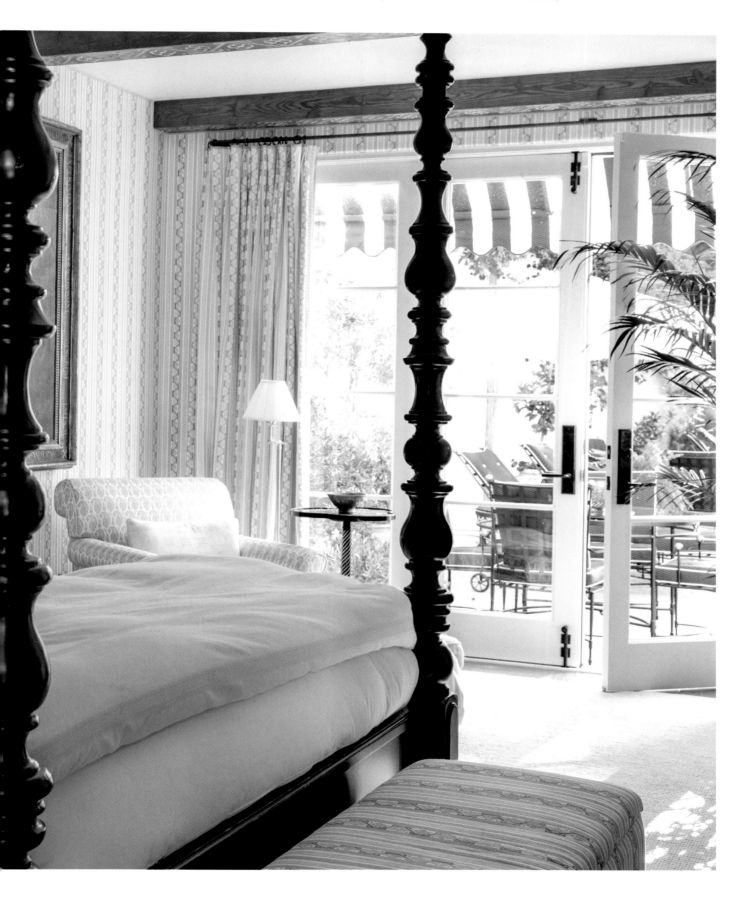

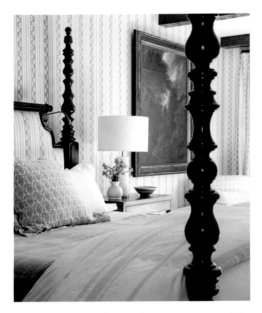

Amid antiques, modern art prevents stuffiness.

Wide white stripes on the duvet lighten the mahogany four-poster bed.

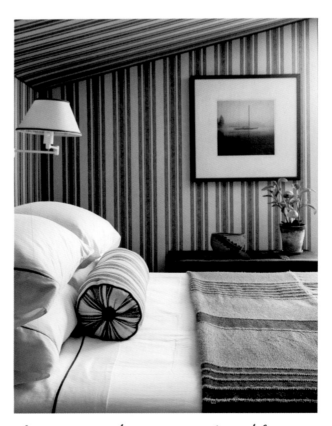

Even the humblest plant can bring life to a work desk.

Layering stripes makes them all the more charming.

An awning stripe
brought indoors.

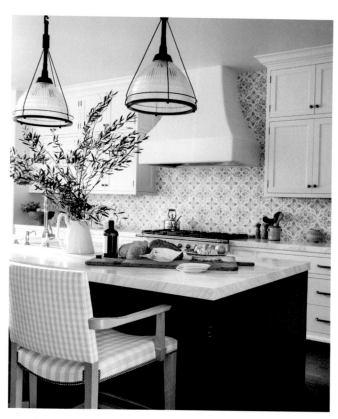

A tile backsplash extended to
the ceiling draws the eye up.

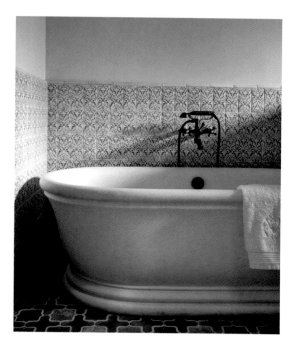

Ornate tiles pair naturally
with terra-cotta floors.

Carved wood antiques bring
in warmth and texture.

ABOVE: In a renovated attic, the guest bedrooms look out to a canopy of palm trees, which kicked off these upholstered green stripe walls and matching furniture and lampshades. OPPOSITE: Is an awkward ceiling an impediment or an opportunity? Tented in a divine fabric, this room is the answer.

Design is about
more than the
artisanal moments
we create; it's
the love for a life
well lived.

CLOCKWISE FROM TOP LEFT: We worked with Marc
Appleton and team to develop intricate and muted tile
patterns inspired by the Mediterranean originals used
in 1920s Santa Barbara. There were no fountains on
the premises, so we installed Mediterranean wall
versions, complete with the deep-water reservoirs,
bronze spigots, and arched stucco detailing you'd
expect in Andalusia itself. Old Hollywood loved
poolside stripes. A sunburst through fragrant
bougainvillea. Wrought iron furniture from the Janus et
Cie Amalfi collection is timeless, especially when
paired with thick bespoke cushions. A portal into pool
paradise. FOLLOWING PAGES: Abundant poolside
seating options and embellished umbrellas give this
guesthouse pool the feel of 1930s Hollywood glamour.

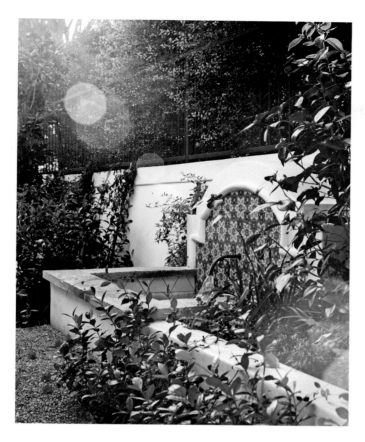
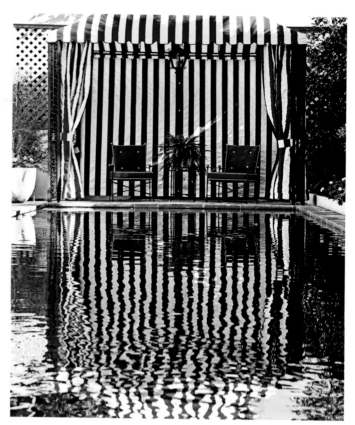

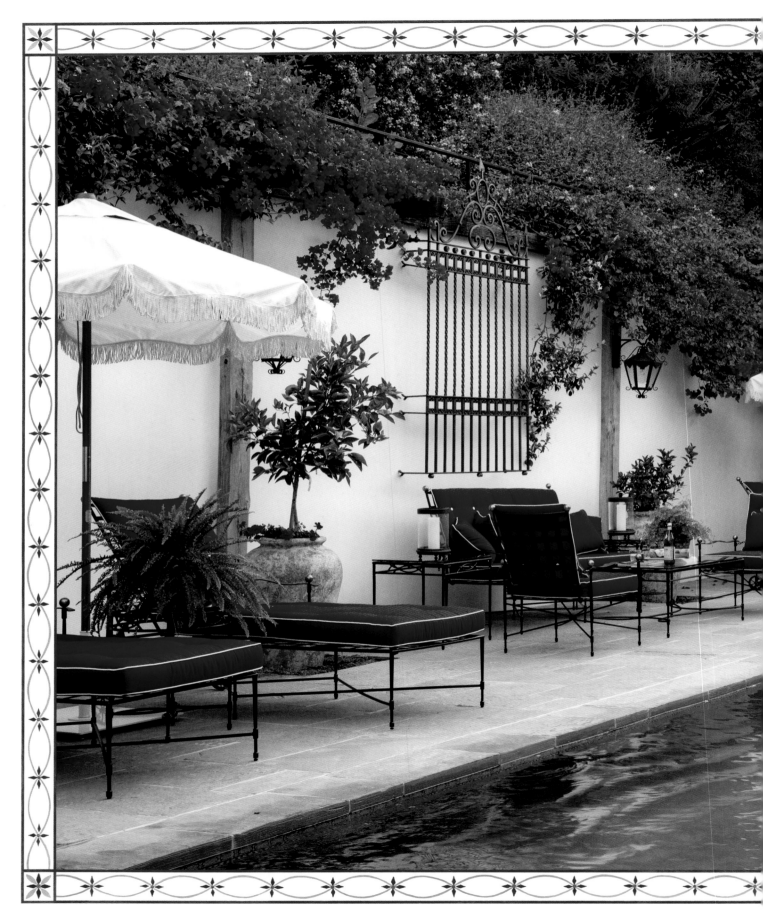

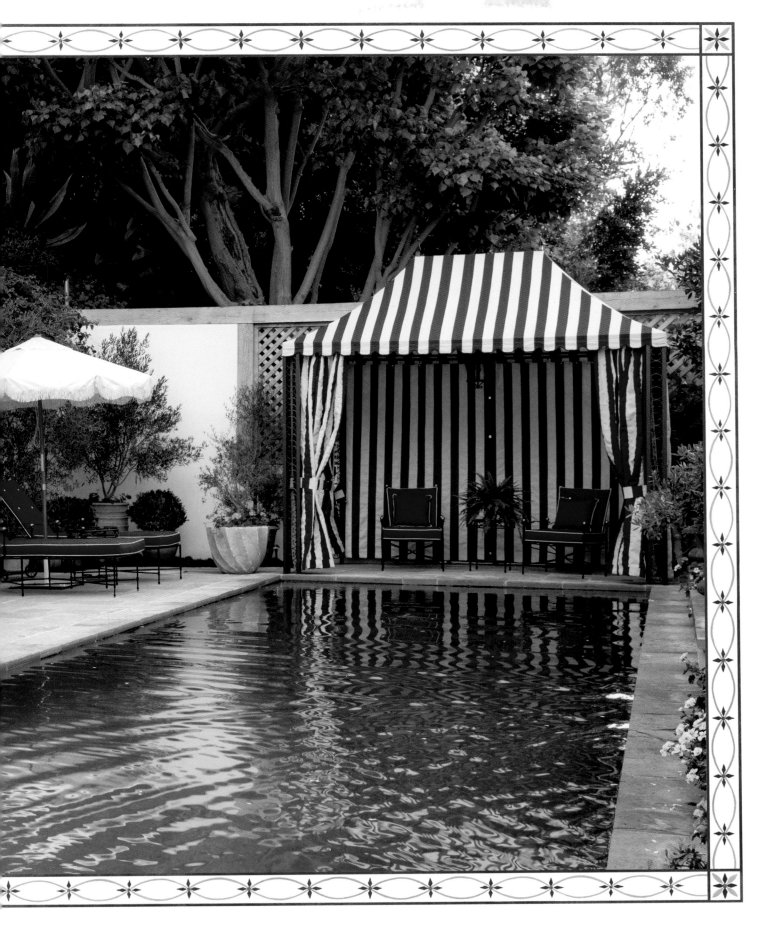

March

ON THE WATER

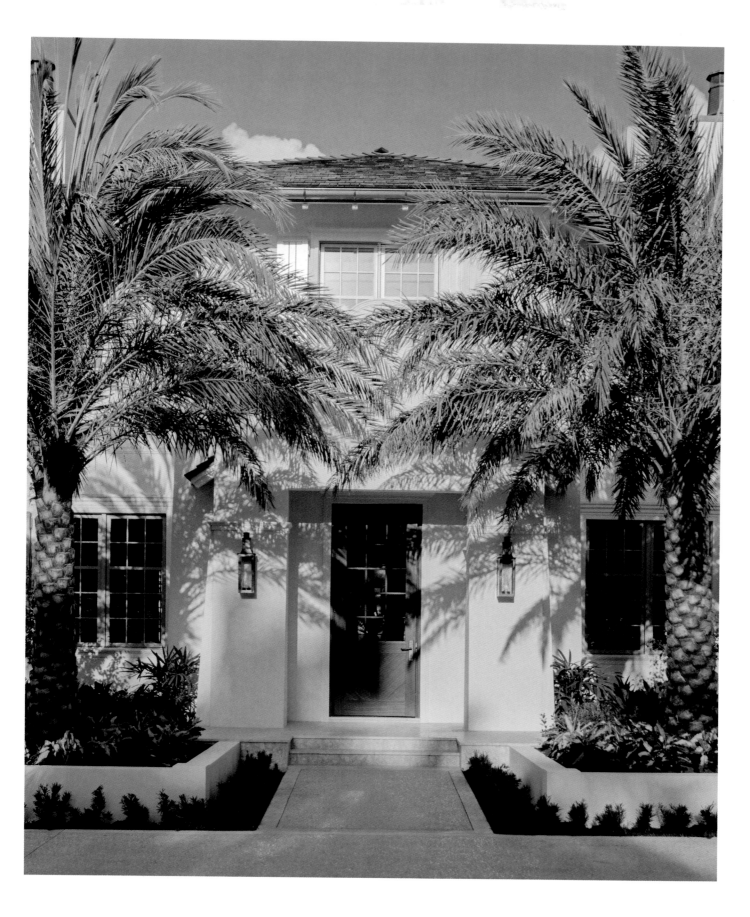

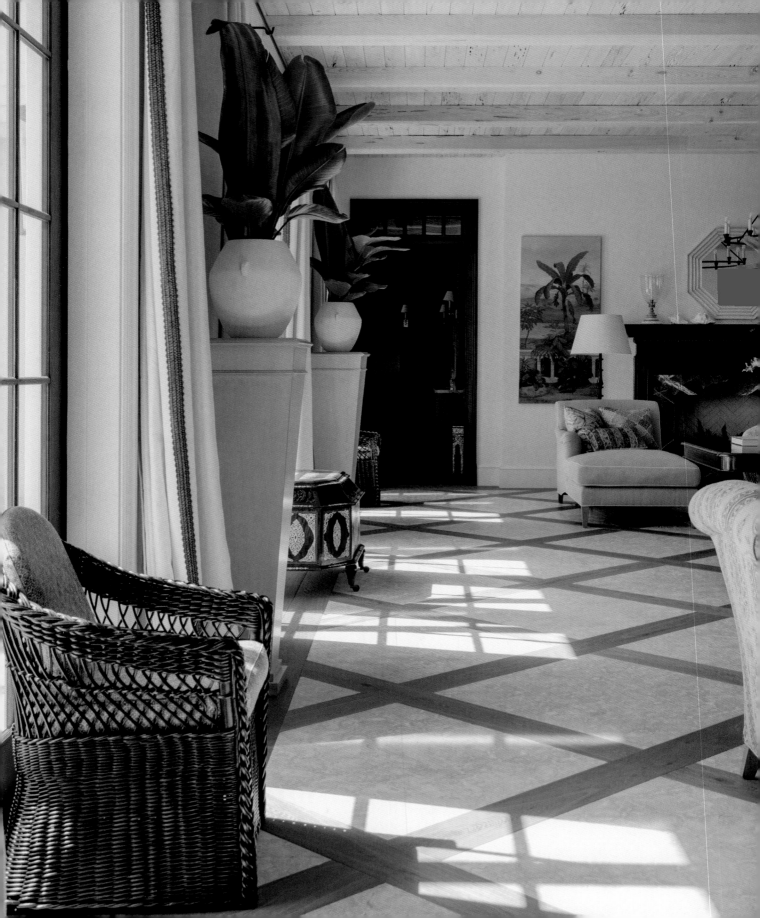

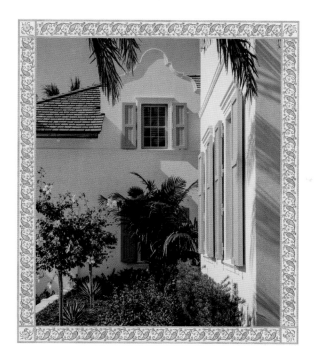

In the paradisiacal beach towns of Florida, the spring season is not altogether different from the winter months. But when March arrives, the natural light in Florida changes. Daylight lasts noticeably longer, dripping with sunshine for twelve delightful hours. The sun is also perched higher in the sky this time of year, casting its glow so brightly that it creates cinematic shadows.

That solar radiance produces riveting profiles on this stucco new build we designed in Boca Raton. The home was inspired by Bahamian and Cape Dutch architecture and has prominent clock gables, flickering gas copper sconces, and blue louvered shutters that are especially lovely along this particular Florida causeway, where salty breezes flow freely. Inside, thick mahogany doors and beautiful transom windows allow soft daylight to filter through the rooms. Pecky cypress ceilings provide a welcoming warmth and underfoot, stone floors with inlaid wood bring unexpected detail.

PREVIOUS PAGE: We installed gas lanterns on the exterior so that they would flicker and dance after nightfall. OPPOSITE: Stone floors with inlaid wood have a checkerboard effect; we lightened up the mood with pickled pecky cypress ceiling beams. ABOVE: Fairy-tale gables and thick whitewashed walls are hallmarks of Cape Dutch architecture, beautifully captured in this home by Dailey Janssen Architects.

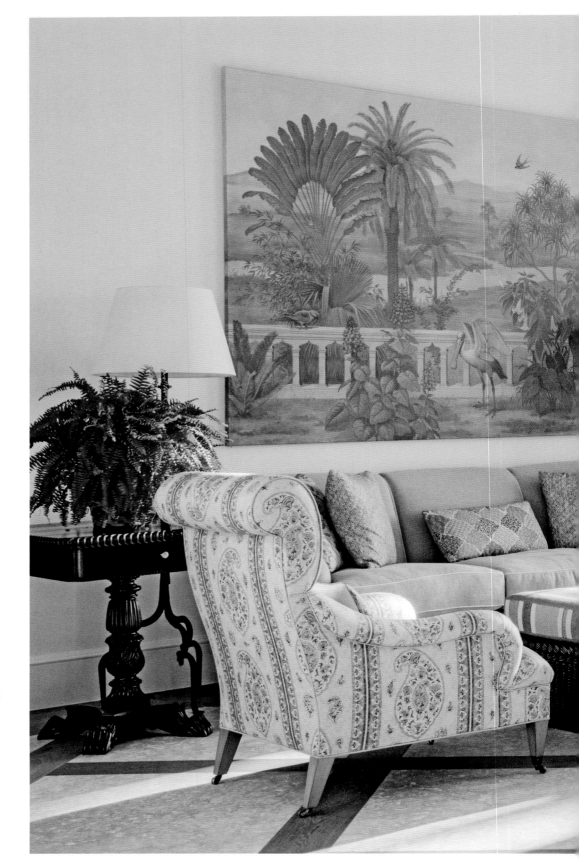

Our decorative painter, Joseph Steiert, devised pastoral art pieces that pull together the home's entire color palette on canvas. The elegance of the chair backs in this living room juxtaposes beautifully against the graphic floors, while the mahogany transoms, doors, and doorcases have a colonial influence that adds to the age-old feeling. I love mixing wicker and wood pieces; the former brings in much-needed texture while the latter helps ground any space.

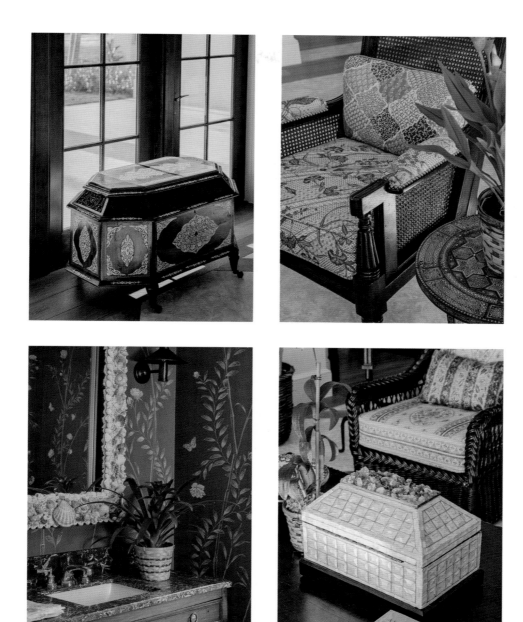

OPPOSITE: You don't need to panel an entire room in scenic wallcovering to make an impact; one hand-painted piece, such as this one by Steiert, can create the effect of a window with a view. ABOVE, CLOCKWISE FROM TOP LEFT: Details can make a space come to resplendent life, including this inlaid antique chest; a woven cane armchair, freshly upholstered in a batik fabric for comfort and added pattern; a stone box; and a powder room hand-painted by Steiert with a shellwork mirror.

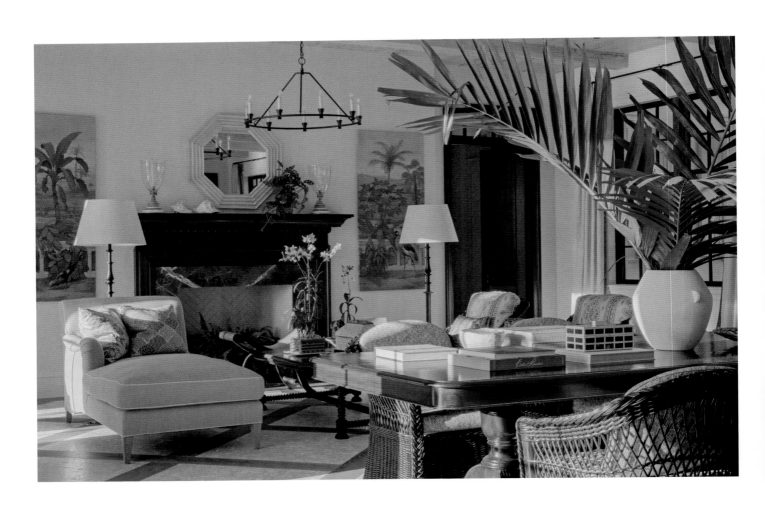

ABOVE: Plants are vital for supplying a sense of life to a room, and it's best if they reflect their locale. Here in Florida, we brought in a generous burst of gracious palm fronds, ferns, and delicate orchids. OPPOSITE: A long colonial wood dining table paired with more contemporary woven rattan chairs divide the sitting areas of the great room, allowing the space to be multipurpose—with dining at the center. FOLLOWING PAGES, FROM LEFT: Transom windows allow additional light to flow throughout, while pale blue kitchen cabinetry softens all that wood. Paired with paisley block print fabrics, these braided and woven seagrass armchairs bring a note of casualness that suits life along the shore.

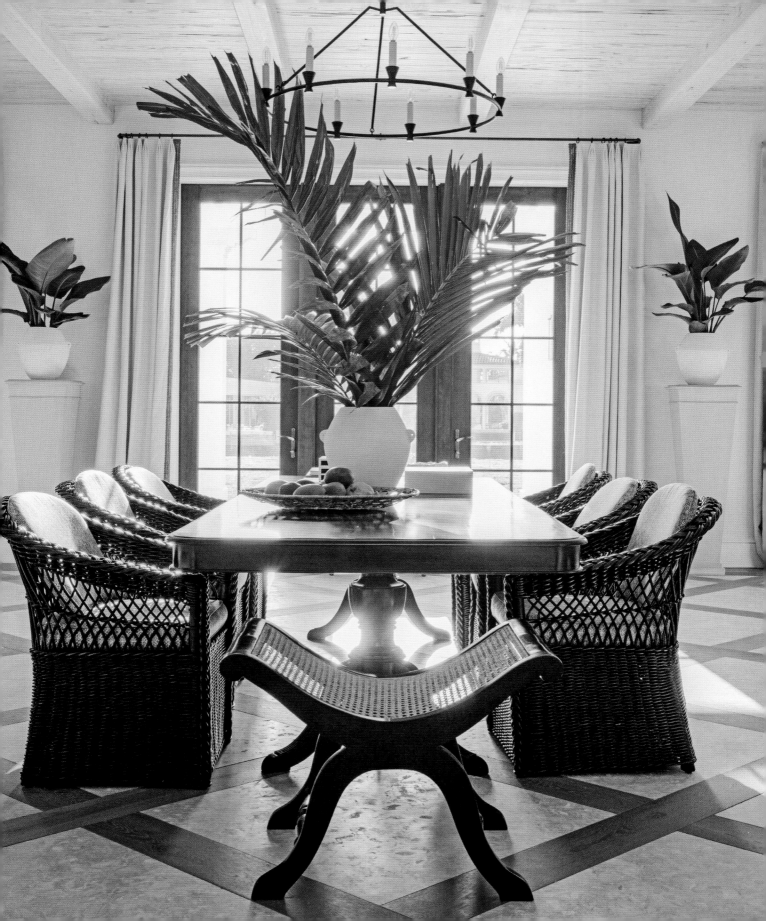

ABOVE: A thick butcher-block counter echoes the mahogany used throughout the home and feels like a holdover from another era, especially paired with an undermount farmhouse sink. OPPOSITE: The island's overhead pot rack made of wood gives an authentic feeling to the architecture; a trio of lights tucked inside provides plenty of functionality. The stools' woven jute chair backs add texture.

You can never go wrong with indigo blue sofas, but the matching ottomans create a tailored sensibility in this family room. The pendant lights over the breakfast nook mirror the lights above the island. Woven seagrass dining chairs bring in a natural touch.

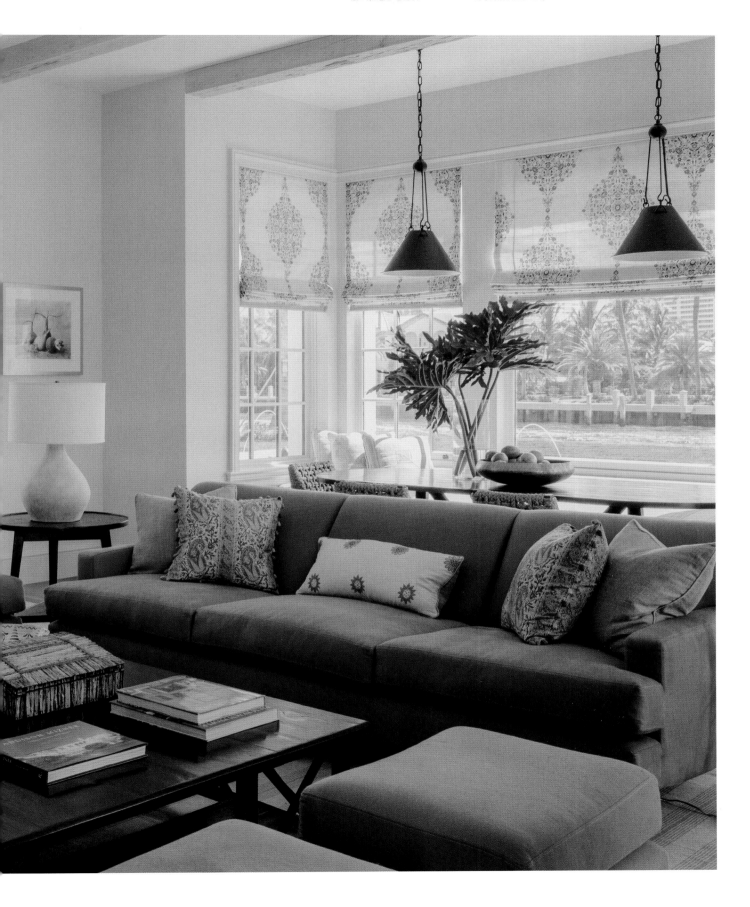

Layers of texture feel comfortable because they're all around us in the natural world, from the glossy sheen of a waterway to the rich, dense carpets of grass.

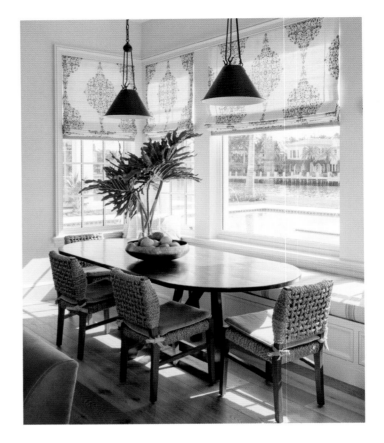

CLOCKWISE FROM TOP LEFT: An oval table feels expansive, but its edges are easier to navigate than squared versions. Custom barstools are pretty places to linger. We echoed the waterway out the windows here in our custom stripe fabric choice. Since the family room sits adjacent to the kitchen, we tucked major appliances away to recede behind pretty soft blue cabinetry. Bowls of local fruit are a living still life painting. Extra throw pillows ensure comfort.

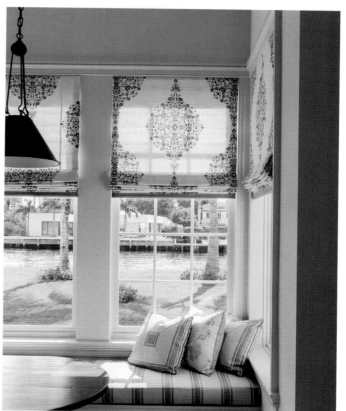
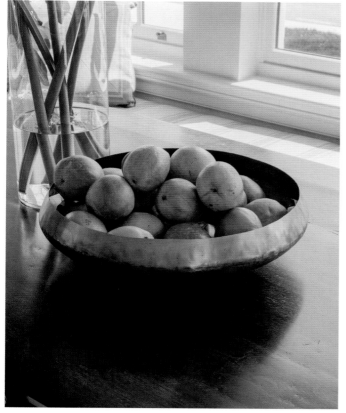

You're instantly transported
to Marrakech when you
step foot in the library, where
the light is transcendent—
thanks in part to the windows
that peer out on the adjacent
waterway. The fabric
applications here reference
the intricate architectural
vernacular of Morocco;
we played with mixing and
mingling the borders,
bases, and cushions on the
sofa, armchairs, and Turkish
poufs for details that
resonate. Walls are paneled
in pecky cypress, a wood
that's native to Florida.
On the right hangs *Untitled*,
1969-1971 screenprint
by Cy Twombly.

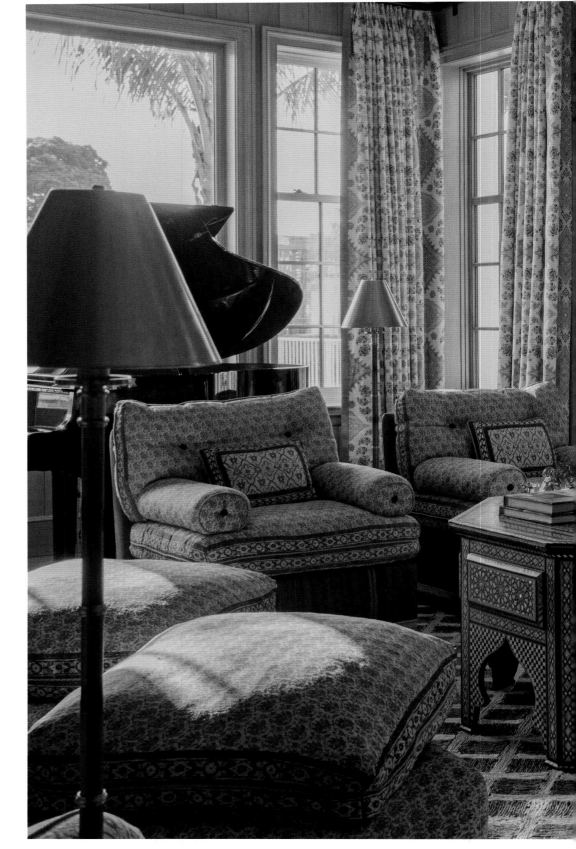

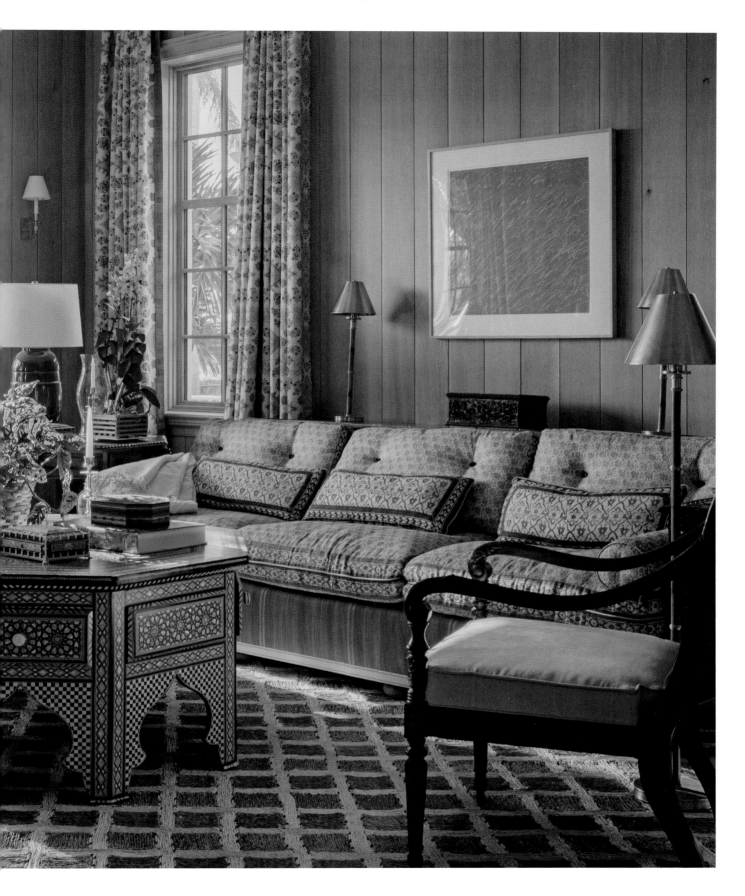

"My wish is to stay always
like this, living quietly
in a corner of nature."

Claude Monet

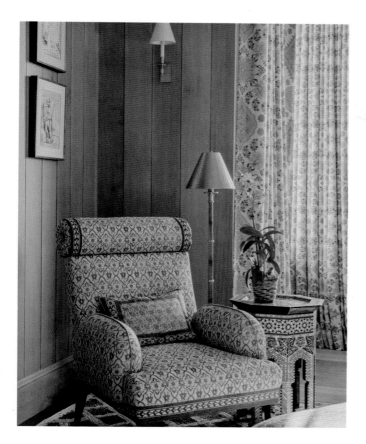
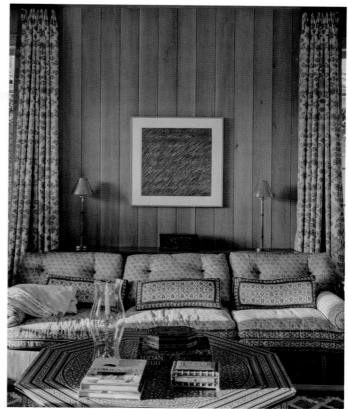

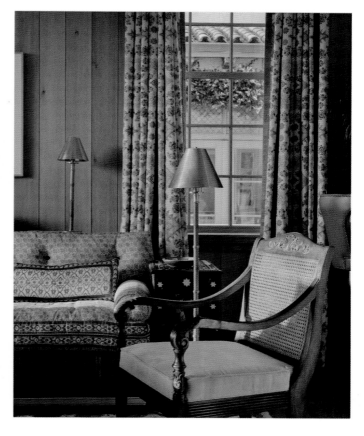

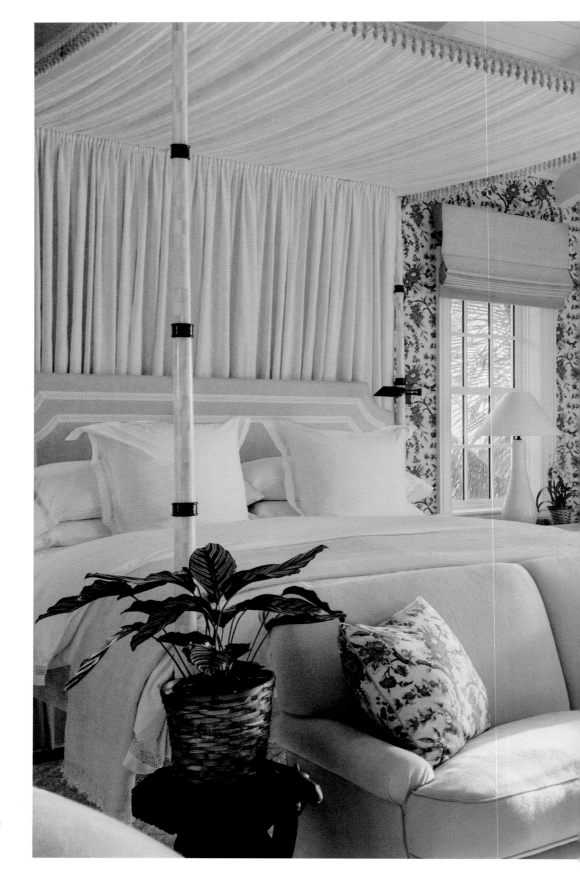

We designed a custom shirred fabric bed hanging complete with beaded trim for the made-in-India canopy bed in this primary suite; it subtly echoes the exposed beams and paneling of the hipped roofline above. Watery blue window treatments and furniture upholstery calm the floral wallcovering like a reflecting pool in a garden.

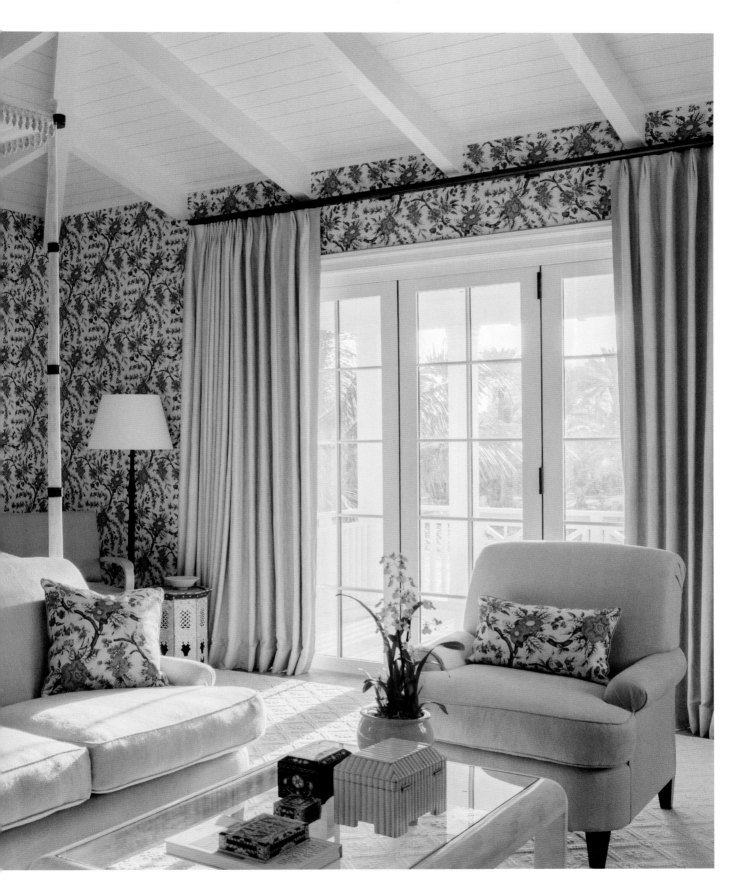

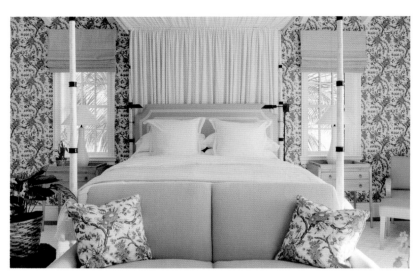

We did a lot of special embroidery throughout, on both pillows and upholstery.

Placing trailing plants on stands transforms them into a moment.

There is no plush bedroom seat that can't benefit from a throw blanket on hand.

Wall sconces hung on a mirror double the light.

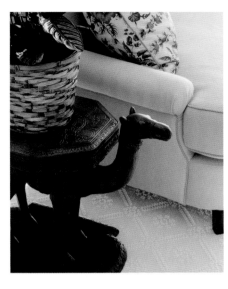

A hand-carved camel side table is a beautiful place to set a drink.

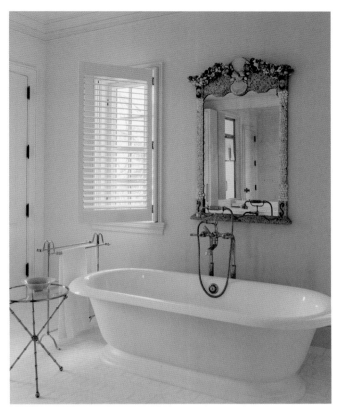

Above a deep soaking tub, a shellwork mirror brings the charms of the sea indoors.

A vintage chinoiserie bamboo armchair and woven rattan coffee table suit the setting.

Mixing soft and woven textures creates a rich and layered effect.

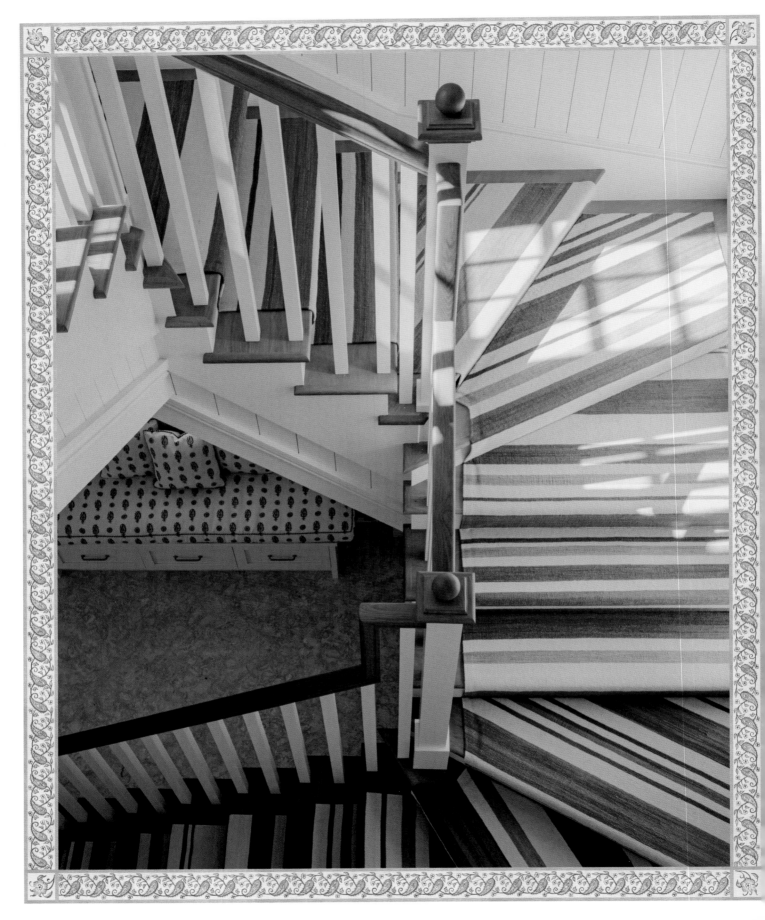

"I like light, color, luminosity. I like things full of color and vibrant."

—*Oscar de la Renta*

None of this feels stuck in time, thanks in part to the homeowners' amazing modern art collection. To juxtapose against their curated pieces, we specifically sought out furnishings that would lend an easygoing Bahamian feeling to the interior spaces, like colonial bone-inlay furniture; shellcraft mirrors and boxes; and lots of natural fibers that supply tactile textures, such as cane, wicker, rush, and jute.

Our decorative painter, Joseph Steiert, adorned the dark brown powder room in fanciful chinoiserie. Powder rooms are often windowless and can feel quite dark, but here, even in the shadows, you have the instant perception of a flourishing garden instead. For the living room, he created the custom lush landscape paintings that bring the whole house's color palette together. It's those little elements that linger in memory and are so worth doing!

Our fabric applications here were vital, too, especially in the library where we played with patterns to juxtapose against the modern Cy Twombly piece: upholstering the sofa bases with one fabric and cushions in another, or adding borders around the box cushions on the Turkish poufs. It all works together to communicate a relaxed Florida feel. Sometimes the motifs you choose can bring their own sense of light.

OPPOSITE: We created a custom striped stair runner in shades of blue with King's House Rugs that emphasizes the graphic lines of the stairs.

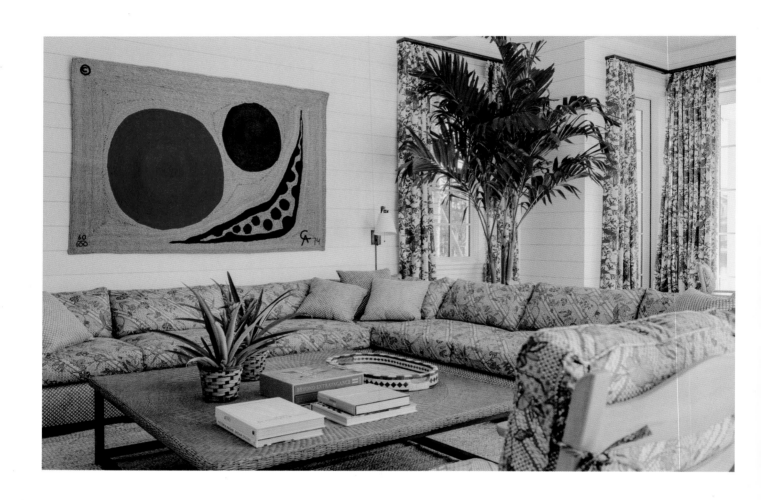

ABOVE: *Moon Tapestry*, 1974 after Alexander Calder provides a peppy jolt of color over the sprawling sofa and woven rattan top coffee table in the sunroom. OPPOSITE: The globe pendant light feels a bit industrial, like it was brought in from an overgrown garden. We like to add cushions to chairs at a game table for comfort.

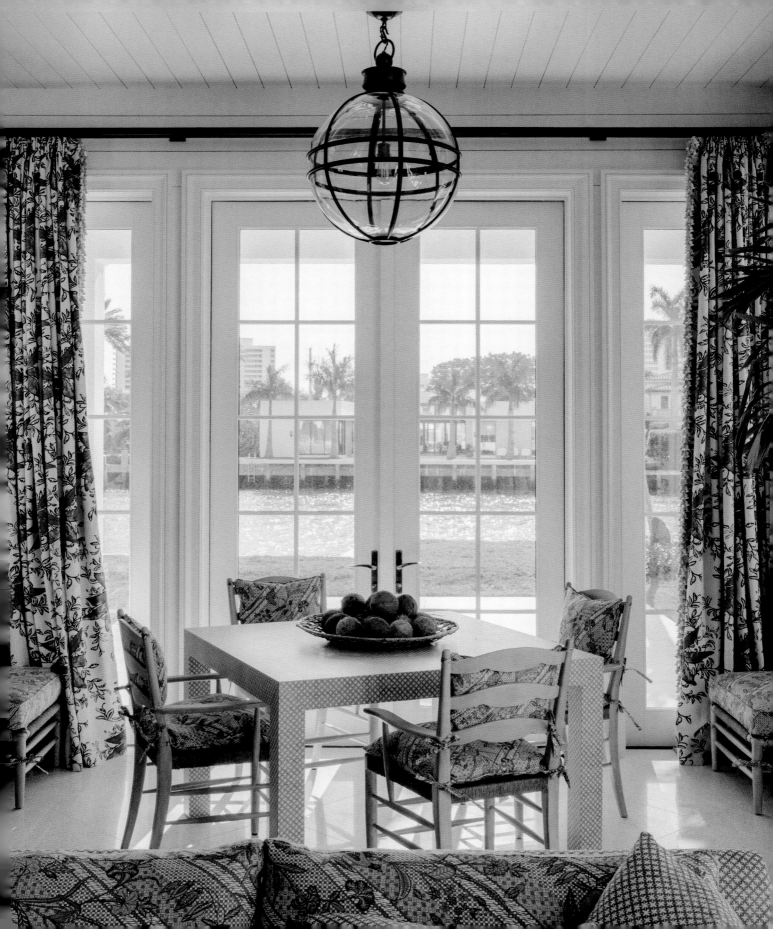

April
SPRING FORWARD

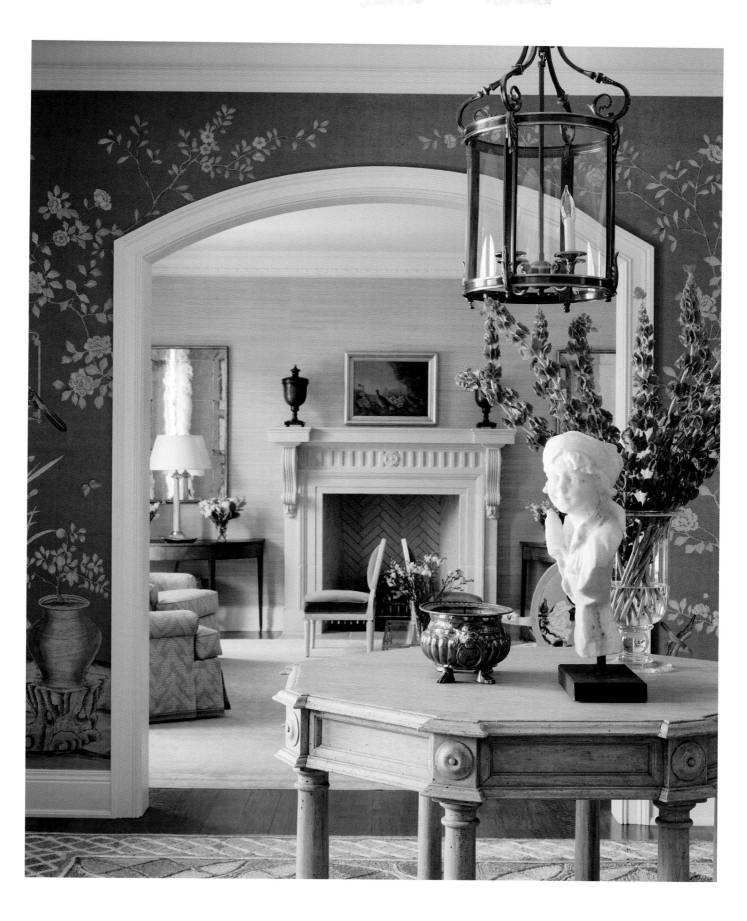

April showers—whether misty and delicate drizzles or brooding downpours—have a magical effect. They're capable of transforming landscapes of rolling lawns and boxwood gardens from their winter-parched tawny hues to a vibrant Kelly green again, seemingly overnight. For this home presiding over three myrtle-dotted acres in the countryside outside Chicago, we reached for the most restorative color there is to inspire the color palette: bracing, crisp April green.

We found our ultimate muse just beyond the windows on the verdant grounds. The property was built about thirty years ago and felt a bit like an expansive European castle transposed on a smaller scale in the Midwest, thanks in part to the home's French Chateau–style architecture and carefully maintained gardens. It helped that this homeowner adores beautiful things and has collected a staggering cache of art and antiques over the years. We

PREVIOUS PAGE: An antique French jardiniere takes pride of place on the neoclassical octagonal table. ABOVE: In the entrance hall, custom de Gournay chinoiserie wallcoverings are a fragrant flower garden that never needs upkeep. OPPOSITE: Pairing modern art with a traditional sofa and Colefax & Fowler pillows creates truly timeless beauty. FOLLOWING PAGES: A pair of mirrors flanking the mantel brings just the right amount of glamour into the green grass cloth envelope of the living room.

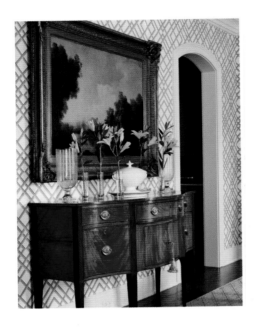

ABOVE, CLOCKWISE FROM TOP LEFT: The lattice wallpaper from Brunschwig & Fils was inspired by a Park Avenue dining room designed by Mark Hampton. A natural fiber rug brings a casual sensibility underfoot. Tucking a garden stool under a demilune table means it's always accessible for an extra drink table, or even seating, in a pinch. A curule bench aligns with wall art hung vertically. OPPOSITE: In the dining room, a soft blue ceiling forever feels like the first sunny day after a spring rain.

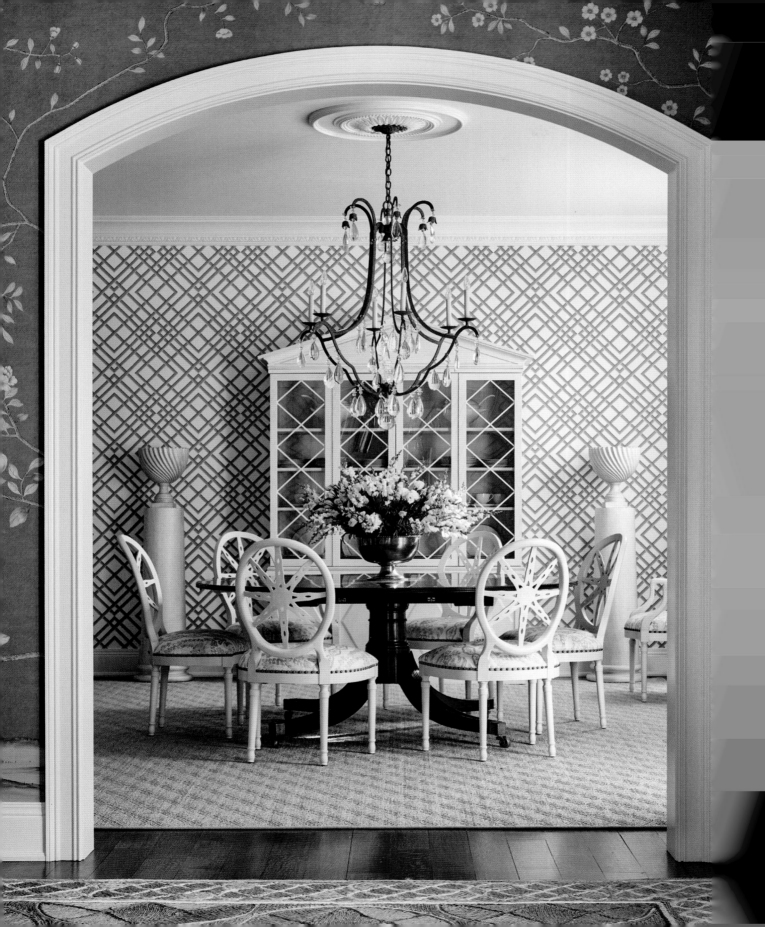

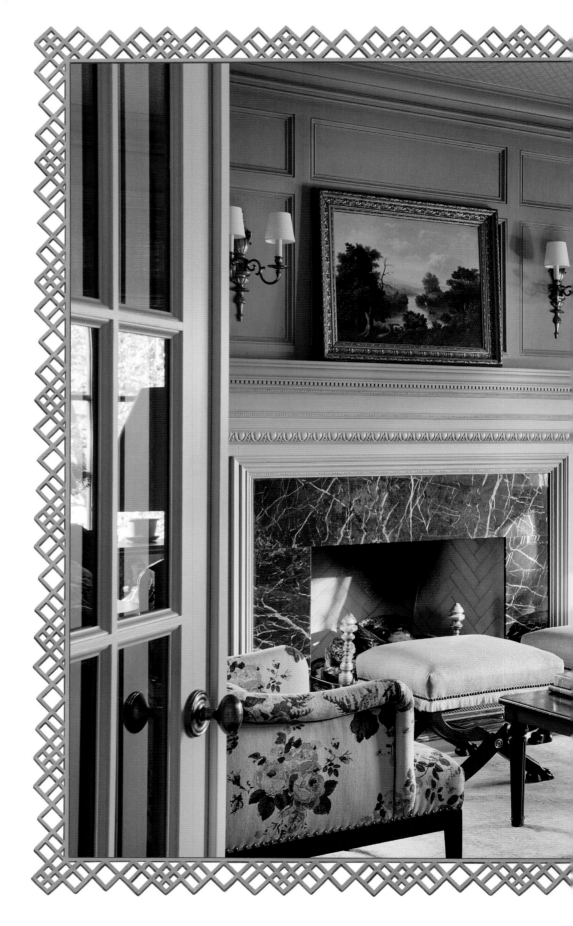

In the library, we softened the existing cerused oak wood paneling with a few pieces of floral linen and throw pillows by Clarence House. I love ottomans nestled by the fire; they provide a cozy perch at cocktail parties, without obstructing the view of the flames.

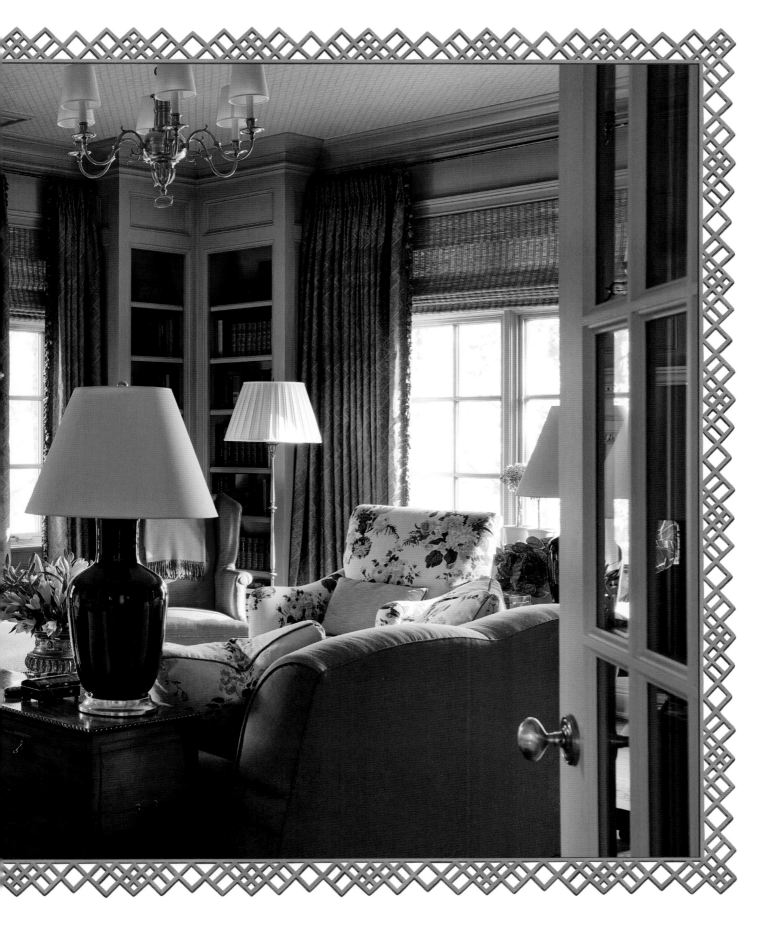

"Nature doesn't need people—people need nature."

Harrison Ford

OPPOSITE: Clarence House's hand-blocked Dahlia on linen is eternally chic. Tucked into the bookshelves, antique botanical prints supply a lush liveliness—an ode to real elegance.

Treat the little things with reverence and work on them until they are exactly right. It's worth it: the smallest amount of craftsmanship brings enormous depth and delight.

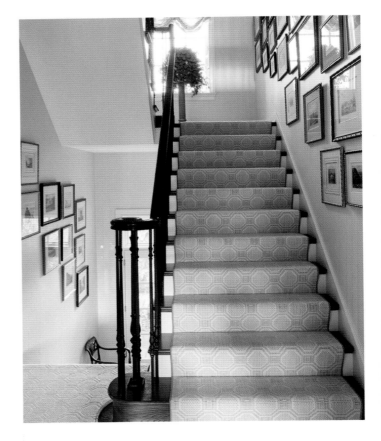

CLOCKWISE FROM TOP LEFT: Gallery walls along a stair are classic, from historic estates in Europe to Gloria Vanderbilt's Manhattan apartment. The custom Namay Samay matchstick blinds and cane back in this antique bench echo—but don't mirror—one another. Relaxed Roman shades with a pom-pom fringe counterbalance the arch. A supple leather wingback always beckons in a library. The green leaves in this powder room's wallcovering bring a reviving freshness like spring. Shirred linings in cabinetry are textural and soft, while blocking inner storage out of sight.

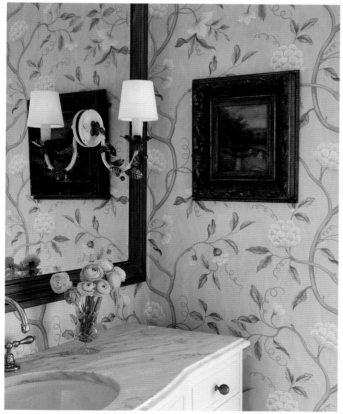

ABOVE: Iatesta Studio's Chesapeake chairs are storybook seats in the breakfast room, especially painted a weathered French blue and topped with custom cushions with a textural border detail: a woven welt. The dhurrie was colored just for us with a Greek key detail by Guinevere. OPPOSITE: Checks can read as overly graphic unless they're neutral. These gingham draperies draw the eye up and match the braided wicker pedestal and urn.

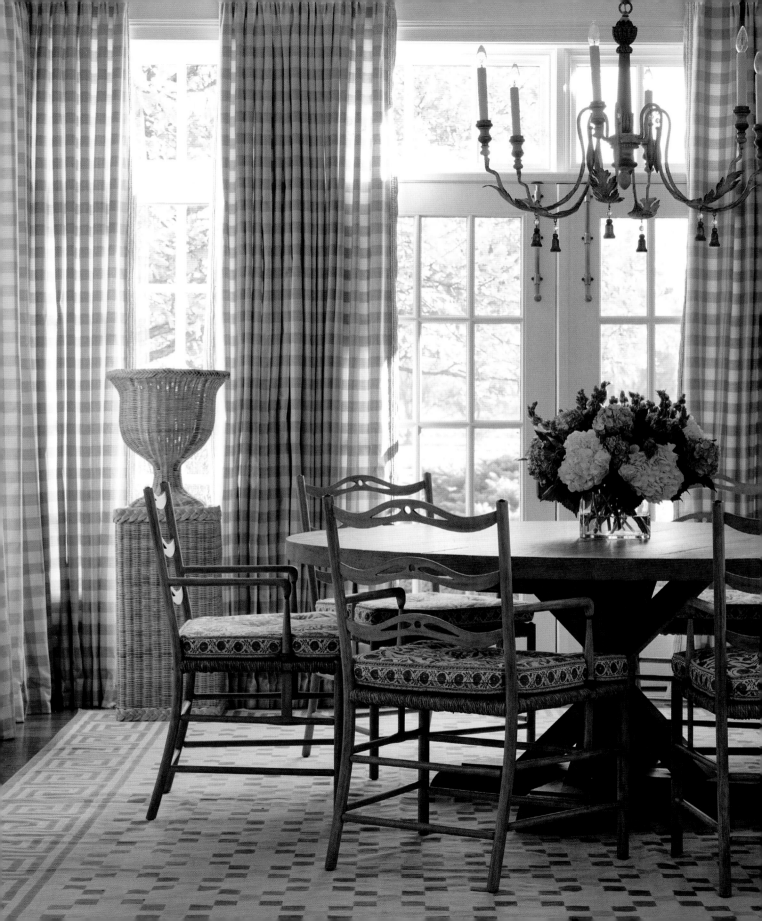

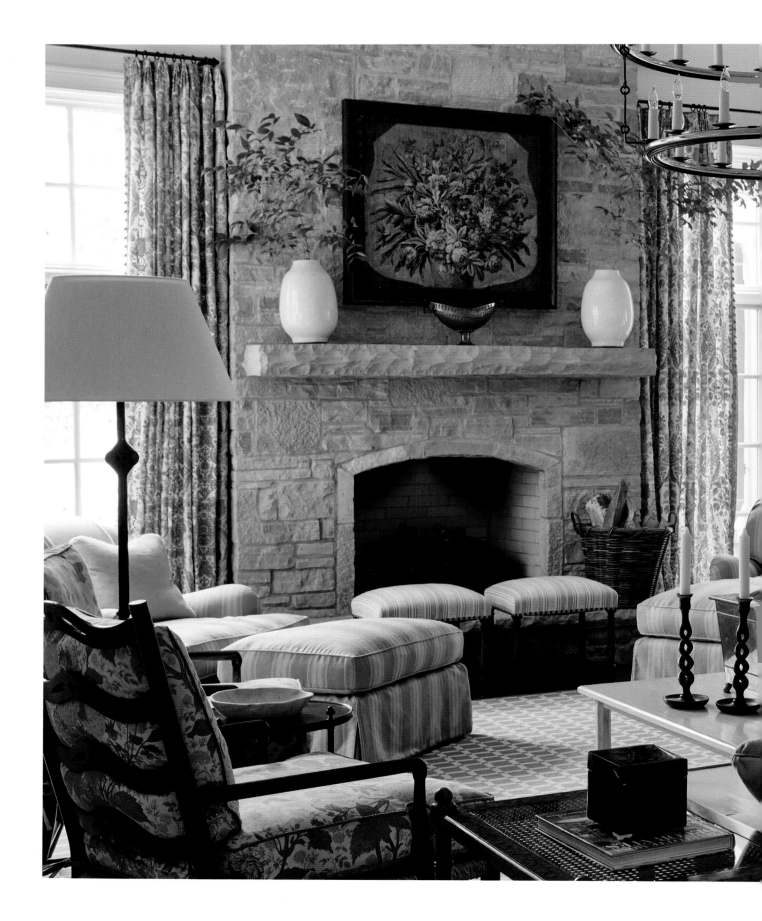

"If you truly love nature, you will find beauty everywhere."

— Vincent van Gogh

loved employing her finds in new ways so that we could up the ante on her enjoyment of them. When decorating, the goal should always be to create a home that reflects you—and your interests and best memories.

As any gardener will tell you, growth takes time. So while the bones of this house were fairly new, we spent many hours of TLC reviving the traditional halls in timeless yet fresh ways that wouldn't read as overly staid: sheathing the foyer with hand-painted de Gournay wallcovering in a custom parakeet green; installing hand-painted furniture, such as the flame-painted desk in the primary bedroom; or adorning the dining room with a minty Brunschwig & Fils treillage that nods, with a wink, to Mark Hampton.

Even the basement was transformed, with ebonized woods to suit the moodier subterranean space, a massive nineteenth-century oil painting of waterfowl, and wicker galore that we stained an inky brown and employed on both the furniture and on decorative brackets hung on the walls for texture. Clearly, I gravitate toward the classical, but you can give a vibrancy to fervently traditional choices by mixing them with the unexpected: a glass coffee table, sprightly upholstery, painted chairs. Good design is a consort of old and new, dark and light, modern and a mere whiff of stuffy. The result is fresh but also comfortably familiar, like a spring rain.

PREVIOUS PAGES: The French blue welts on these custom sofas and armchairs are restorative: a drink of fresh water on a warm spring day. Overhead, the double-ring chandelier is unexpected and modern in polished copper. OPPOSITE: Wherever I can tuck a bench cushion for lounging in an underused nook, I will. The way we applied the stripes here—including a mitered edge on the pillow—surprises and contrasts the stone walls in a subtle way. FOLLOWING PAGES, FROM LEFT: Lined with Lee Jofa's Hollyhock fabric, this primary bedroom hall is a stroll through a manicured cutting garden. We custom hand-painted this commode for the primary suite, and the results evoke Gustavian Sweden in the best way.

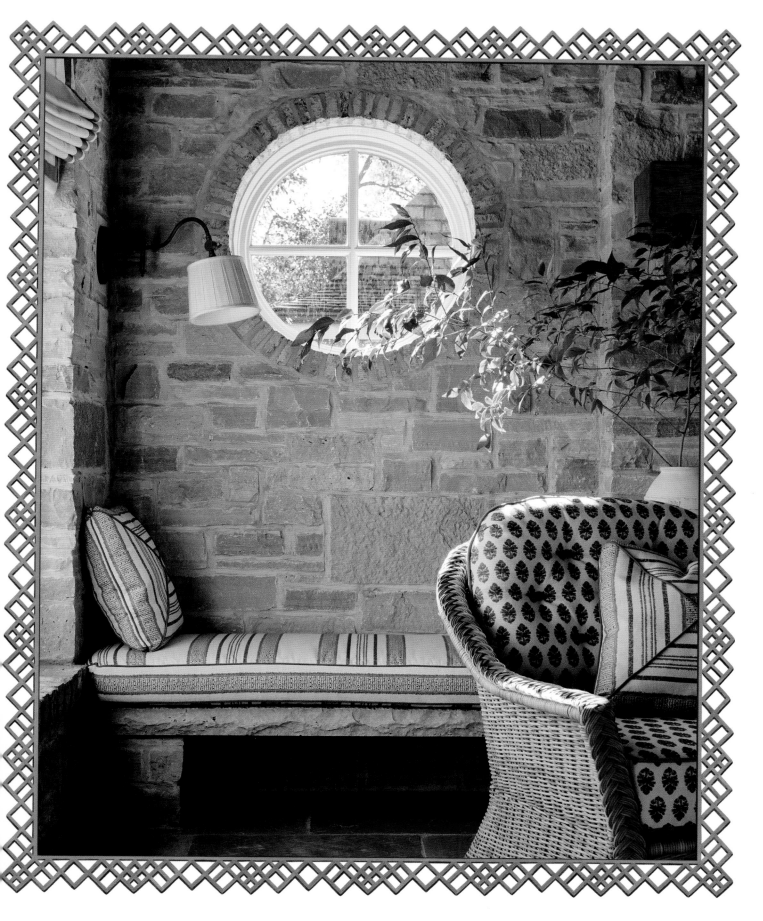

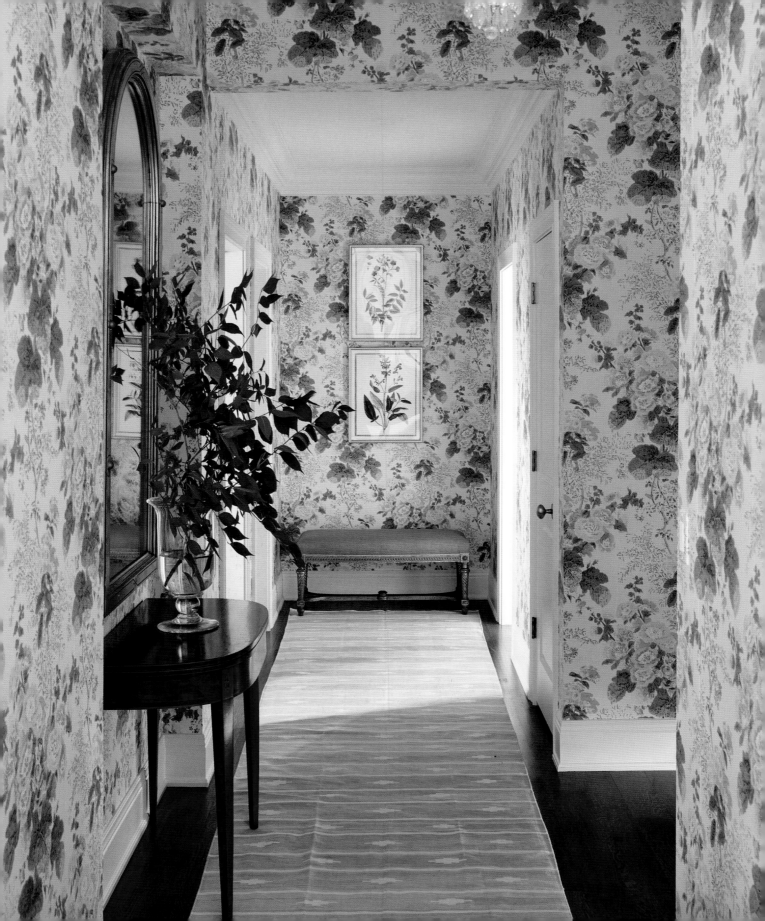

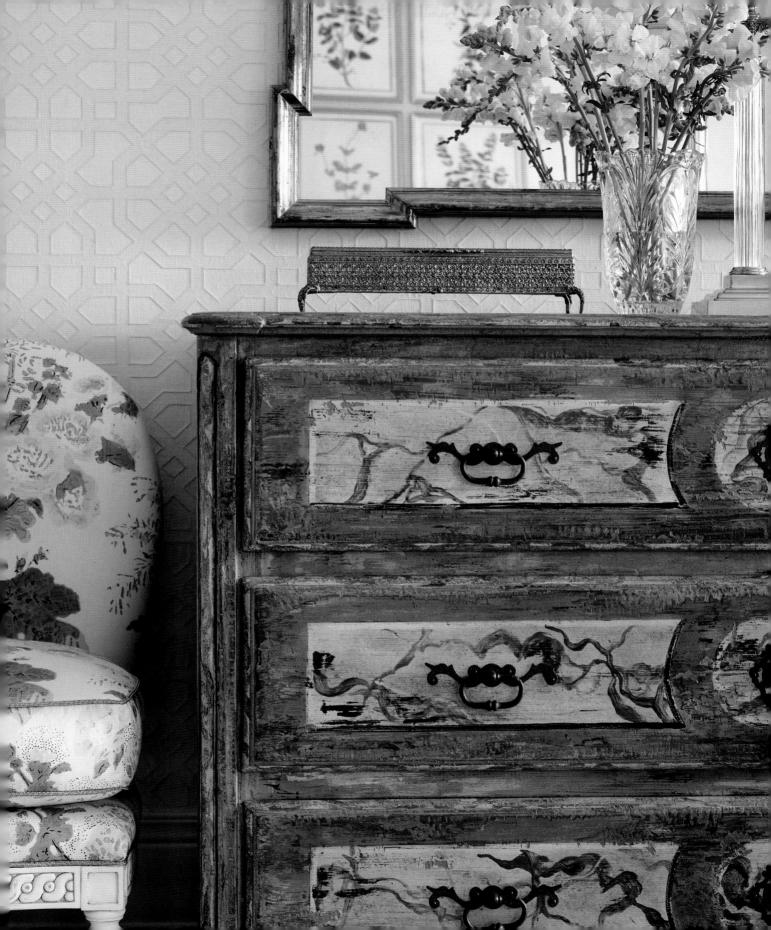

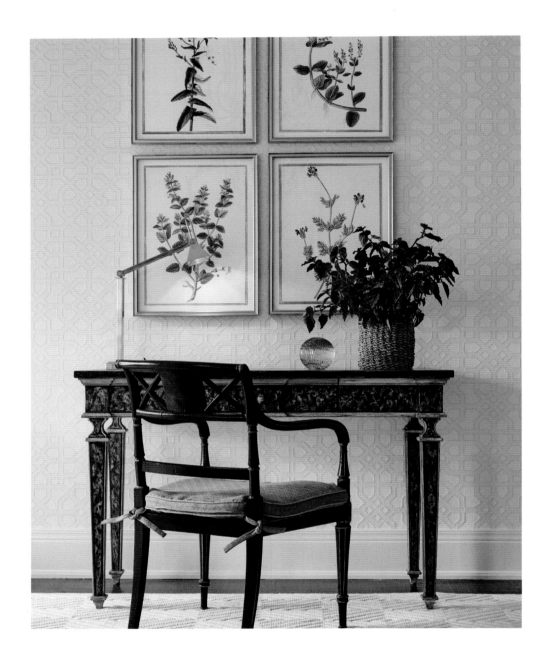

ABOVE: A custom flame-painted desk. OPPOSITE: We adorned the walls in the primary bedroom with an embroidered fabric, then painted the formerly brown beams in the tray ceiling a creamy white to lighten the mood. Elegance at every turn. FOLLOWING PAGES: The basement family room doesn't feel subterranean, thanks to the fresh yet familiar design scheme where a massive antique landscape painting contrasts with cozy ebonized woods.

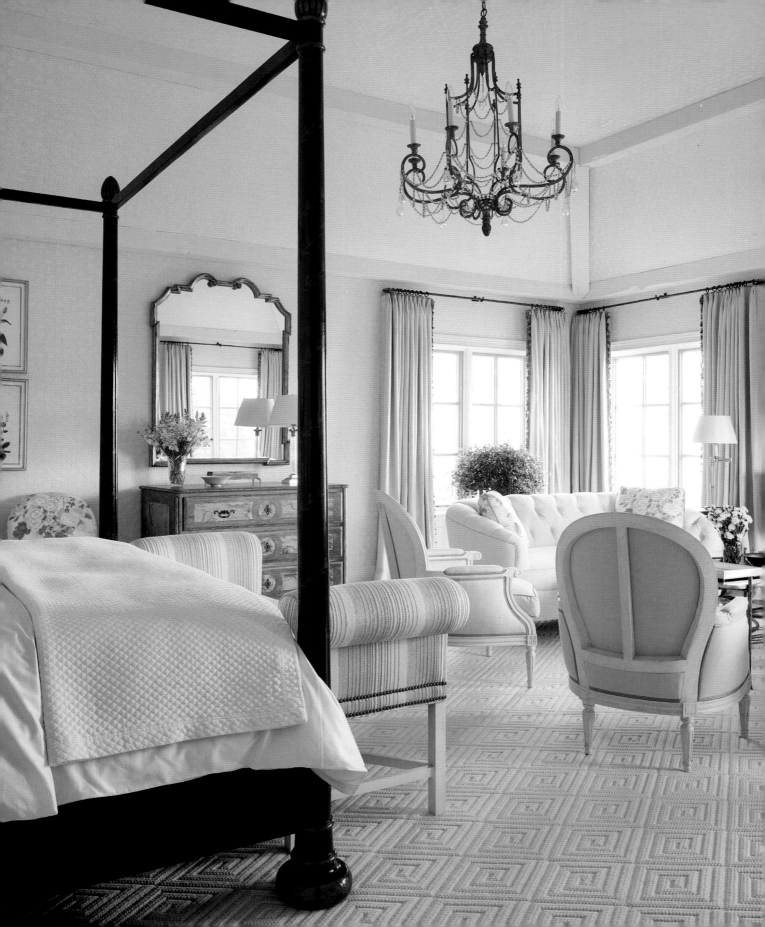

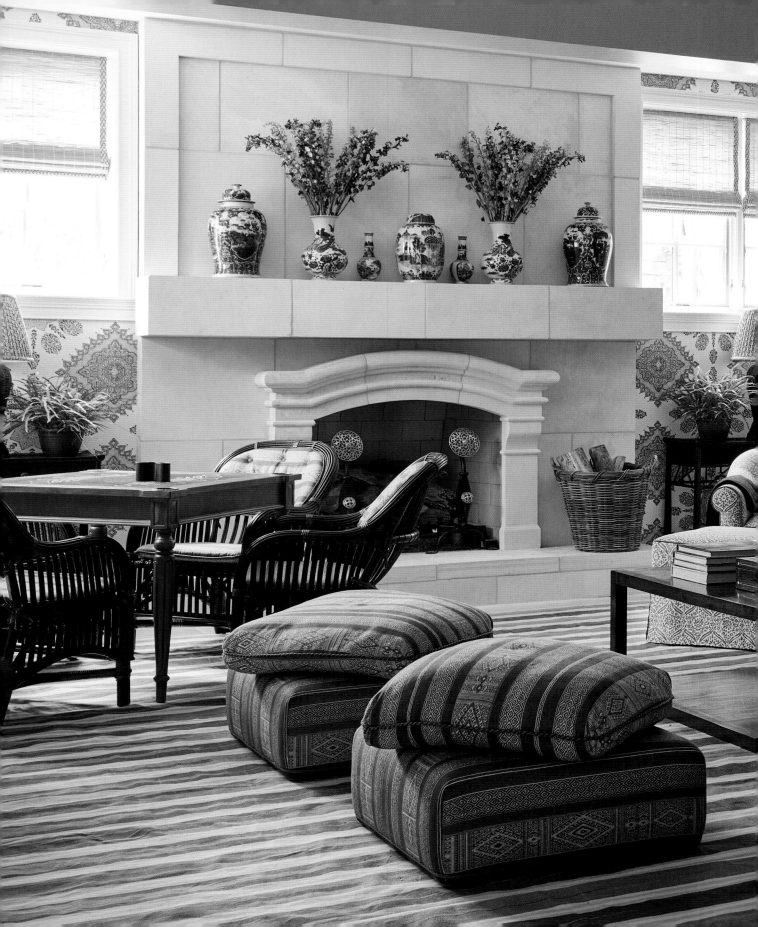

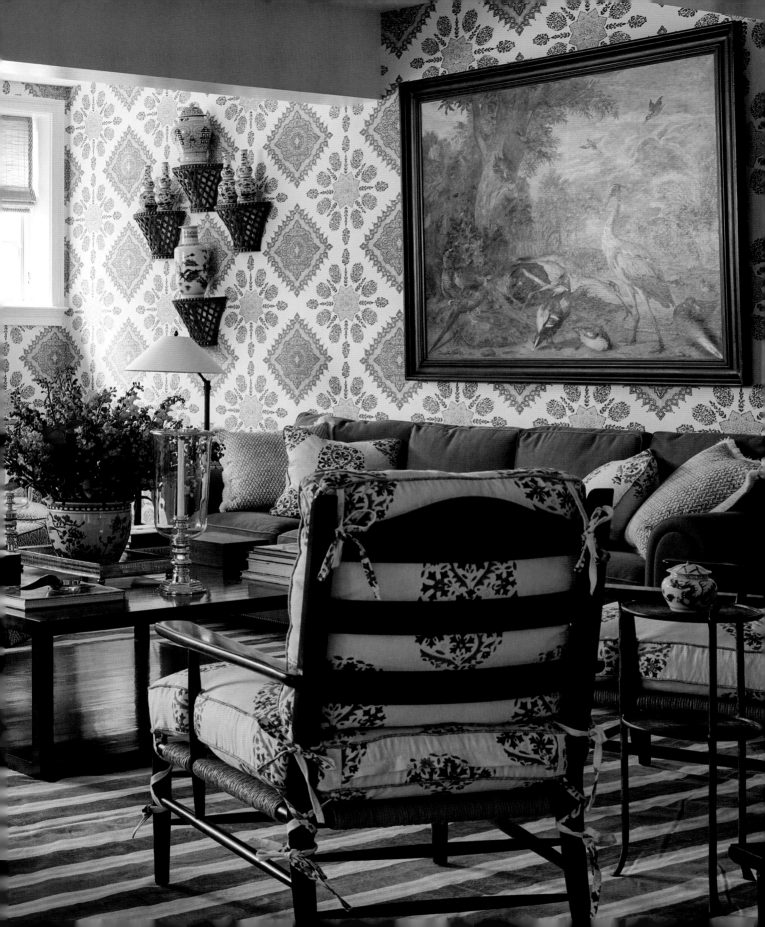

A billiards room made sophisticated in awning stripes.

Chocolate and blue: a handsome color pairing.

The inlaid compass star has decorated antique tables to great effect for centuries.

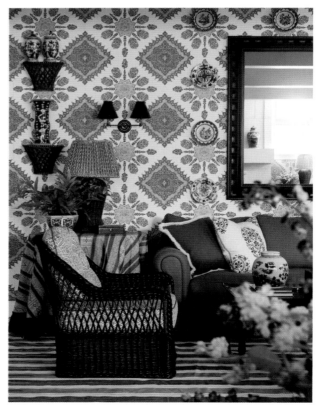

A touch of black can bring a pattern-rich room down to earth.

Blue-and-white porcelain is displayed on textural painted wicker brackets.

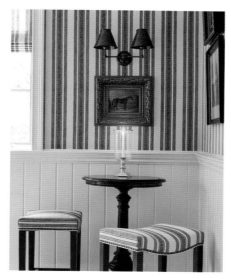

A high top in the corner has a pub-like feel.

Mixing patterns of various scales helps each motif sing.

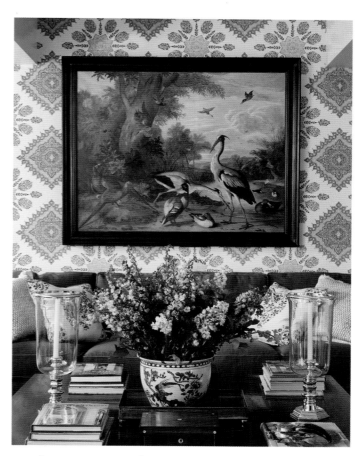

The oil painting visually anchors the sofa.

May

FLOWER POWER

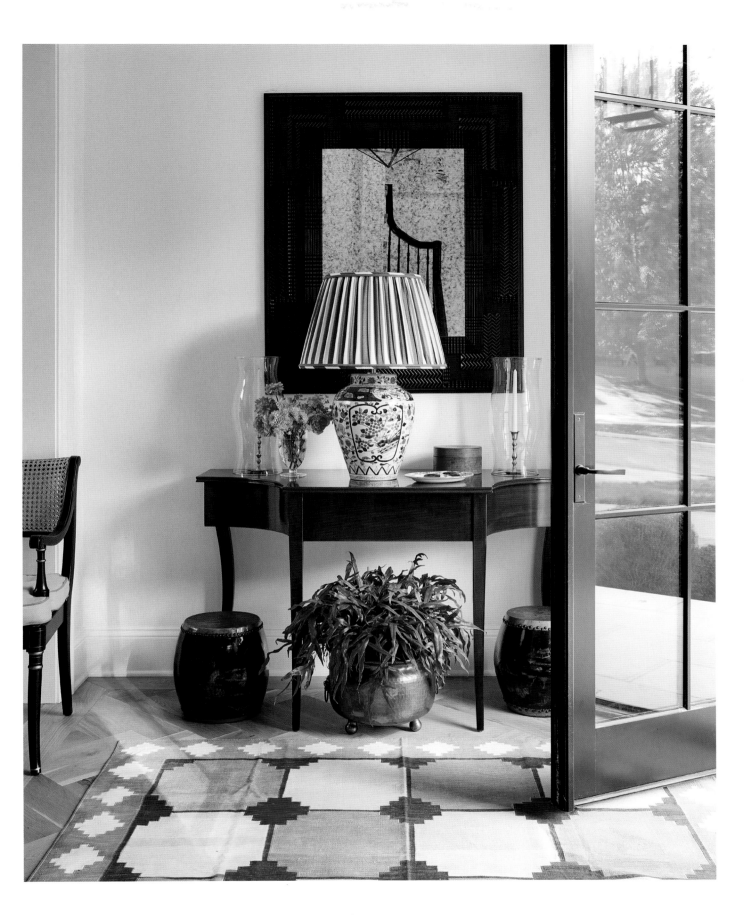

Midwesterners often breathe a sigh of relief when the month of May dawns. It's peak spring. With winter's squalls firmly in the rearview, temperatures can reach seventy or even eighty degrees, bringing fragrant lilacs and blousy peonies into bloom. Barn swallows, magnolia warblers, and scarlet tanagers have returned; spires of purple lupines dot the meadows; and locals watch fawns toddle, Bambi-like, on the plains.

Fitting, then, that the abundant beauty of nature was our ultimate inspiration for this newly built Mission Hills, Kansas, home. But it came in the form of an unlikely source: a collection of centuries-old Imari porcelain. Originally designed in seventeenth-century Japan, these Edo Period ceramics are embellished with flowers, birds, fish, and mythological creatures. Imari is almost always done in cobalts, iron reds, and gleaming golds—a fun and unfussy color palette that perfectly suits this wonderful family.

PREVIOUS PAGE: Tucking a footed jardiniere under a console table is a wonderful way to bring life to the edges of the foyer. ABOVE: A round and fringe-skirted table introduces softness and warmth into the strict lines of the bookshelves in an upper hall. OPPOSITE: Imari porcelain inspired the color palette of this home, especially in the dining room, where it became our muse for the custom hand-painted de Gournay wallpaper with Imari motifs and May flowers. FOLLOWING PAGES, FROM LEFT: China blue drapery panels with an ivory inset draw the eye skyward into the double-height ceiling of the living room. Layered patterns and colors can act as storytellers, even on a tabletop.

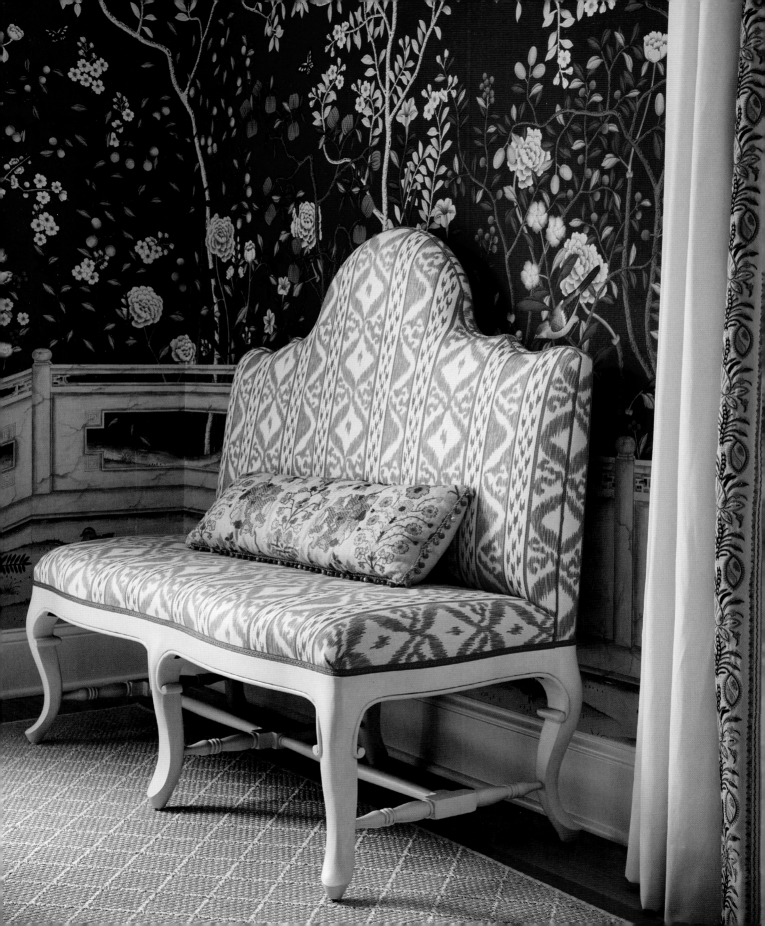

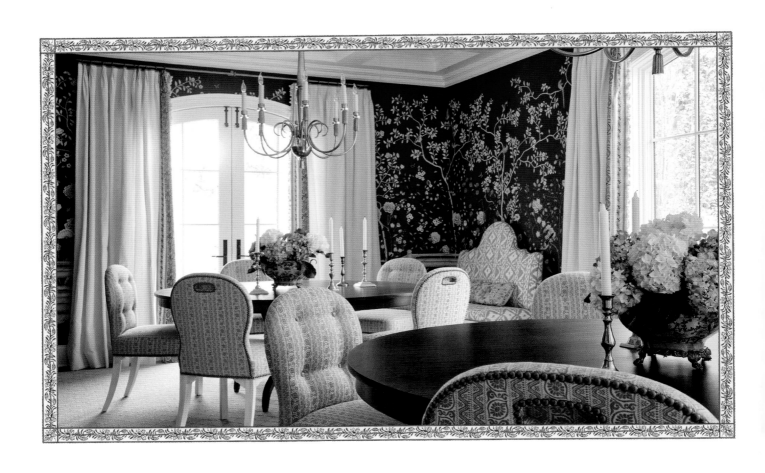

ABOVE: This family loves to entertain, so we designed a dining space with two tables that can be pushed together with leaves and added two custom settees for extra seating. OPPOSITE: The patterns in ancient Imari porcelain famously reference the beauty of nature, from spring blooms to berries to graceful birds on the wing.

124 FOREVER BEAUTIFUL

"I like the sudden shock of non-sequitur color. Color, in fact, is my weakness."

—Babe Paley

The existing architectural plan was clean and perhaps too simple, so we made it more traditional, bringing in details like crown moldings and millwork. That extra layer created a warmer and more timeless interior. One of my favorite spaces is the dining room, where we had the wallpaper custom-painted to echo the Imari collection on the consoles and tables. In the living room, the hues of Imari are everywhere: solid blue drapery with an ivory inset laid the foundation, while a coral Pierre Frey upholstery became our hero fabric on two chairs and pillows, adding that joyful pop of blush! When there's a big floral or signature pattern like that, I like to do something subtler on the rug, or vice versa—which is why you'll see a custom striped dhurrie. A more intricate pattern would have been too loud.

It's important to stay open to possibility, and willing to change course. In the sitting room lined with Gracie wallpaper, we had planned to install an L-shaped sofa facing a cabinet with a little TV for viewing. But after a couple more site visits, we realized it would be even cozier if a U-shaped banquette wrapped the whole room. And it is!

Throughout the interiors of this home, you'll see a touch of black here and there in railings, lighting, frames, and chair legs, all as obsidian as the night sky. Those blacks, and bronzes, serve to add punctuation, creating a pause in the otherwise colorful spaces. After all, every house needs a little drama.

OPPOSITE: The tongue-and-groove paneling and coffered ceiling were added to the subterranean media room to supply needed architectural details. The custom art pieces and corner banquette are drawn from the Imari color palette so they're in unison with the rest of the home, albeit in more modern silhouettes. FOLLOWING PAGES: Look closely at these powder rooms and you'll spot antique Imari porcelain plates layered over the Iksel wallpaper patterns—an idea we had later in the design process that has had so much creative and innovative impact.

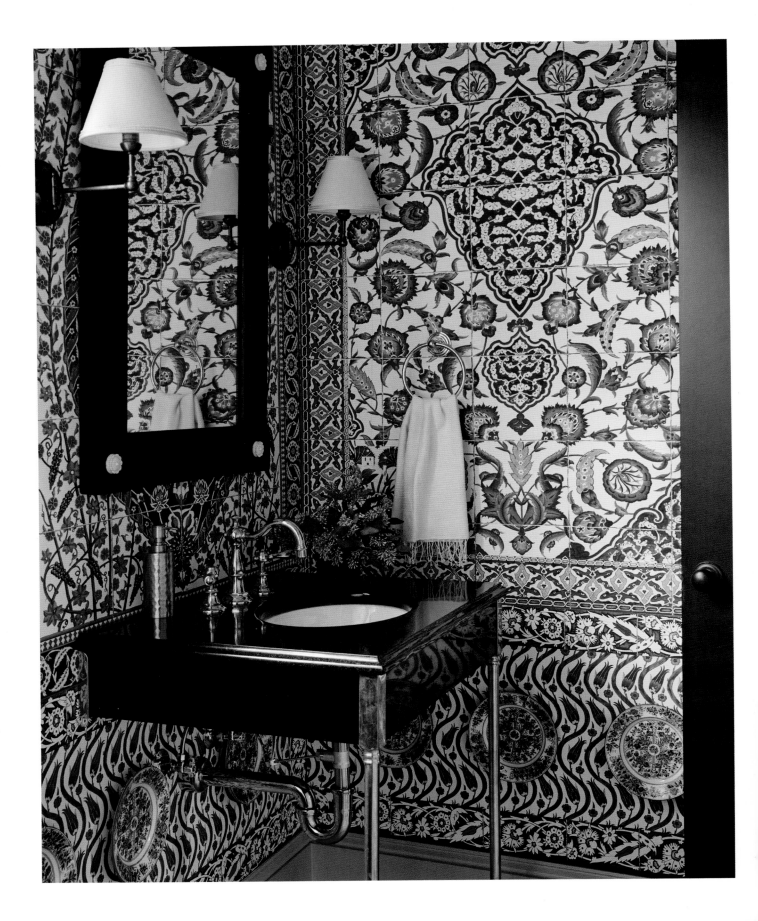

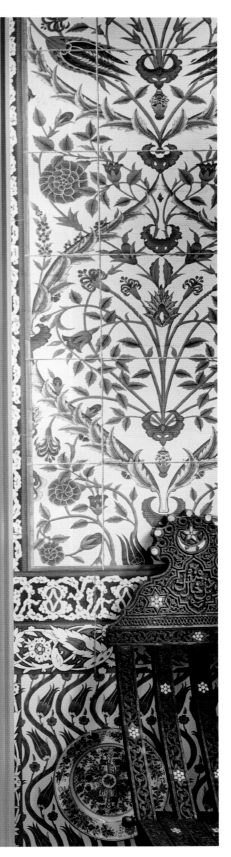

The motifs and color palettes of centuries past have so much to teach us, and every hue and rendering speaks volumes.

CLOCKWISE FROM TOP LEFT: Custom embroidered draperies with a happy tassel trim. The lacquer turquoise study, with a wallpapered ceiling. Symmetrical moments help calm the eye. Dressmaker details and custom applications can make throw pillows feel even more curated. When the wallpaper is as vibrant as this, sometimes the ceiling and floor must recede. The leather armchair in the study is a near-perfect match for the walls.

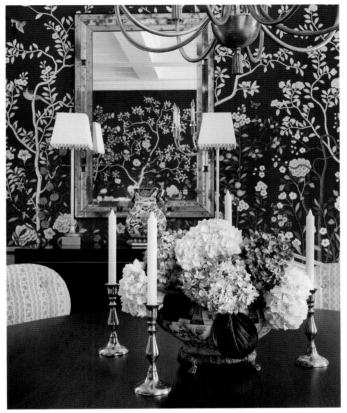

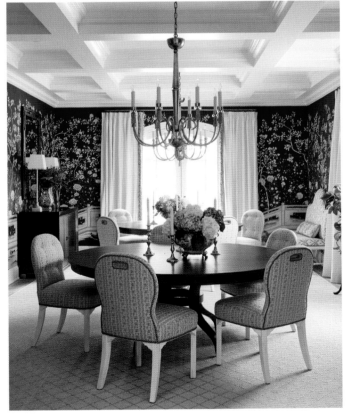

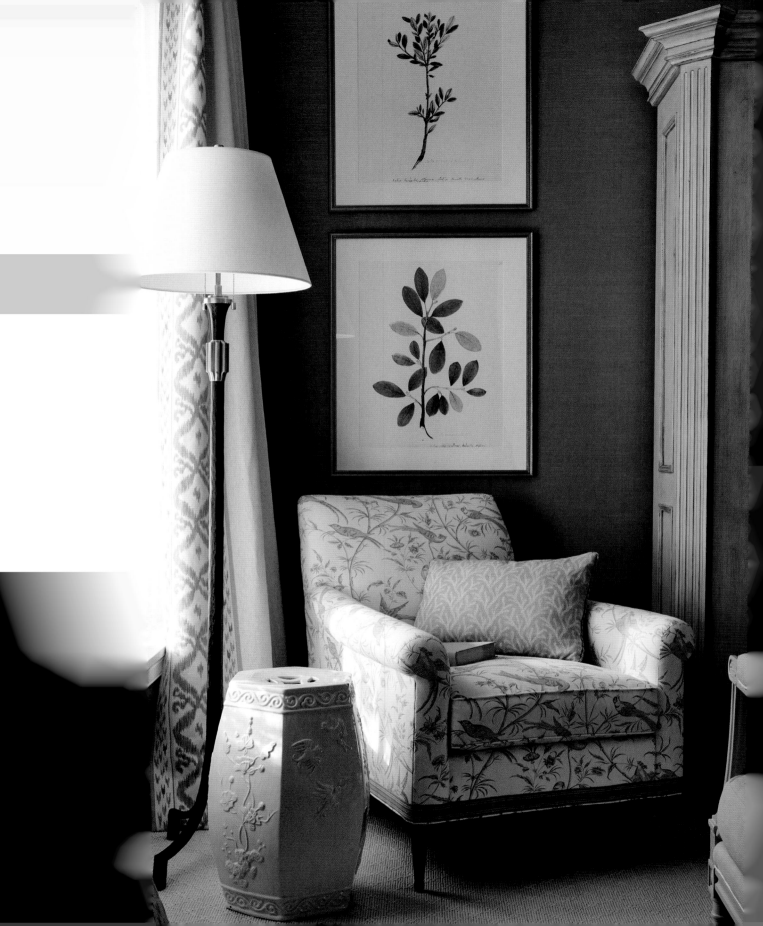

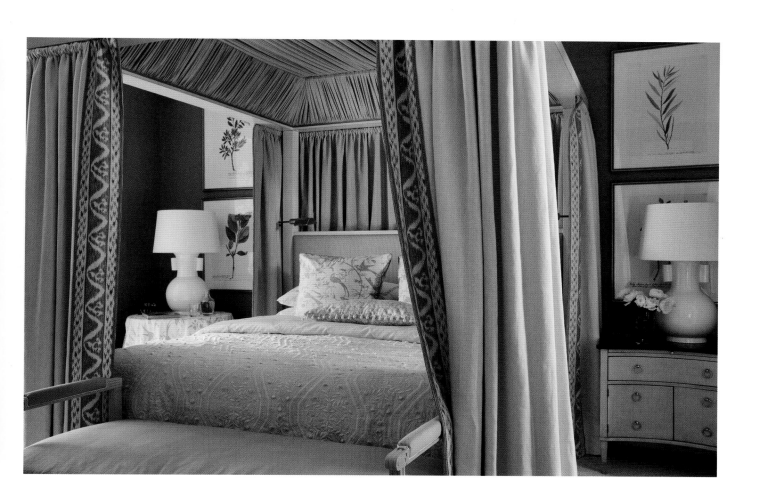

OPPOSITE: Botanicals from the Ornis Gallery bring the outdoors in. ABOVE: In the primary bedroom, we designed a highly detailed canopy bed with ikat borders on the bed hangings, interior ticking stripes, and a richly embroidered coverlet. In the calming colors of clouds and sky, it's especially soothing. FOLLOWING PAGES: We were originally going to build an L-shaped sectional here, but quickly realized the space practically demanded a cozy U-shaped sofa that would wrap the nook. What better place to curl up with a book?

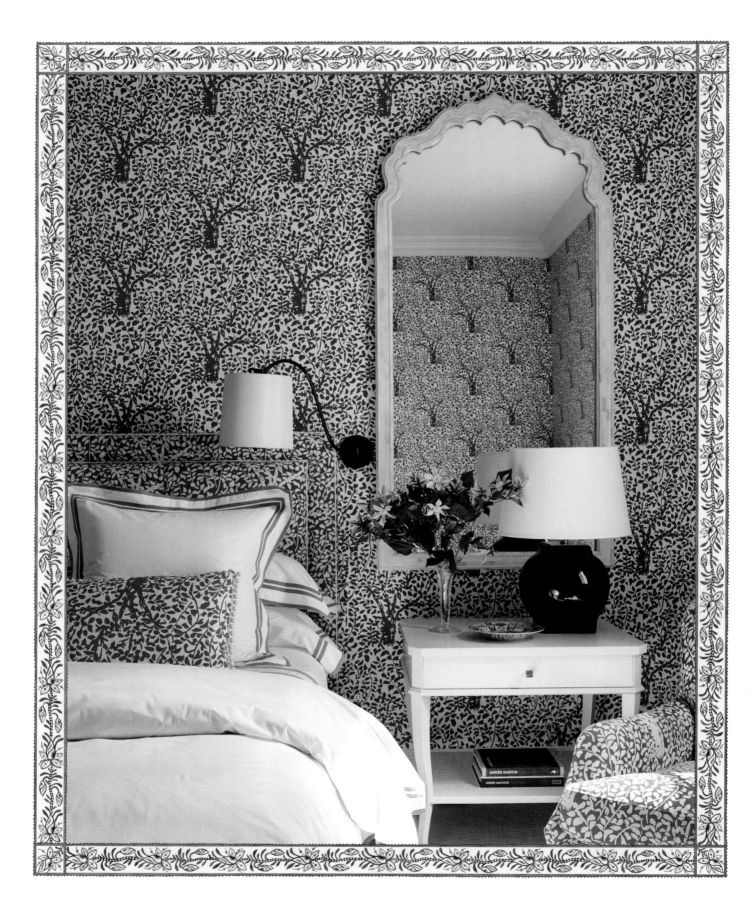

"Sometimes the simplest things are the most profound."

Carolina Herrera

A woven rattan tray gives texture and function to the ottoman.

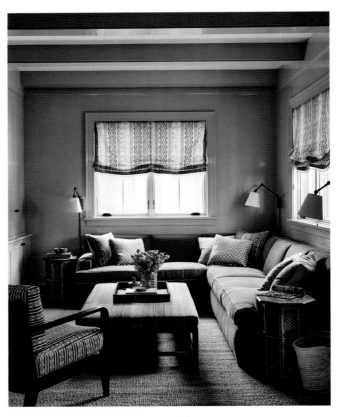

Blue on blue creates a serene retreat in the family room.

Hung in a grid, mellow botanicals become bold and graphic.

A pom-pom trimmed pillow delights.

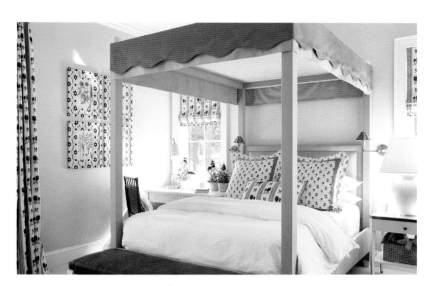

Pink scallop details are joyful on a girl's bed.

Bursting botanicals are stronger together.

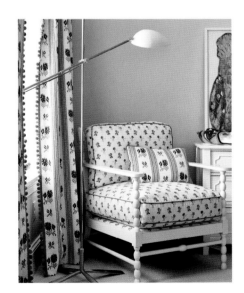

Using similar patterns keeps it all in the family.

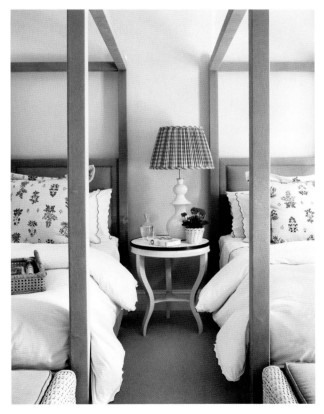

Children's rooms should be no less considered than adults'; we all need a place to dream.

June

FRESH AIR IN THE HAMPTONS

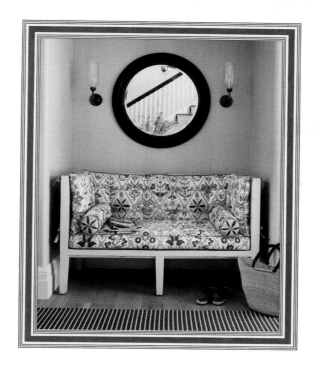

T‍ucked away at the outer reaches of Long Island, the Hamptons hold an eternal allure. That's especially true in June, when the freshly cut grasses are emerald green, the sun shines golden yellow, and the sky and sea create an endless expanse of pure, transfixing blue. At its best, life out east is barefoot and relaxed; summer as it was meant to be. Is it any wonder some of Jacqueline Kennedy Onassis's favorite childhood memories were made during her annual migrations to Lasata, her family's summer house here?

This East Hampton weekend home sits just steps from town and the beach, and although it was a new build designed by architect Frank Greenwald, we wanted it to have soul—to look like it's stood there for generations. We painted its exterior and shutters in tennis whites—a classic approach here—while infusing a young, artful modernity (with just the right dose of traditionalism) to the interior. Typical of the Hamptons, the house has what feels like countless bedrooms for visiting guests. But we worked with Greenwald to create a historic feeling with traditional millwork, v-groove walls, and box beam ceilings.

PREVIOUS PAGE: Mitered stripe pillows and piping are details that add personality. OPPOSITE: Horizontal stripe details on the cushions of a rattan set are unexpectedly elegant—forever ready for a summer garden party. ABOVE: We appointed this settee to slide perfectly into this nook and designed it to have the look of an antique found in a Swedish farmhouse (albeit with Oscar de la Renta for Lee Jofa fabric).

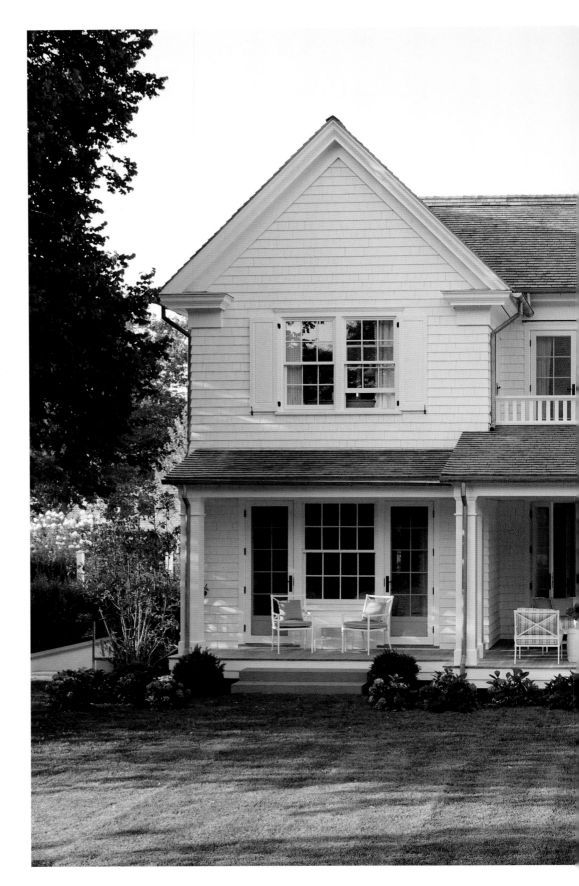

On summer nights, fireflies dance above the rolling grasses of East Hampton, best enjoyed from perches like this long garden porch—a ground-up build that we designed to be both classic and clean.

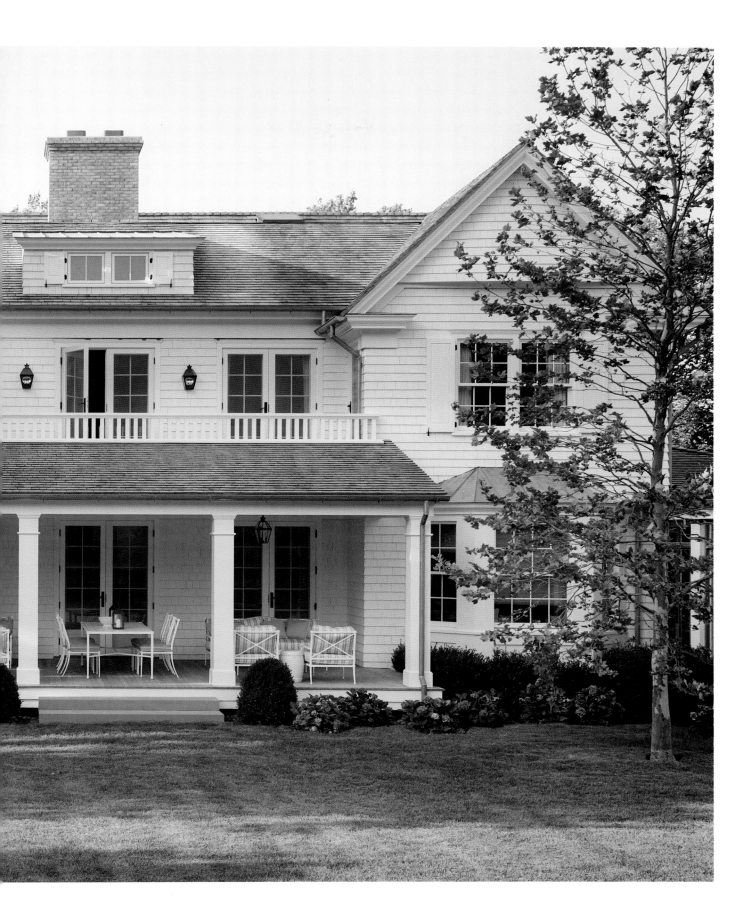

"Summer's lease hath all too short a date."

— *William Shakespeare*

The myrtle topiaries, hydrangea, hurricane lanterns, stripes, and diminutive florals we used are traditional to the area. But juxtaposed against an integration of modern art, they become cool. We also employed windowpane textiles in various scales. The pattern is a great representation of what this house is: clean and geometric, yet with a traditional spin.

No detail was too small. The upper catwalk above the main living room nods to fusty New England libraries in the best way, with its wrought iron wall sconces and a collected hodgepodge of books. Underfoot, the striped cotton-wool rugs are reversible, a tactic that's been used for centuries to quickly give a room a fresh start.

We used a very distinct color palette in this house: creamy whites, robin's-egg blues, and leaf greens that reflect the Hamptons's manicured boxwoods; happy sunshine yellows; and ivories as pure as the sand on Two Mile Hollow Beach. Many rooms in the home are devoted to just one color. There's a simplicity to that, and a cleanliness. It's easygoing—just like summer.

I love windowpane textiles: they're so geometric, but still clean. I like to employ them in different scales for added impact (here, we did a dramatic large windowpane on the pillow fronts and a more diminutive version on the backs). Amid all these strict lines, nature stands apart, from the just-cut hydrangea to the faux bois magnifying glass on the coffee table. The wool rug is reversible—handy in a family home.

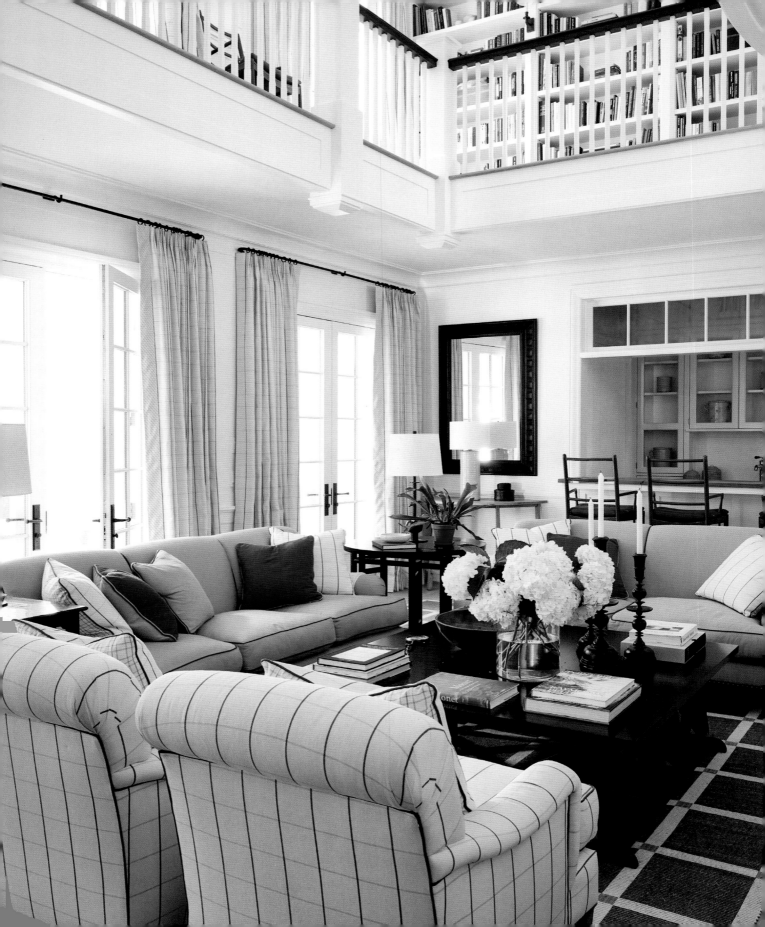

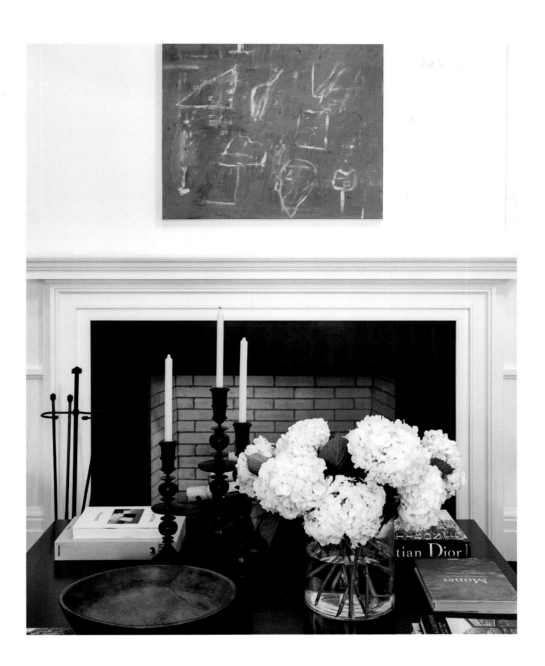

OPPOSITE: Every room needs a solid to ground the patterns. Around the catwalk above this double-height living room: a library of well-loved beach reads and studious tomes alike. The bar tucked at one end of the room provides another spot for conversation. ABOVE: A painting by Nashville artist Kit Reuther lends a jolt of green.

We worked with architect Frank Greenwald to transform the upper catwalk into a functional library with bookcases. It's a lovely place for R and R—you can pick up a book and walk out the French doors to an often sun-swept patio. A skylight in the vaulted ceiling allows daylight to flow freely; striped runner rugs supply comfort underfoot. After dusk, the myriad wall sconces emit a warm summer glow.

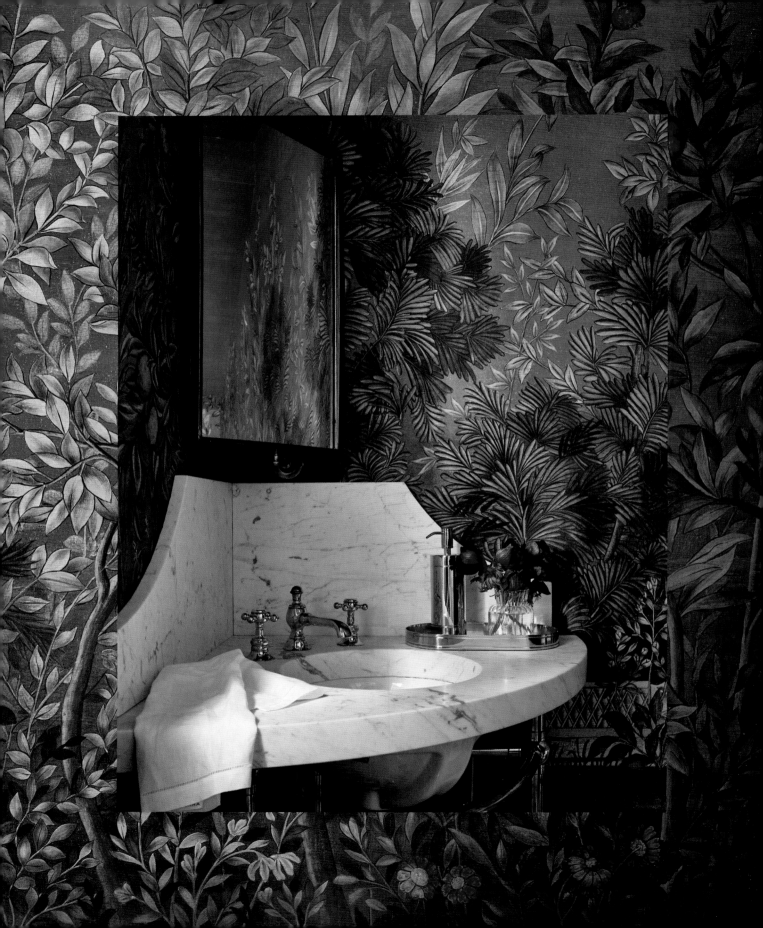

"Adopt the pace of nature.
Her secret is patience."

Ralph Waldo Emerson

OPPOSITE: Powder rooms are the ideal place for drama. We made a custom sink to tuck into the corner to suit the floor plan; the Iksel wallpaper is meant to reflect the world beyond the windows: endless blue skies and lush green trees and plants. FOLLOWING PAGES: We custom designed Swedish-influenced pieces for the dining room and had their finishes weathered for an antique effect.

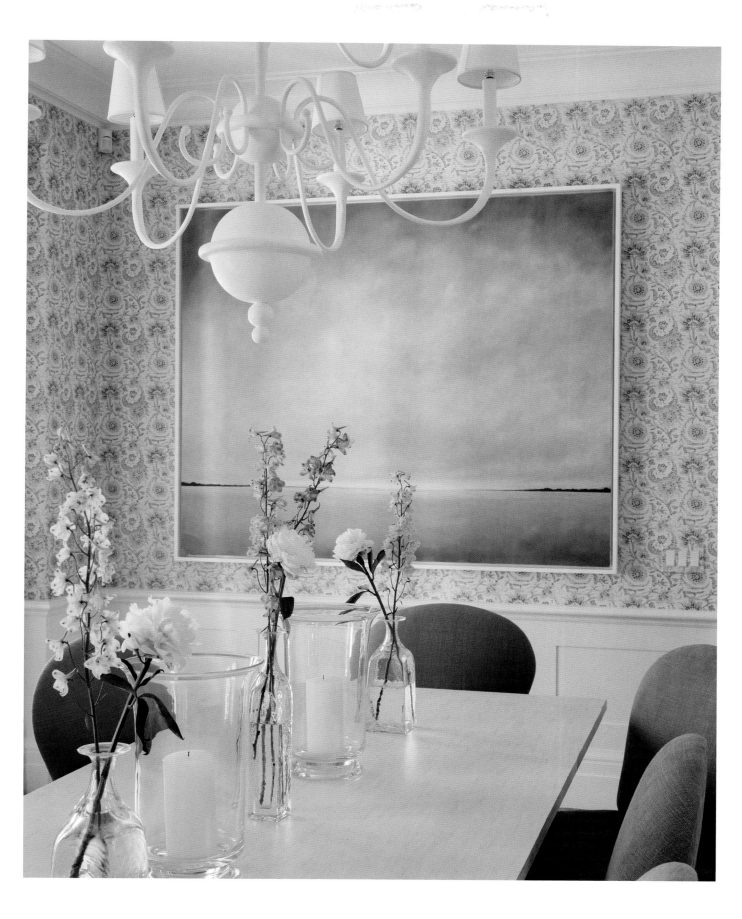

RIGHT: For my Hudson Valley Lighting Collection, I designed the Windsor chandelier—a very traditional American shape—in plaster, so it would feel more modern. We employed a lot of classic silhouettes here, but in unexpected finishes that make them feel fresh and clean. FOLLOWING PAGES: In the family room tucked just off the kitchen, a sectional upholstered in robin's-egg blue performance linen is very easy to live with.

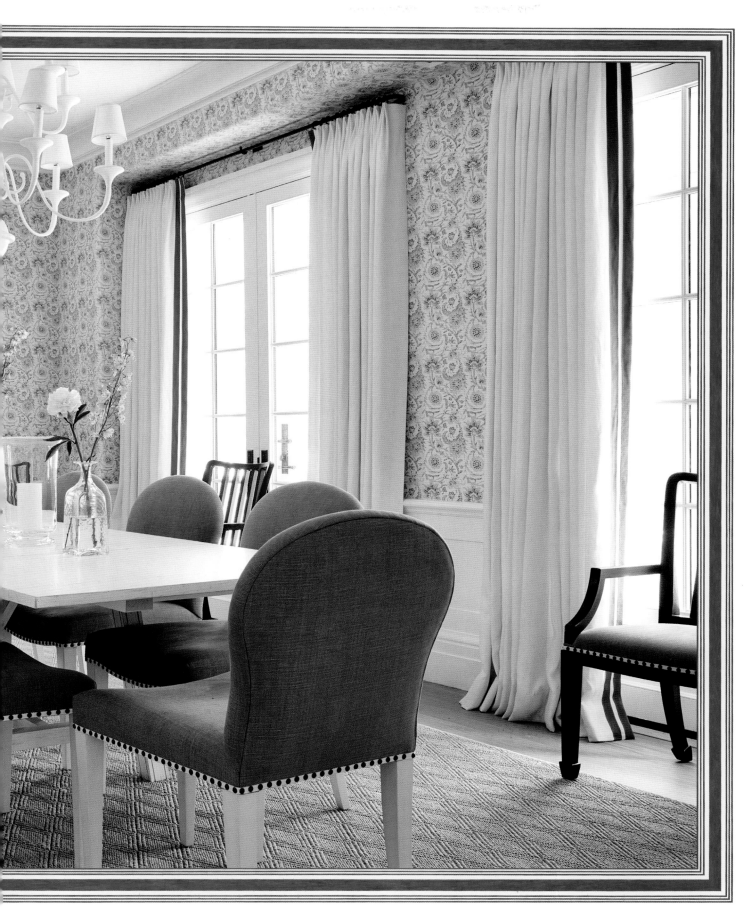

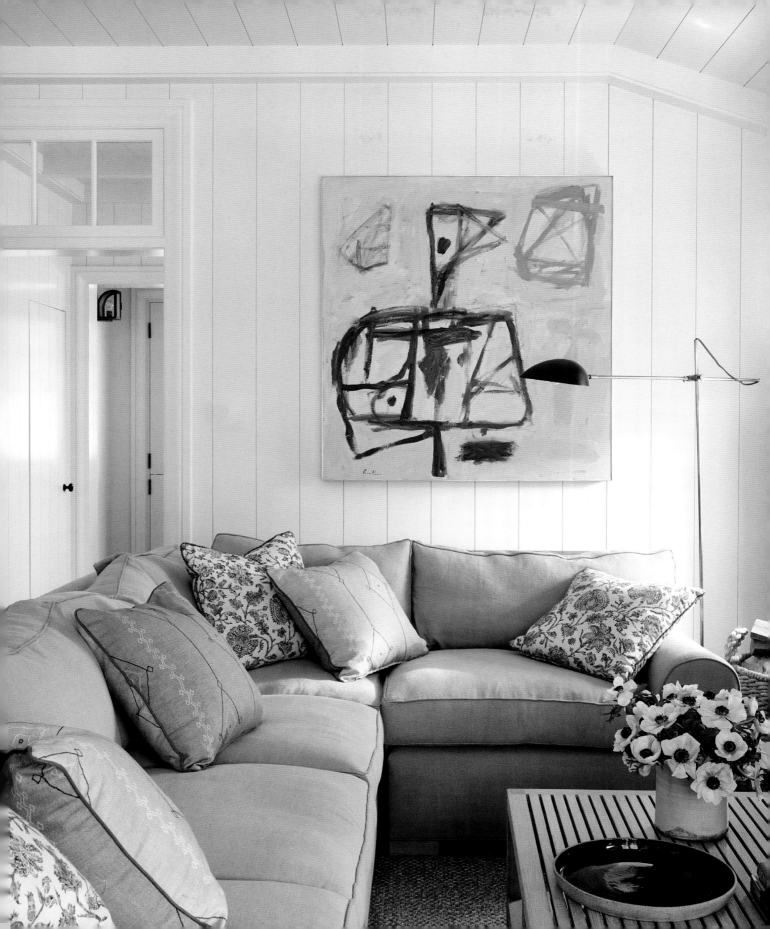

Blue is more than a color. It's a sanctuary: an echo of the sea and sky that restores the soul.

CLOCKWISE FROM TOP LEFT: Transom windows add to the airy aesthetic. Bell jars are so perfect for the Hamptons, we used them on the pendants and wall sconces alike. The handsome plaid table skirt is wool, an unexpected fabric for the beach. The checks and windowpanes used throughout the house are reinforced by the plaid bench cushion. The stair runner is a subtle take on *marinière* stripes. Chicken wire and shirred panels bring texture to humble cabinet doors.

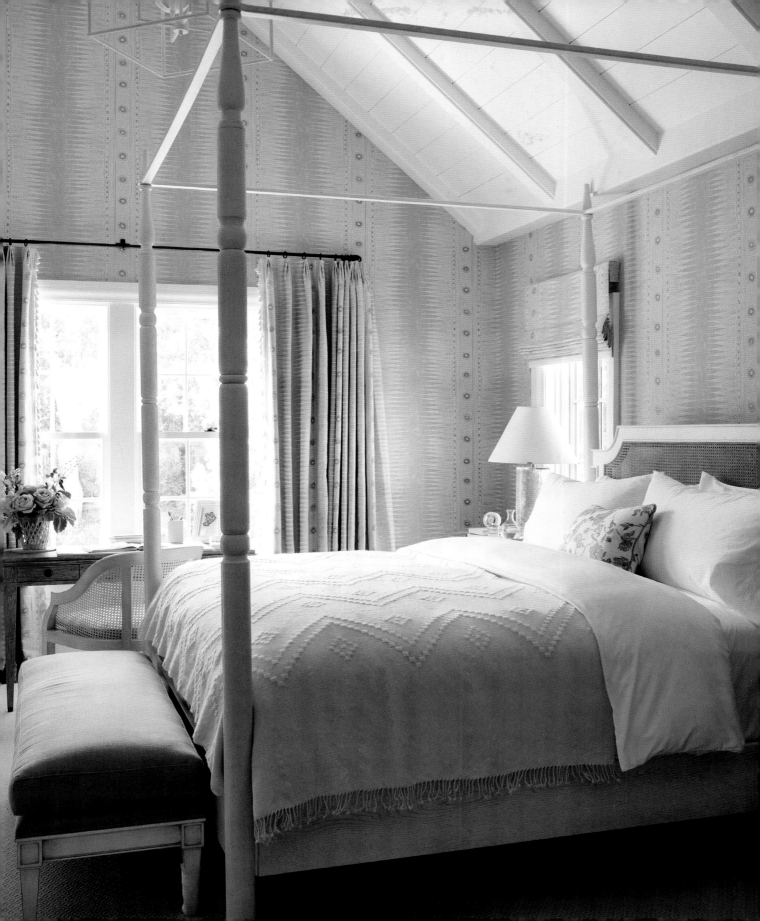

PREVIOUS PAGES, FROM LEFT: In the primary suite, we juxtaposed a contemporary piece over this midcentury parchment leather chest for a collected-over-time effect. I love the linear nature of the wallcovering in the primary bedroom—a Lee Jofa pattern that's both structured and soft, and puts the focus on the art. We customized the finishes in this space, distressed whites and cerused oaks, so they'd feel appropriate with the cane on the armchair and headboard. ABOVE AND OPPOSITE: A Schumacher print will provide endearing respite for years to come in this guest bedroom, made even more elegant with a matching pillow.

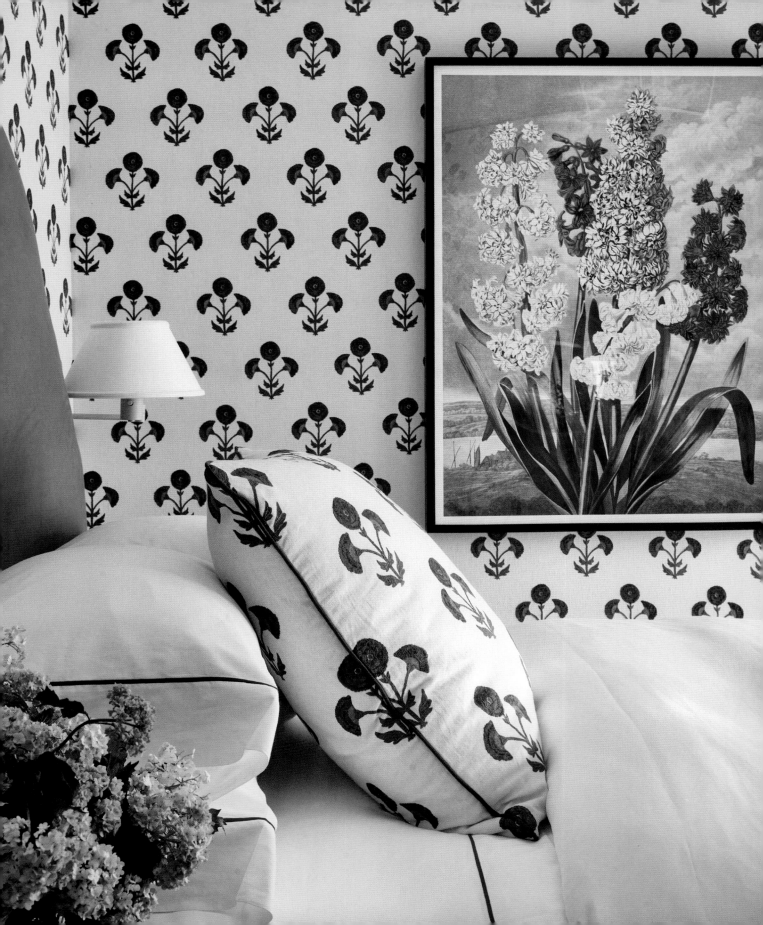

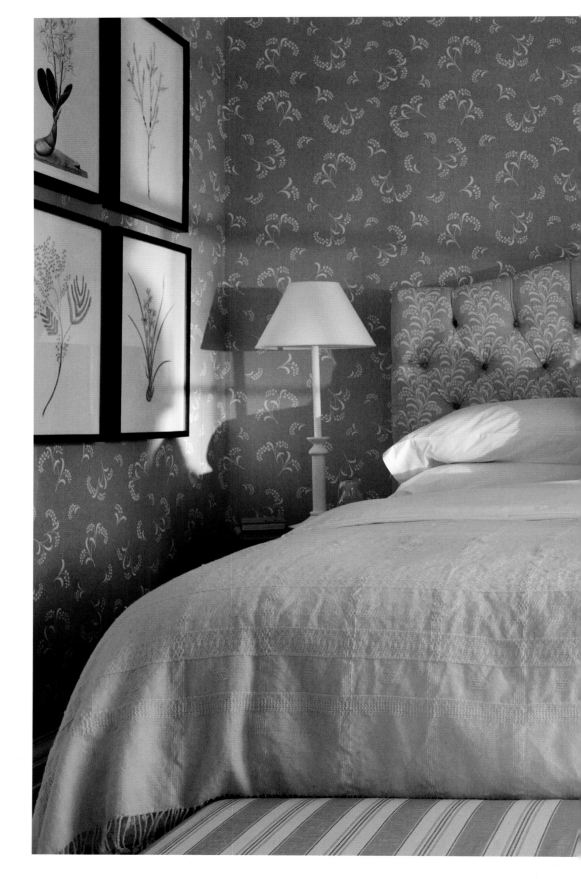

RIGHT: If you've ever wanted to try living inside a sunflower, this guest room's sunshine yellow pattern by Carolina Irving will get you close. We chose a coordinating fabric for the headboard, and I love the way the vines trail up the tufting. PAGES 170–71: Shaded by an allée of trees, a pair of tables and sets of benches provide a shaded area for evening dinners and afternoon coffee alike.

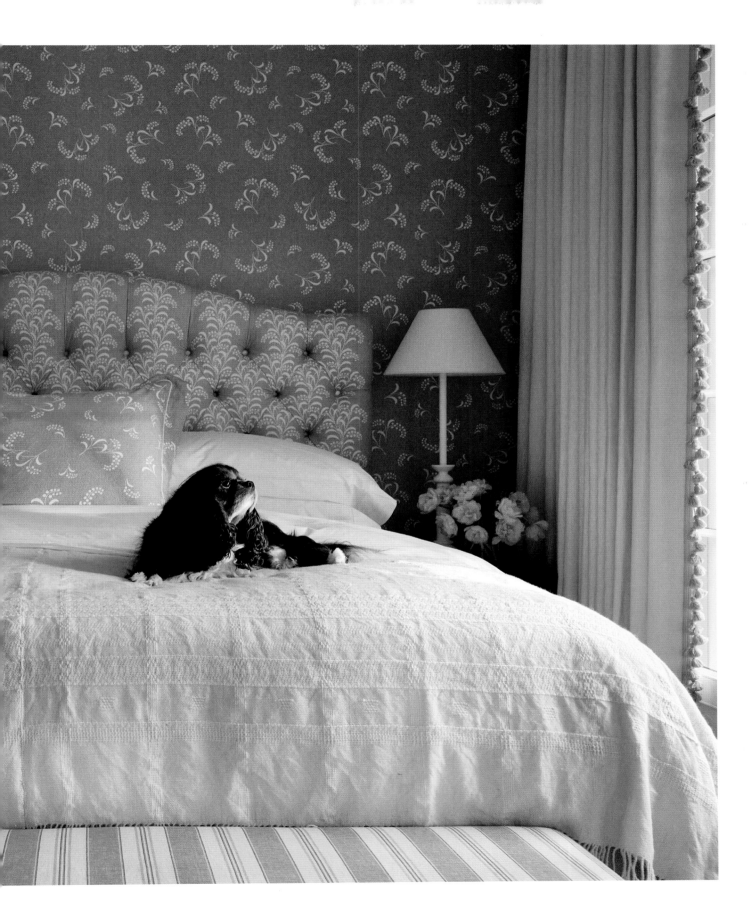

Stripes evoke the beach on a sunny day.

Framing botanicals in black provides contrast and beauty.

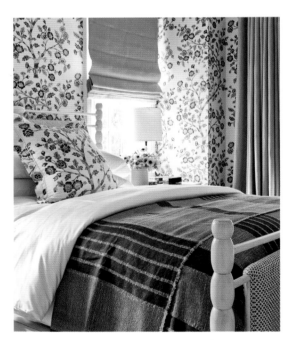

Roman shades and stripes calm the Tree of Life print.

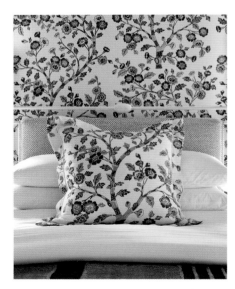

Green suits this pocket of Long Island: lush and leafy.

No detail is untouched—not even the bed legs.

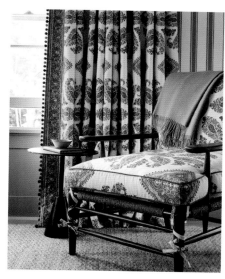

Every bedroom can use a perch for reading and daydreaming.

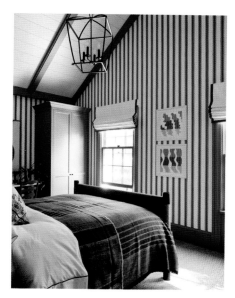

We emphasized the exposed beams, painting them the same blue as the rest of the trim.

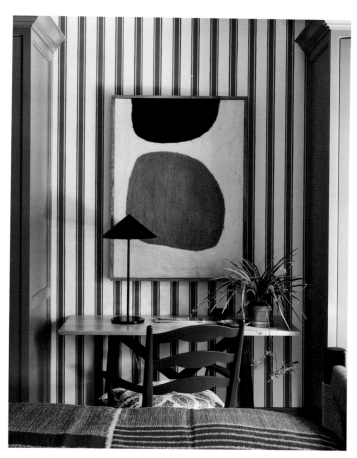

An overscale ticking stripe is very East Coast.

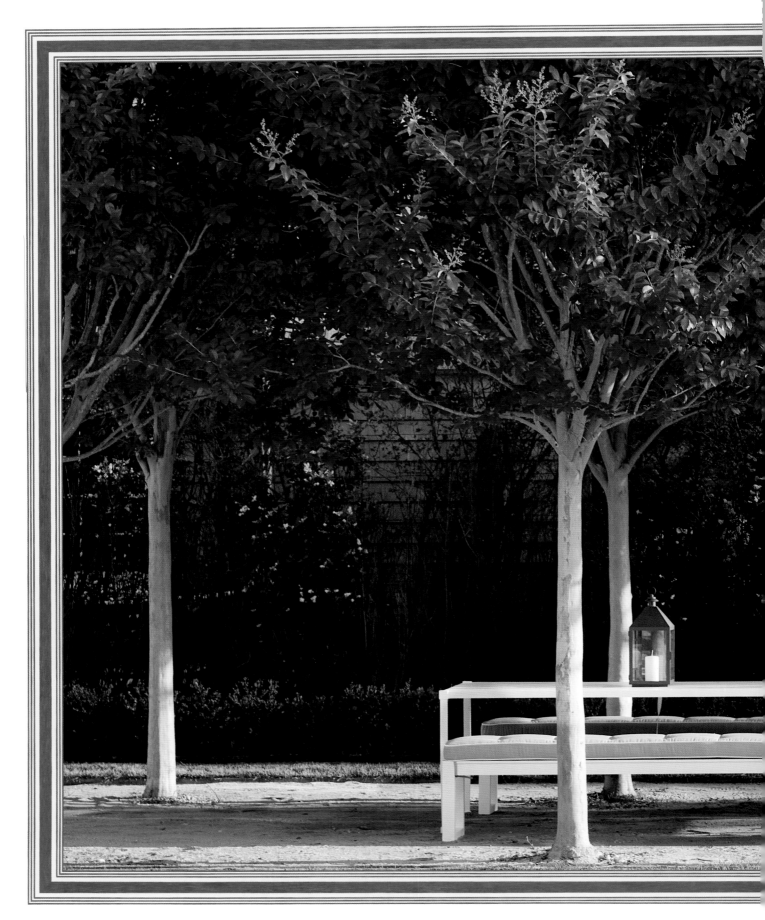

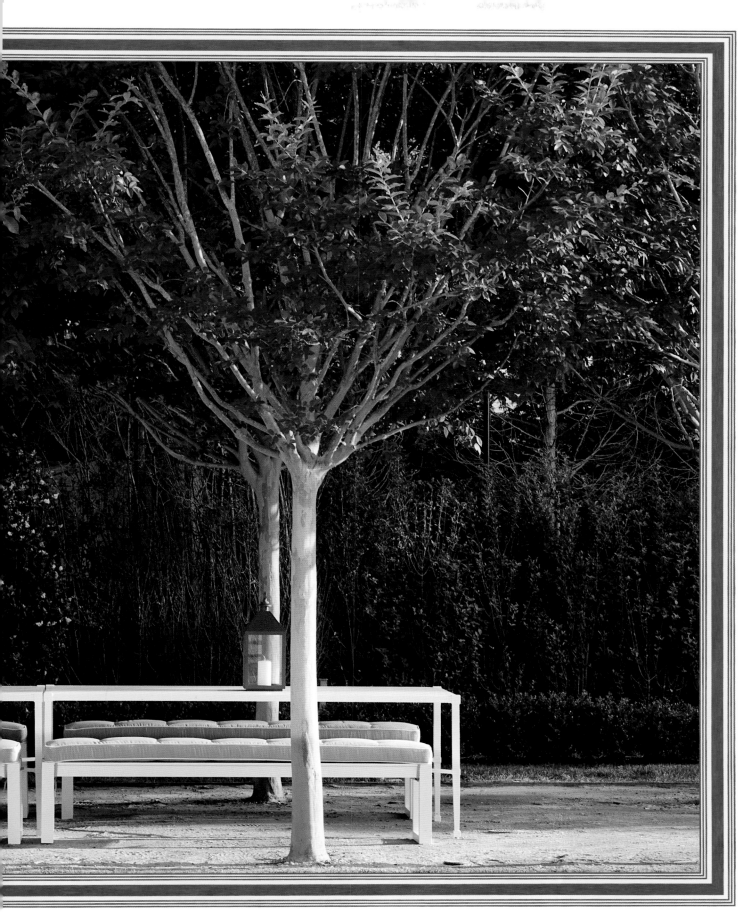

July

COASTAL CALIFORNIA

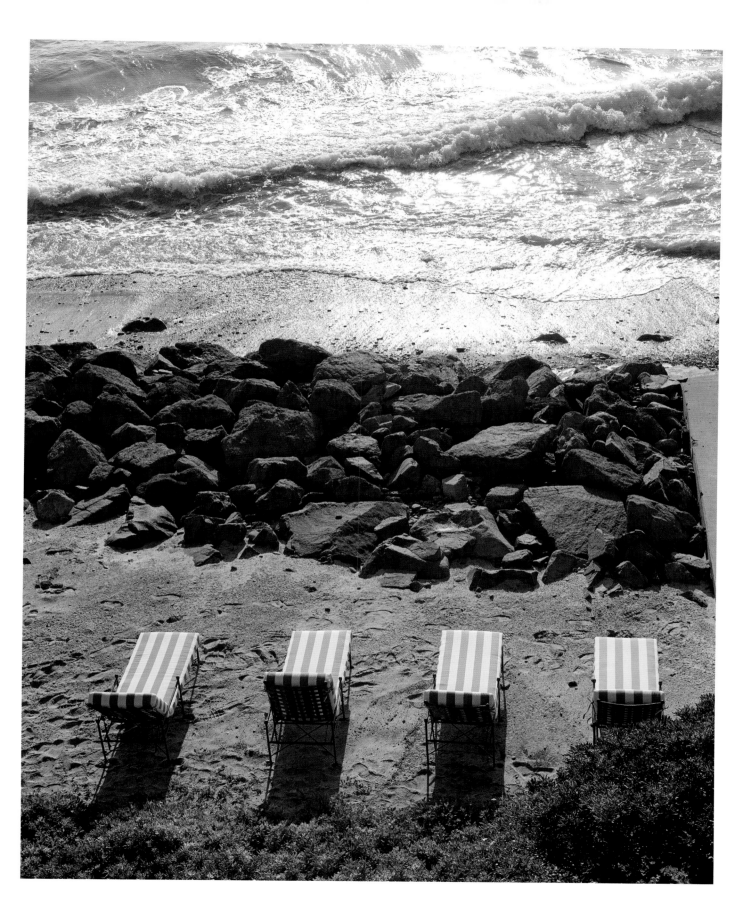

In the height of summer—when the heat index pushes one hundred degrees and even the sturdiest of garden roses wilts on a July afternoon— there's little more reviving than a spell by the misty sea. What's more invigorating than the ocean, which metamorphoses itself with every breaking wave? So I was beyond delighted to help rejuvenate this historic California coastal home blessed with fairy-tale architecture.

With its steeply pitched hip roof and low octagonal turret, the Norman exterior summons images of the rural farmhouses that have studded the French countryside since the eleventh century. These elements might seem antithetical to beach life, but—paired with breezy turquoise blue windows and doors and charming terra-cotta tiles as in this home—the architecture is pure SoCal, especially perched along the shore. Pieces like the original antique coffee table and a floral fabric on quilted pillows were more than worth keeping; they helped engender the design approach of the whole house.

PREVIOUS PAGE: Striped chaises along the seashore. ABOVE: The American flag wouldn't be the same without its stars and stripes. OPPOSITE: We opened up the home's foyer so you can see the ocean from the front door. Shades of blue replicate the skies above, bringing lightness to a brick entrance courtyard.

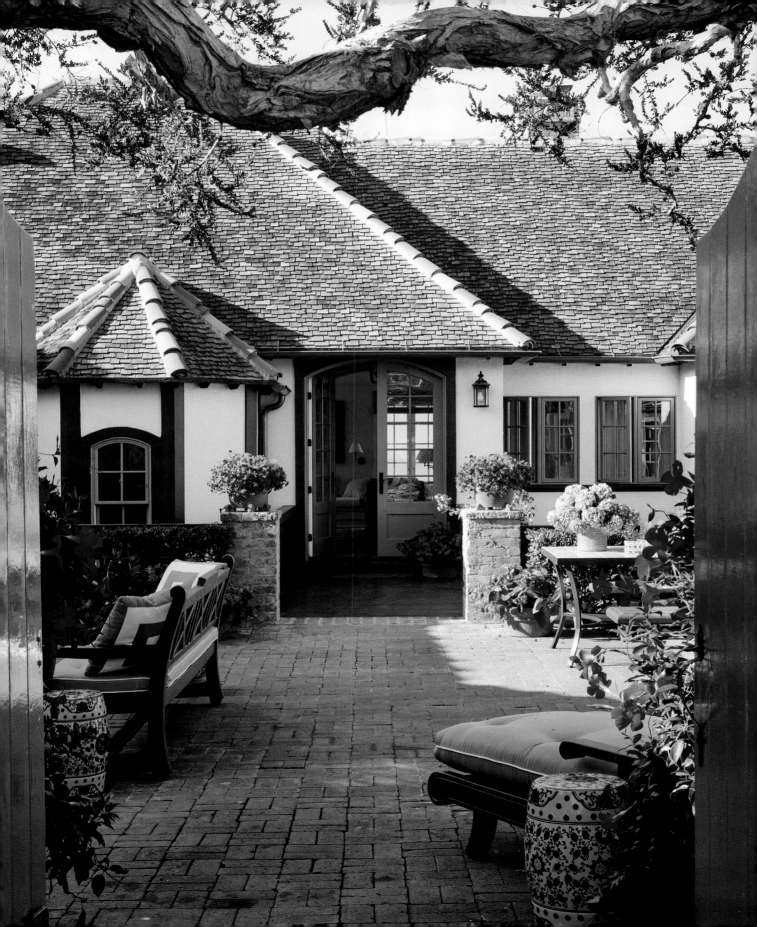

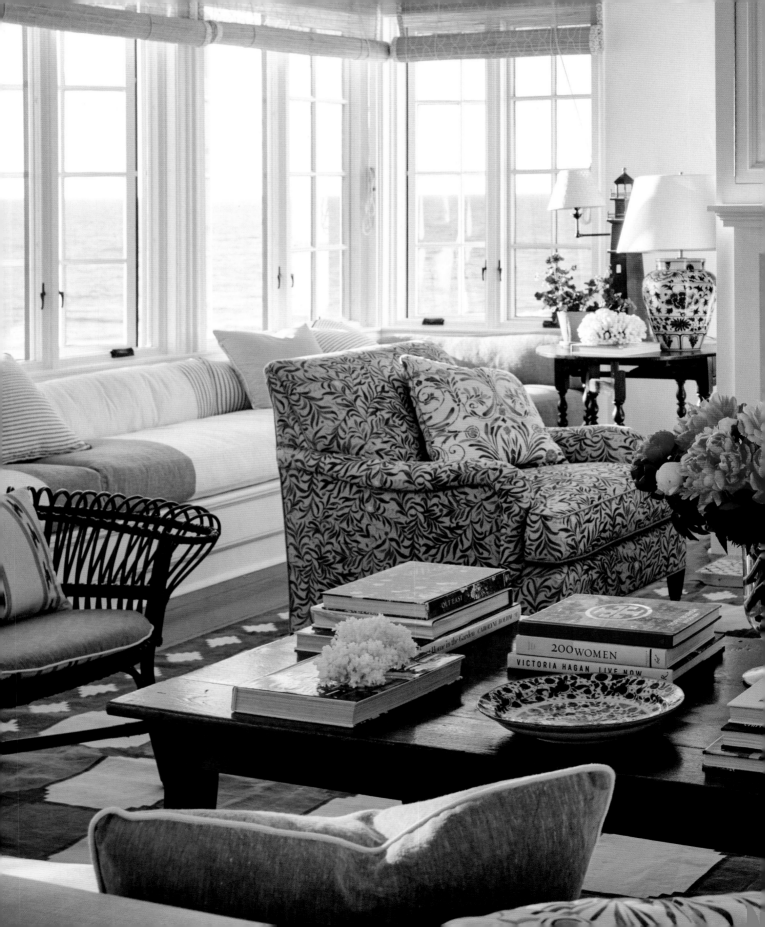

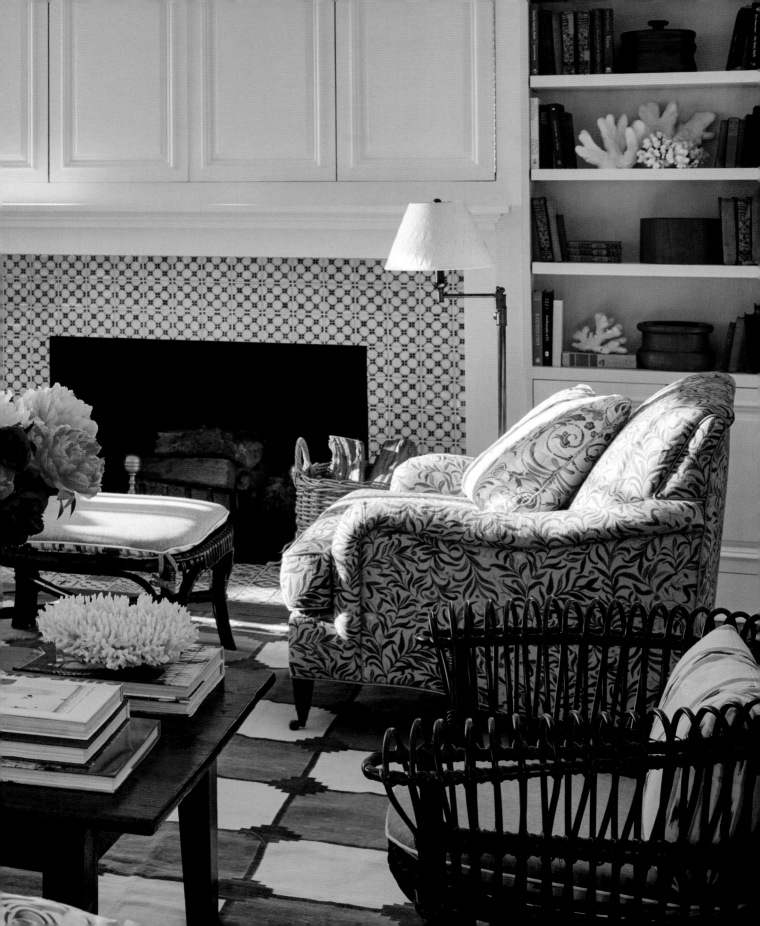

> "I've always felt that having a garden is like having a good and loyal friend."
>
> —*C. Z. Guest*

Yet in other ways, a subtle sea change (so to speak) was in order. We opened up the entryway so you can see the water the moment you step through the front door—talk about a good first impression! Installing a wide-striped banquette under the living room windows gave the inhabitants an idyllic place to sit and look out at the Pacific, especially in the pink, gauzy light of dusk. Some of my favorite elements are all the bespoke touches we carefully designed, including the Iksel wallpaper in the dining room that we custom colored; hand-painted tiles; and the blue-and-white decorative painting that frames the upstairs doors, windows, and hallways, which was inspired by the home's original wave-shaped stair balusters.

In the bedrooms, after hanging simple grass cloth on the walls for beachy texture, we lifted the motif from each room's chosen "hero" fabric and turned it into a border for the crown molding, baseboards, and doorways. Look closely and you'll see that we echoed the same pattern overhead, too, by hand-painting them on the ceiling beams. We felt such detail was vital to add interest and an enveloping feeling. Like the tessellations of a nautilus shell or even the curl of a wave, some patterns are too good to not repeat.

PREVIOUS PAGES: The span of blue Pacific Ocean that seems to unfurl to infinity and beyond from this living room was the ultimate inspiration for our color palette. OPPOSITE: The breakfast room is upholstered in a Namay Samay yellow fabric that looks beautiful in the morning sun. FOLLOWING PAGES, FROM LEFT: Custom Iksel wallpaper adorns the dining room, in blues that echo the sea beyond the windows. The home's existing heirloom furniture brings additional warmth and the hand of generations. A bowl of lemons ushers one of California's most fragrant fruits indoors.

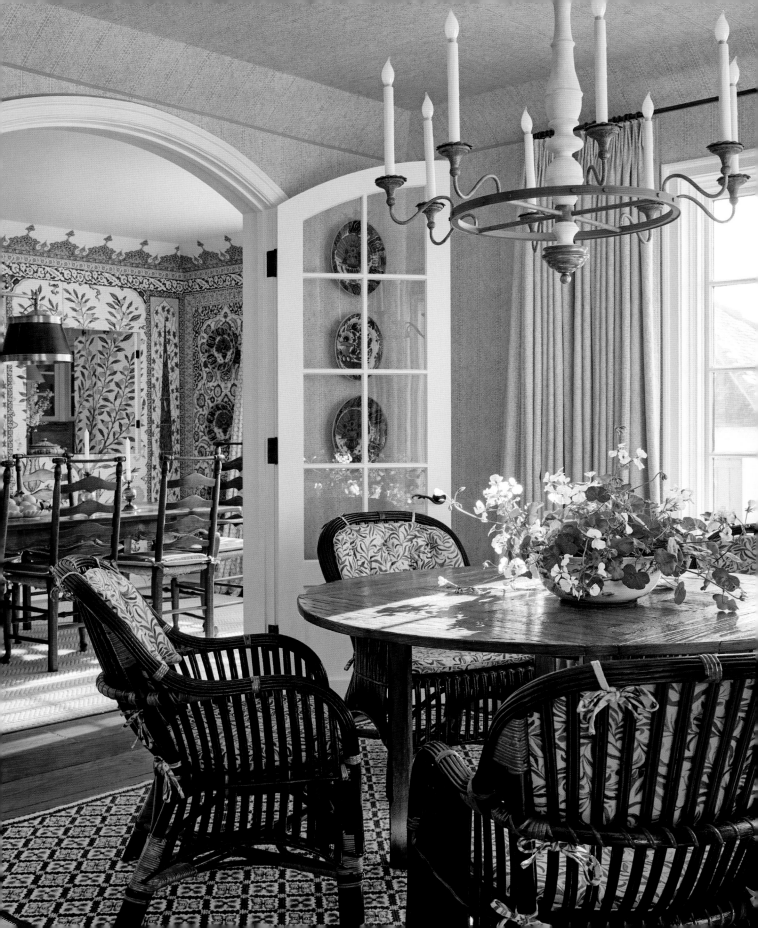

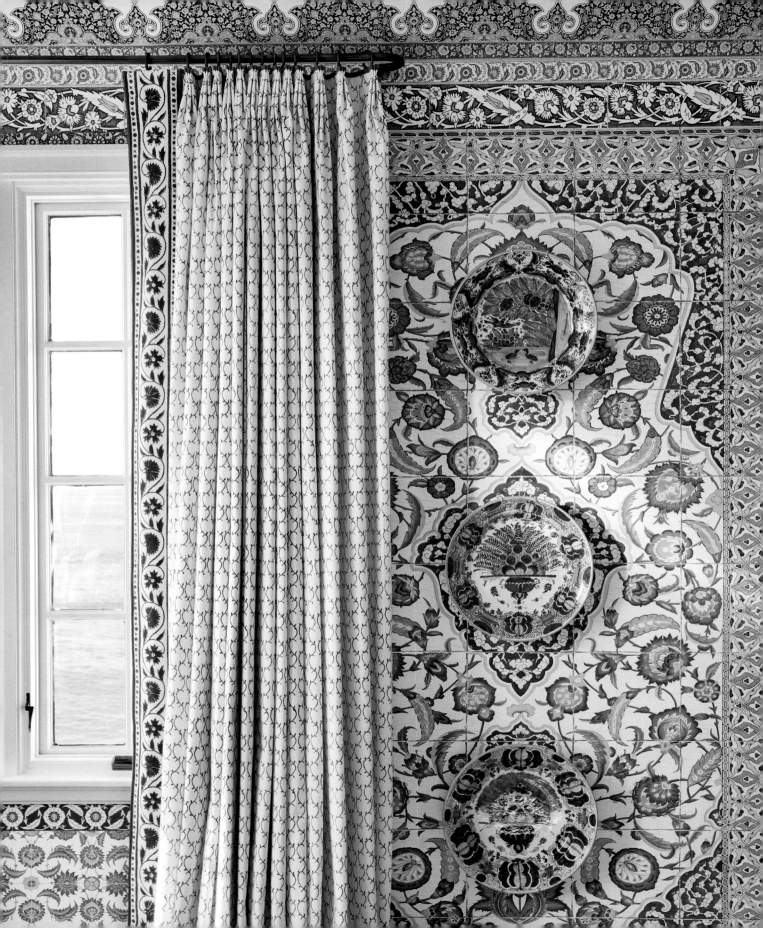

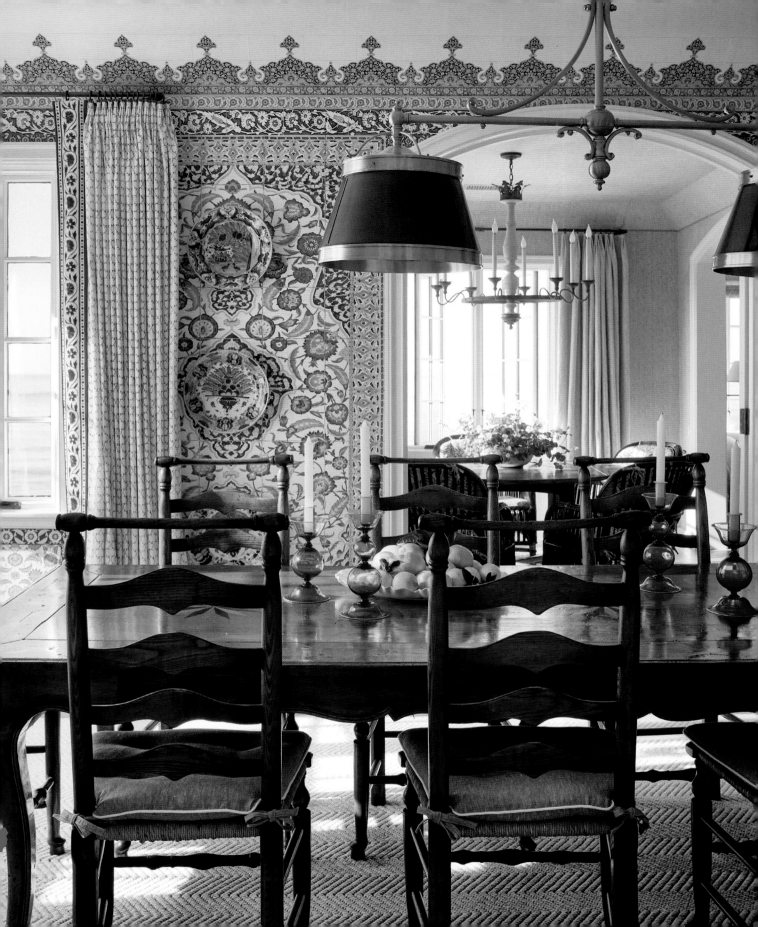

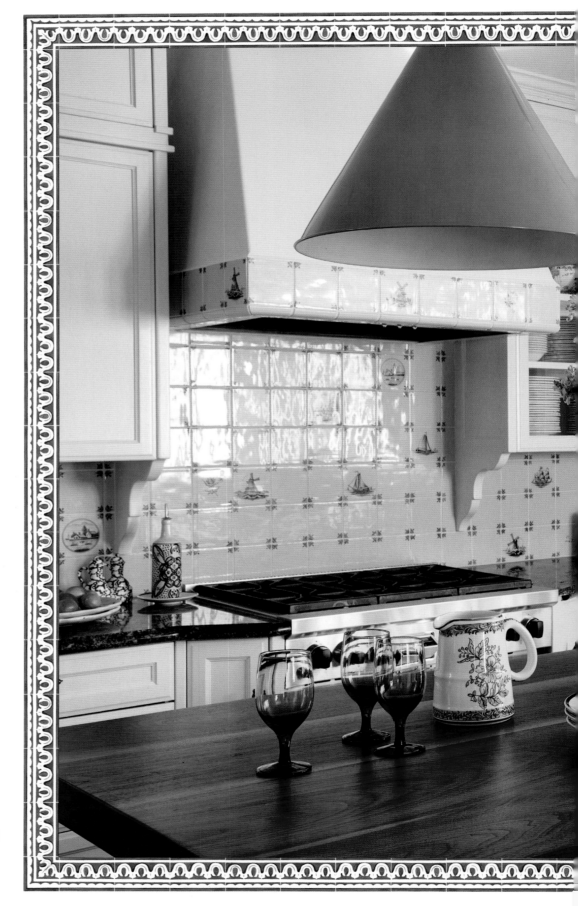

In the kitchen, we kept the home's original Delft tile, but we painted the cabinetry in Farrow & Ball's Borrowed Light. The Ann-Morris cone lights, too, are custom painted in Farrow & Ball: a color fittingly called Cook's Blue.

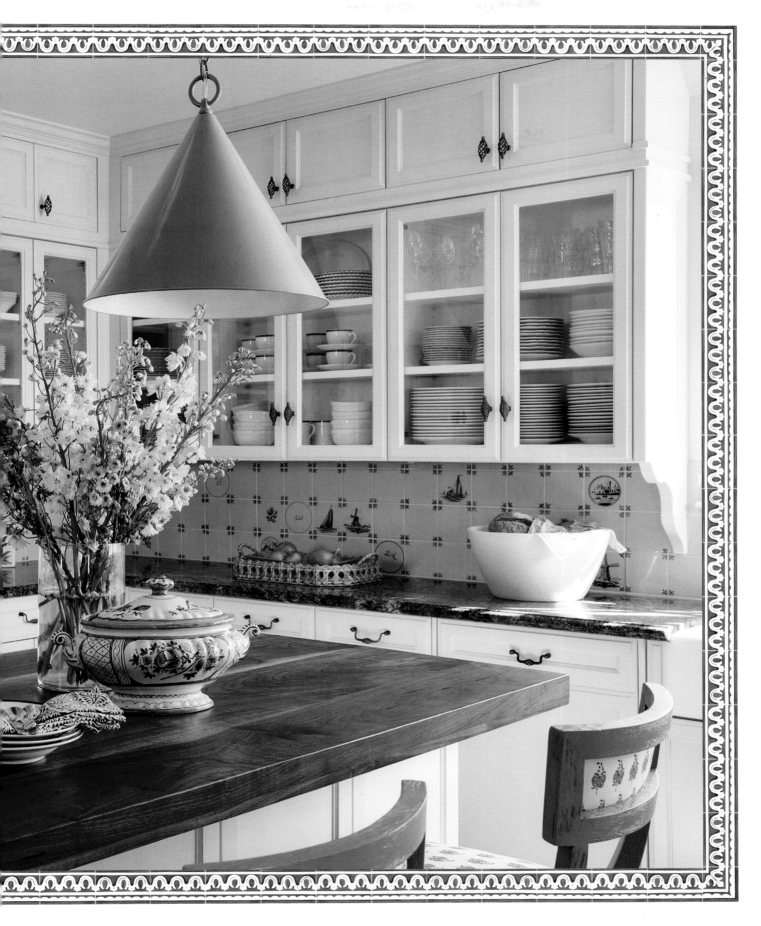

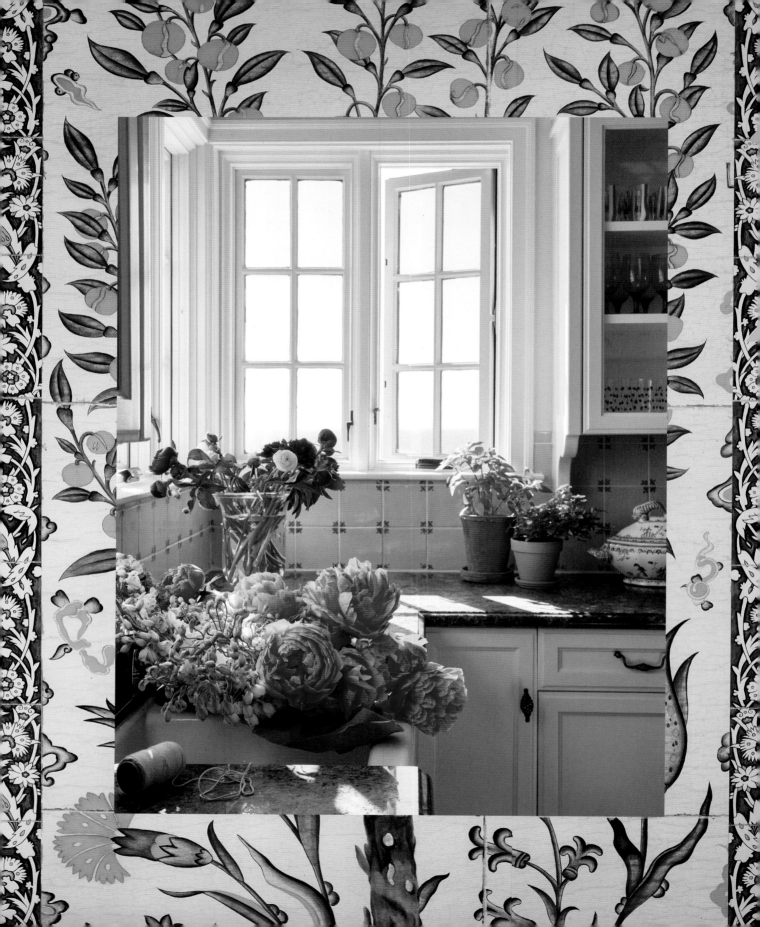

"Live in the sunshine.
Swim in the sea.
Drink in the wild air."

Ralph Waldo Emerson

OPPOSITE: In summertime, keeping windows open as often as possible brings the scents of the outdoors in. A soft breeze can revive the soul, especially when paired with wafting fragrance from just-cut peonies.

There is so much
possibility in
paint, and so
much potential in
the paintbrush.
Don't hold back.

CLOCKWISE FROM TOP LEFT: We had stair risers enhanced with hand-painted tile that echoes the waves. The turret ceiling architecture is highlighted with hand-painted lines. Mingling graphic motifs with floral ones strengthens both at once. Custom painting inspired by a wave motif used in this coastal community lent a storied touch to this bathroom. The sea: a forever muse. Custom painting on the doorways, woodwork, and down the walls emphasizes the depth of field in this hall.

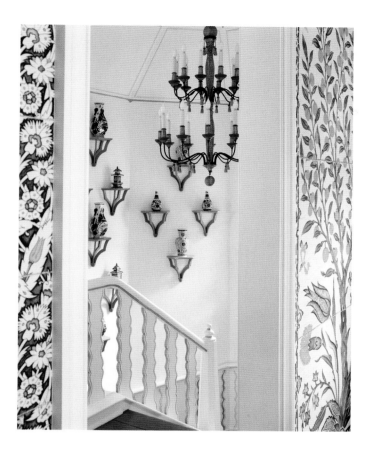

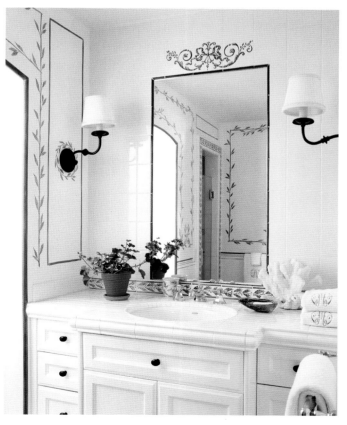

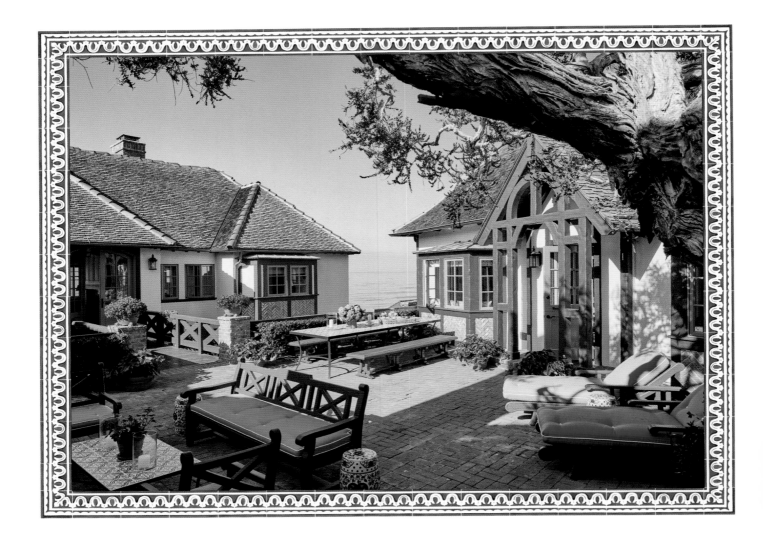

ABOVE: The X-backs on the outdoor furniture mirror the home's fencing and woodwork details within the gable ends. OPPOSITE: At the entrance to the guesthouse, a shell grotto mirror has an unspoken message in its reflection: "Welcome to the beach!"

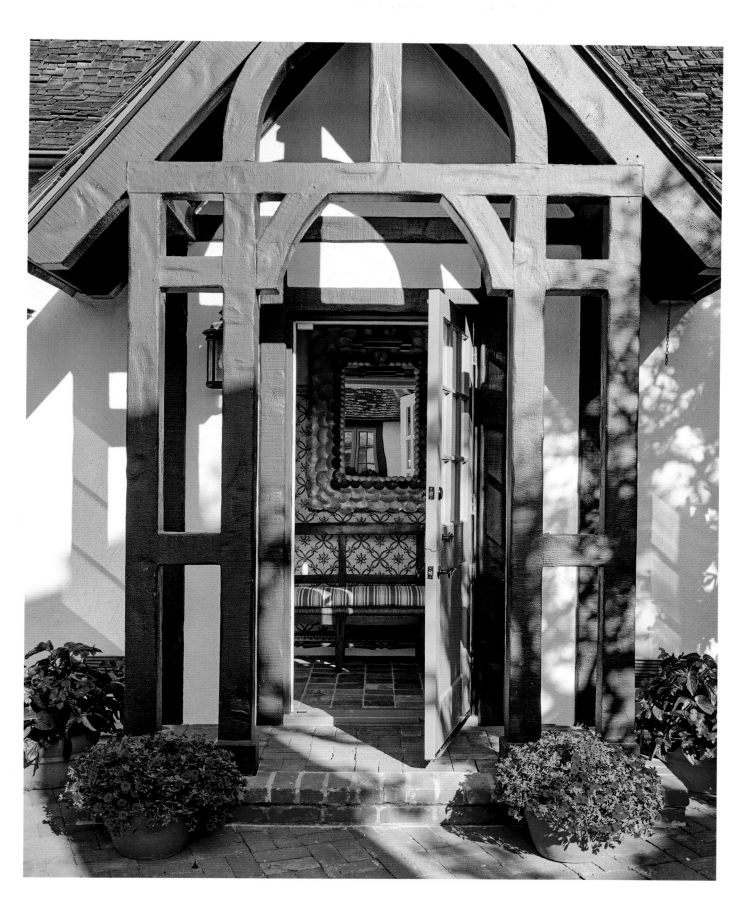

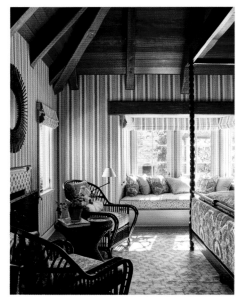
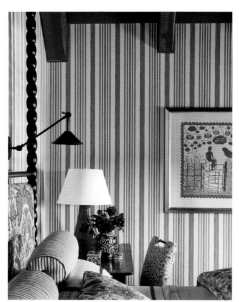

ABOVE, CLOCKWISE FROM TOP LEFT: Stripes are a dynamite pairing with paisley: always have been, always will be. A twisted cord lends a tailored sensibility to throw pillows. We love reading lamps above a headboard for function. On chilly nights, the fire is instantly cozy. OPPOSITE: The red tape trim we applied around the woodwork gives the striped wallpaper a finished effect in this guest room.

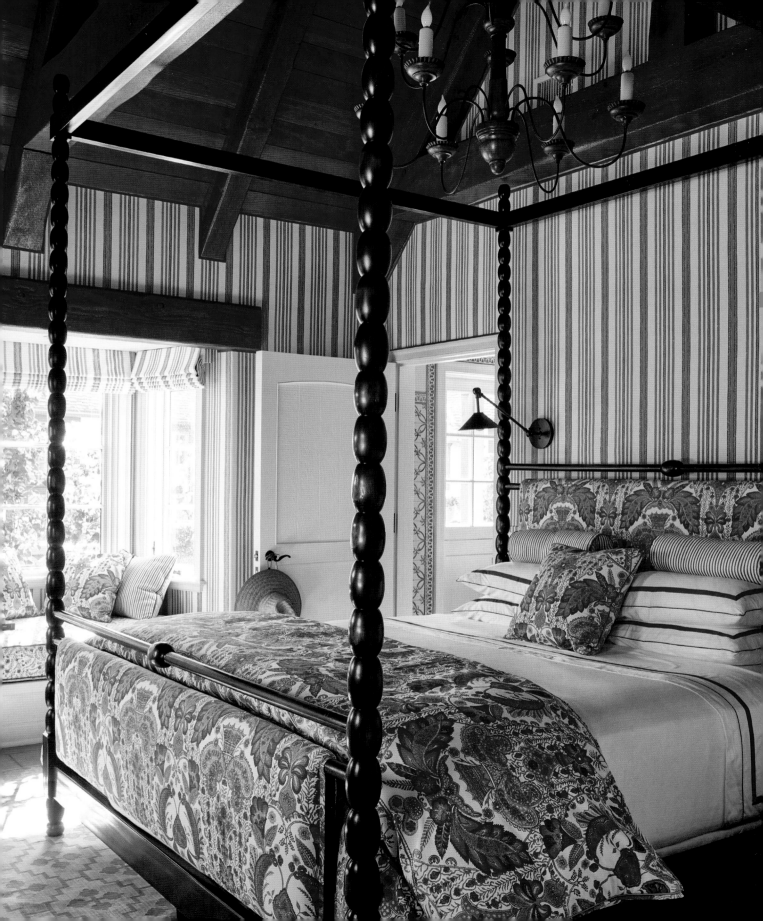

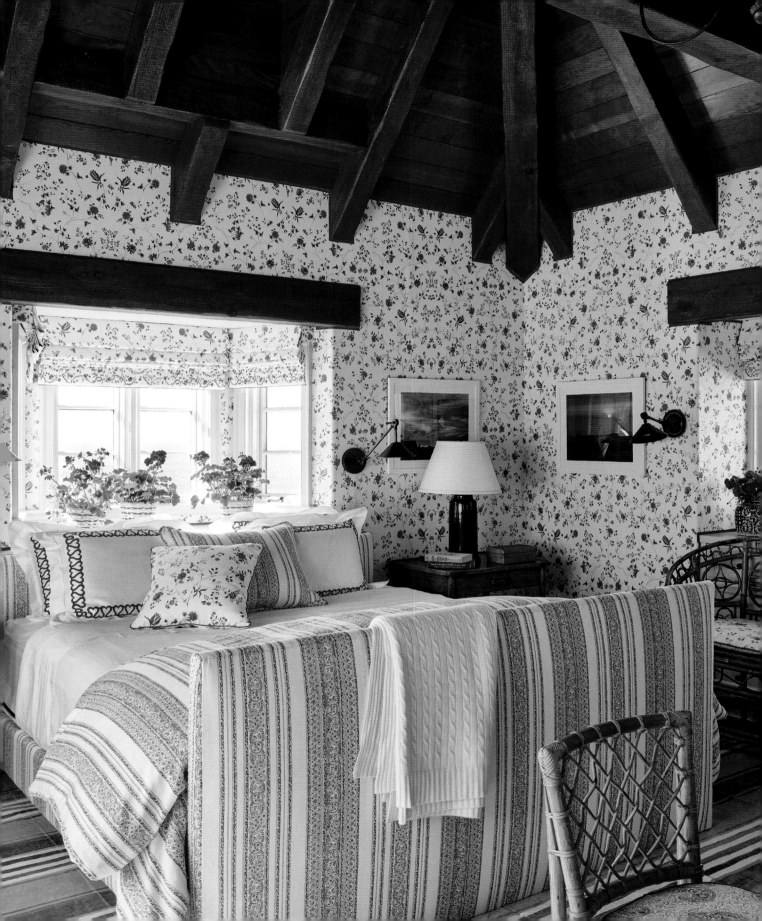

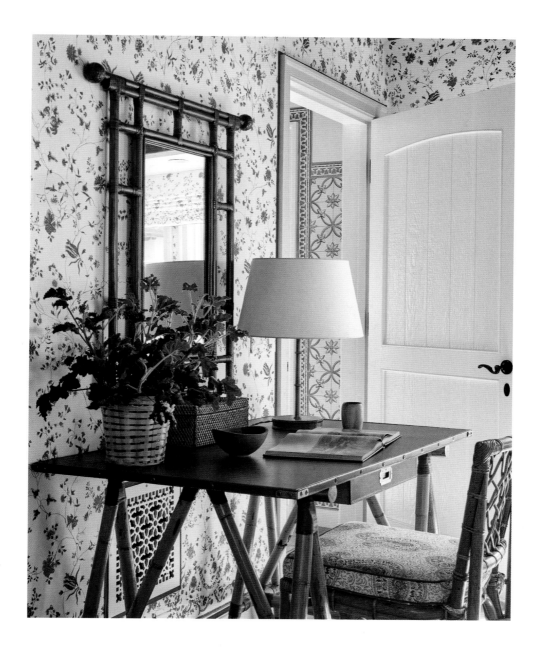

OPPOSITE: It's unexpected to nestle a bed under a window, but here we simply had to. How lovely to let the salty air sail in over your pillows as you sleep. ABOVE: The homeowner had a lot of rattan and woven furniture in her collection; we took that as our cue to make more custom pieces. Bamboo chinoiserie furniture, a mirror, and a campaign desk let this bedroom's office setup speak of faraway lands.

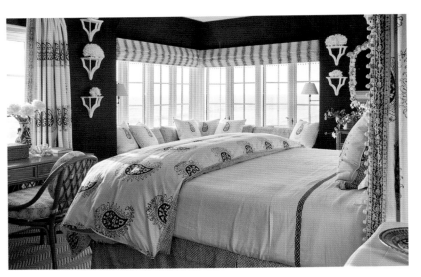

The corner banquette overlooking the water signals vacation at a glance.

Deep cushions say "relax."

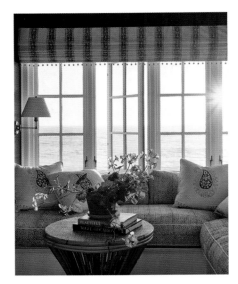

Potted geraniums are a favorite (and always fragrant) flower, especially at the beach.

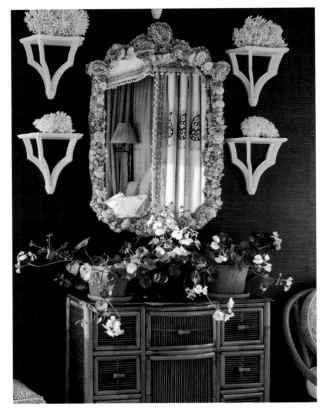

Shells and bamboo: a perfect pair.

You can never have too many stripes.

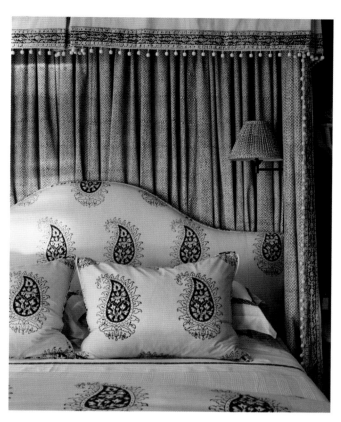

The antique batik from Les Indiennes brings an extra artisanal touch to this bespoke canopy.

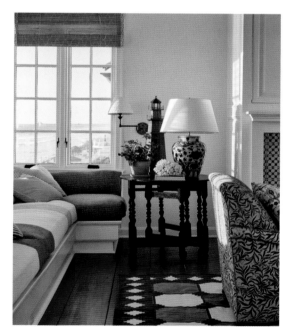

Matchstick blinds are coastal classics.

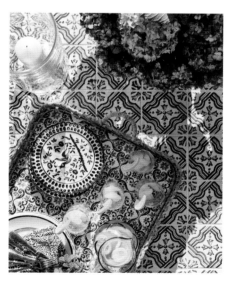

We made custom blue-and-white tile tabletops for the terraces.

August

BERMUDA REBORN

Pink sand beaches are exceedingly rare. But Bermuda has a bounty of them, edging the British island in the pastel hue. Alongside glass-clear turquoise seas, these rosé shorelines are like a sunset that never fades. Add coral reefs that teem with rainbow parrot-fish, flourishing botanical gardens, and classical architecture, and Bermuda feels like paradise found.

It can, however, get *hot*—and especially sultry in August. Generations of Bermudians have found solutions in architecture, erecting homes with high ceilings (allowing humid air to rise), louvered shutters that can block the sun, palmetto and olivewood trees that provide blessed shade, and plenty of outdoor verandas for a fresh breeze. The island's water collection law—which requires all local homes to harvest 80 percent of the rainwater that lands on the roof—is especially smart. This particular house's white stepped roofline performs beautifully on that front, while adding a bit of architectural eye candy to the stucco Regency Revival exterior.

PAGE 197: Bermuda's subtropical climate is verdant and lush, and home to native plants that can't be found in the wild anywhere else on earth. PREVIOUS PAGES: The rooflines of Bermuda are stepped for water collection—a mandated look that also adds style. ABOVE: Palm fronds are ancient symbols of peace. OPPOSITE: A loggia can become the ultimate outdoor dining room.

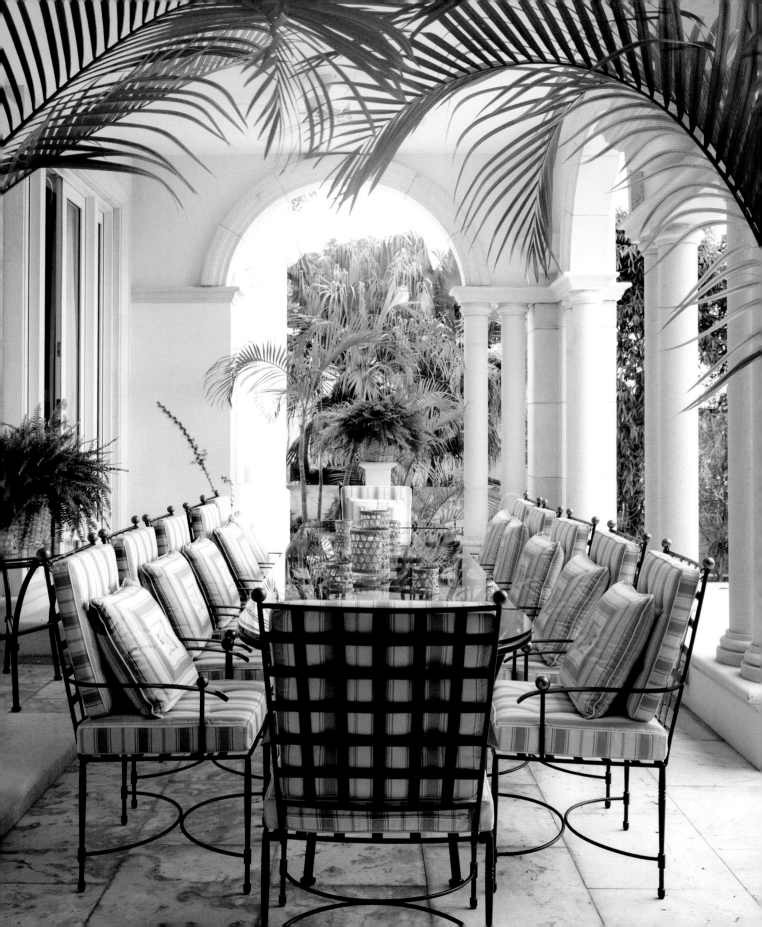

ABOVE: We preserved the existing wrought iron double doors on the Regency Revival home.
OPPOSITE: A borne settee in orchid pink is the warmest welcome in the foyer, especially trimmed in bullion, and it pairs beautifully with whimsical chinoiserie details hand-painted by Steiert.

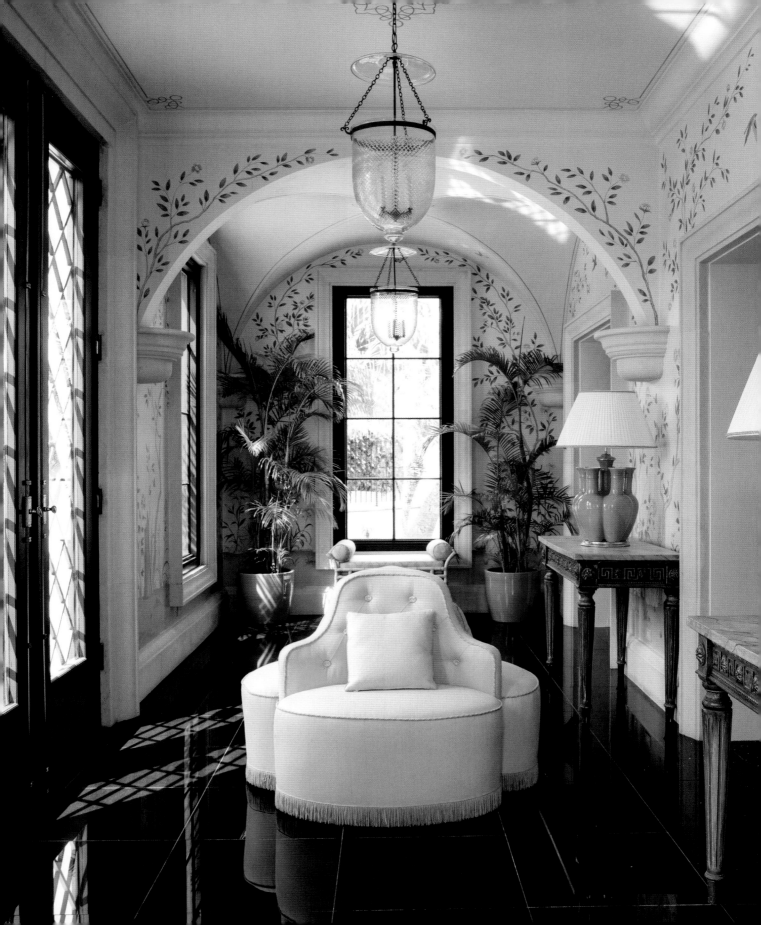

ABOVE, CLOCKWISE FROM TOP LEFT: Hand-painted decorative scrolls on the ceiling illuminate the bell jar lanterns. A tailored cord on the borne settee gives it a needed contrast. The strength of the Greek key juxtaposes against the flora on the walls. Bamboo armchairs, fancified with tasseled cushions. OPPOSITE: The gleaming black marble floors are as reflective as a mirror.

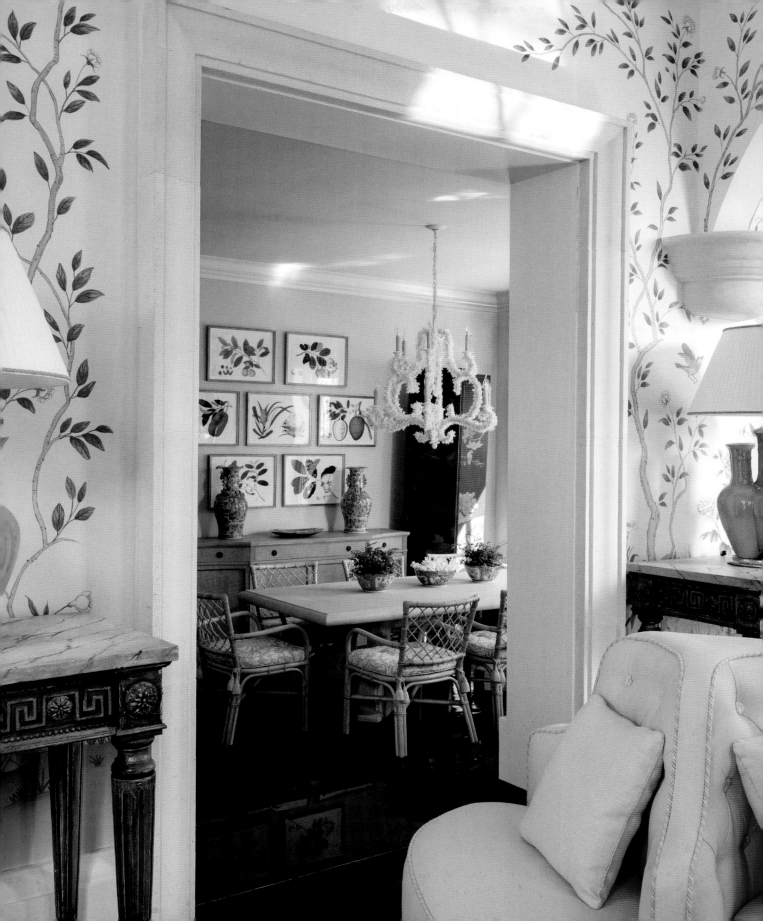

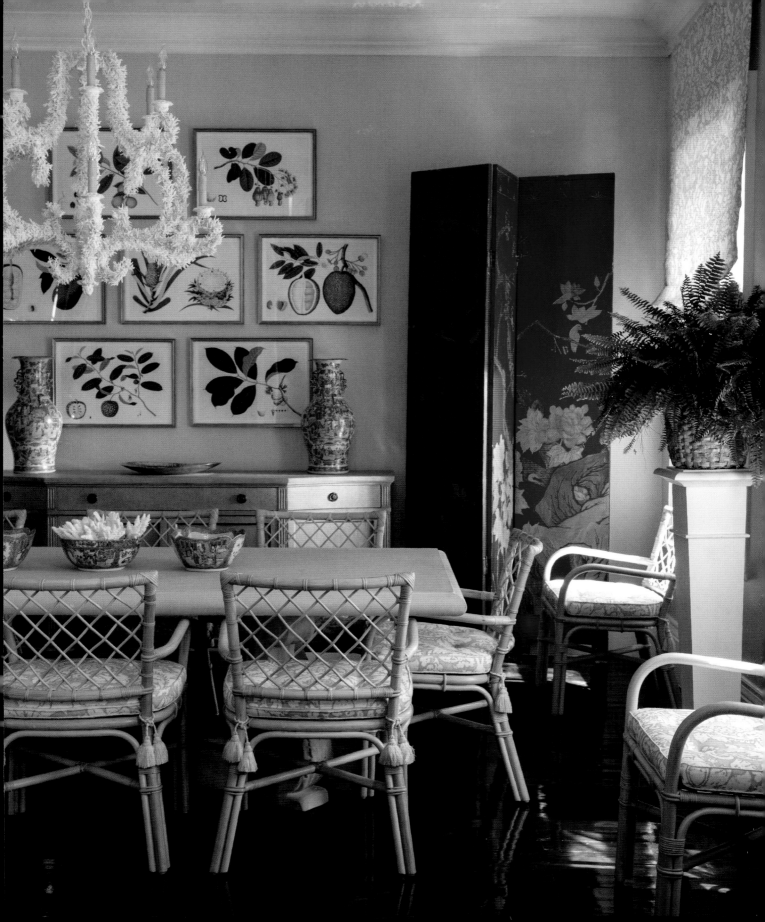

"A life without love is like a year without summer."

Swedish proverb

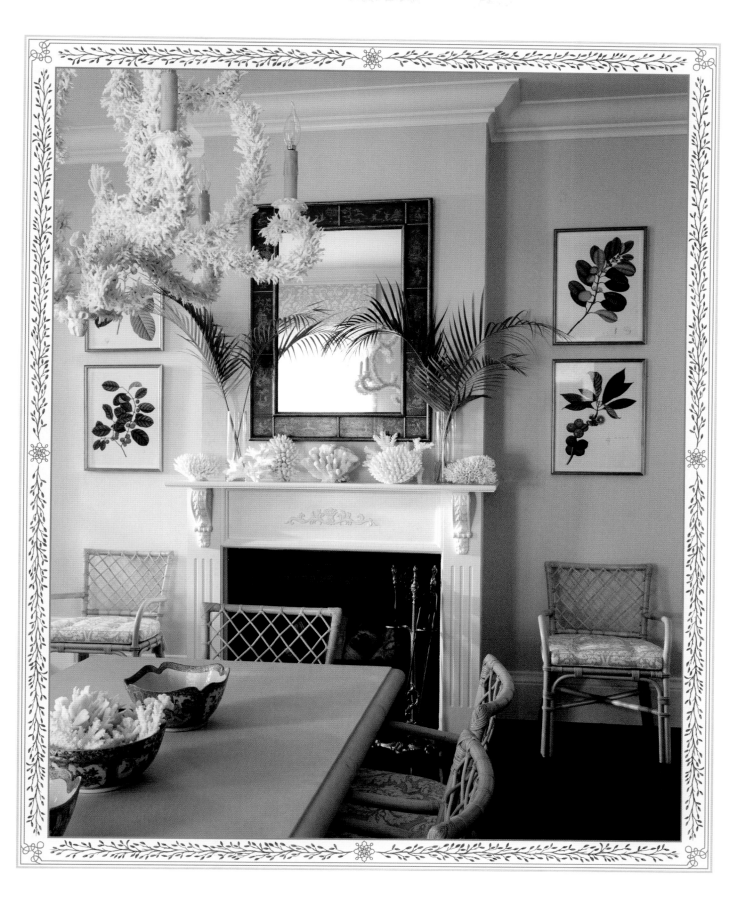

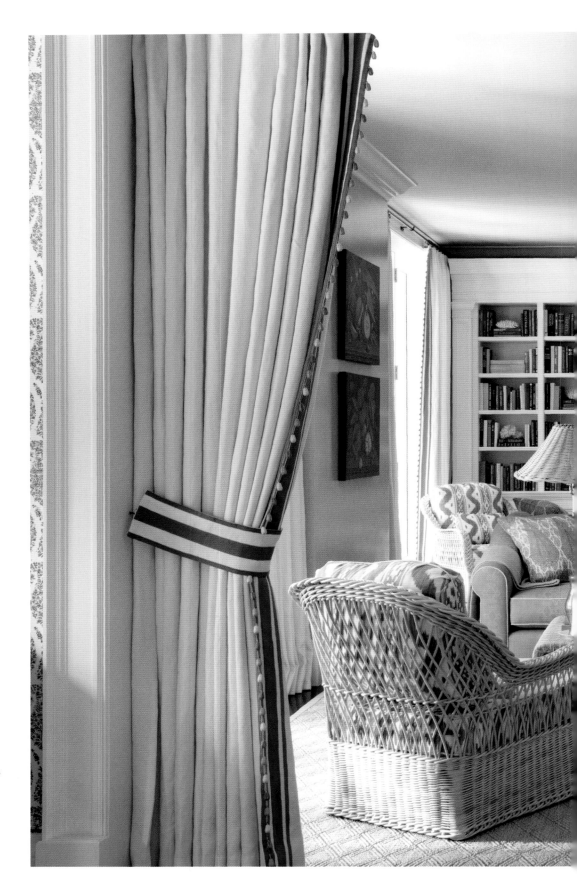

Commingling woven
Soane and Bielecky Brothers
wicker (which we used
throughout the house) and
diamond sisal rugs with
traditional choices, like
portieres and back-to-back
ikat sofas, relaxes the scene.

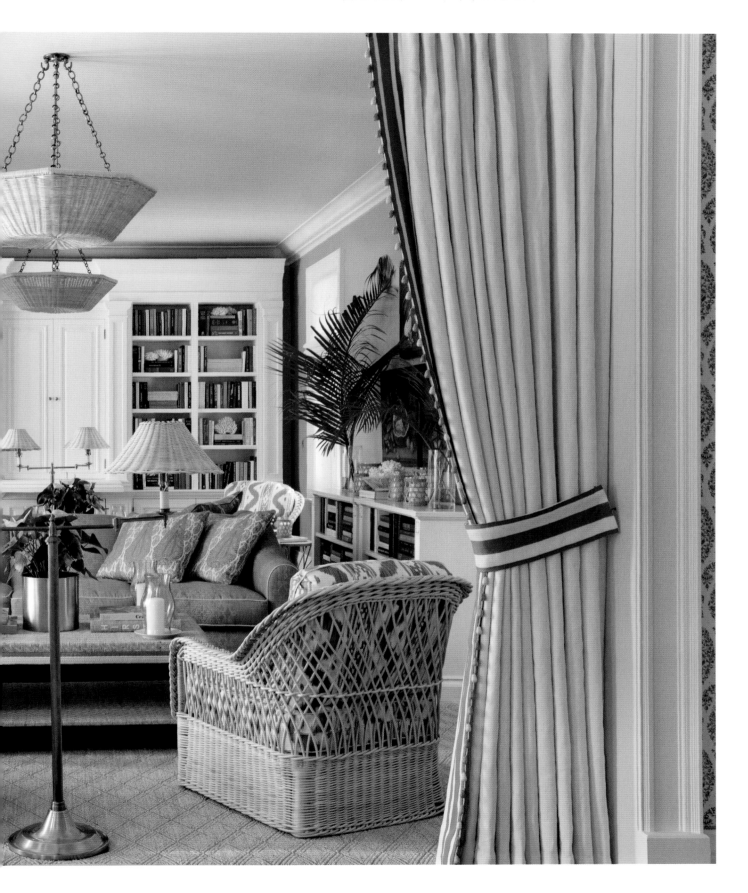

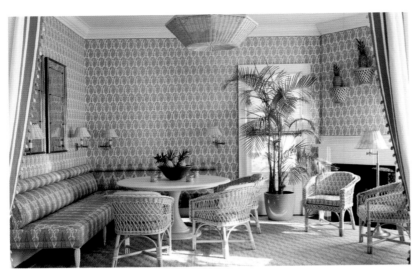

There's little more inviting
than a corner banquette.

Braids and pom-poms:
eternally lovely.

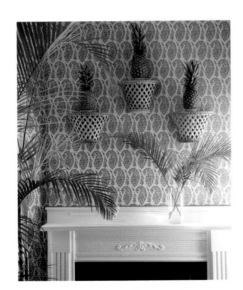

Pineapples have been a
symbol of welcome since
the eighteenth century.

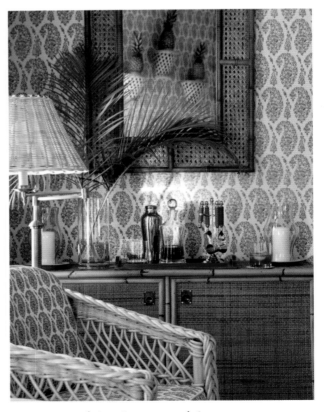

Raising the bar with
a custom drinks station.

Bolsters "finish" a bed.

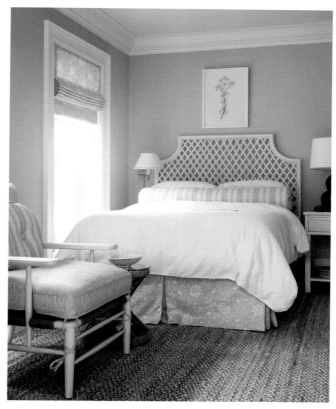

Lattice is always tropical.

Cantaloupes by our decorative painter.

A tulip table pairs well with a built-in bench.

"To plant a garden is to believe in tomorrow."

— Audrey Hepburn

Inside, we honored many of the regional design styles as well. We added a lot of seashell details, such as the custom shellcraft chandelier in the dining room. Wicker is another theme that we installed throughout the house, including handmade furniture by Bielecky Brothers as well as subtler accents such as the lattice wall brackets and wicker lampshades. Woven finishes like this add texture and feel inherently summery, but in these European silhouettes, they're also elegant and refined.

Barefoot and breezy, it's not—by design. We brought in Georgian and Regency pieces to pair with the more coastal choices, a mix that feels lasting. Our decorative painter adorned the archways on either side with a leafy floral chinoiserie that ascends to the center point, framing where the bell jar lanterns are hung. I just love the glossy black marble floors and black wrought iron doors, which were original to the interior. You might notice we didn't add any window treatments in the entrance hall. We wanted it to feel open and airy—and it does. The perfect spot for a borne settee that's as pink as the Bermuda sand in the summer.

OPPOSITE: A flurry of orchids become de facto art on their woven brackets in the stair hall. In wide pink and cream stripes, the wallpaper is soft and subtle, and reads as a neutral.

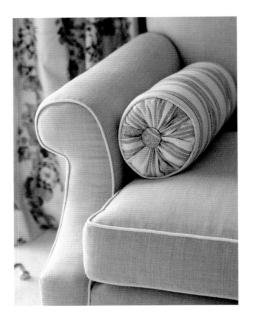

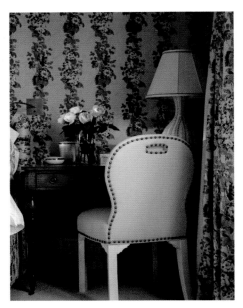

ABOVE, CLOCKWISE FROM TOP LEFT: We used bolsters as a theme throughout this house; they're eternally elegant. A contrast cord in white on an armchair adds a touch of tailoring. Every room needs a place to draft a handwritten note. These paintings of Bermudian fruits by our decorative painter make up the color palette of the home. OPPOSITE: The Rose Tarlow Bloomsbury Merlot chintz on the walls, bed, and bench is so warm and welcoming; in glazed cotton, it suits the seaside locale.

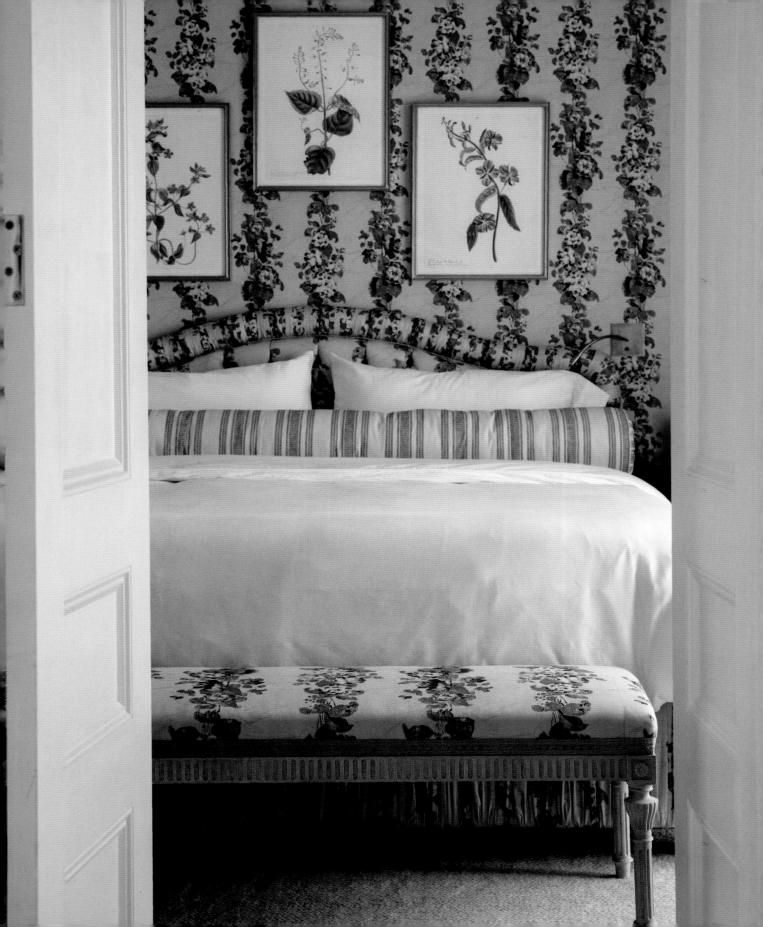

Reading a wonderful book is a bit like taking a journey, but the trip is made all the more lovely in a beautiful library.

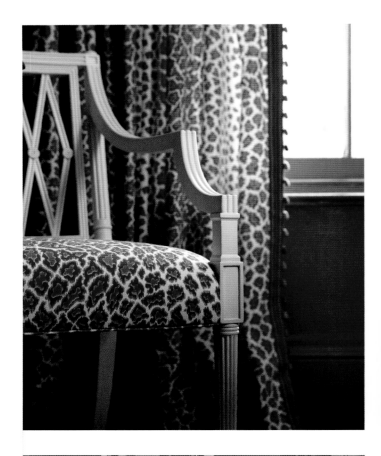

CLOCKWISE FROM TOP LEFT: Animal print roars in the library. We lacquered the room in red and added a trundle daybed for overflow guests; the desk is topped in leather, a handsome touch. The Union Jack flag flies throughout Bermuda, a British territory. Windowpane check upholstery highlights the 1940s-inspired lines of this custom armchair. We matched the fabric on the custom brass lampshades to the room—key to a finished effect.

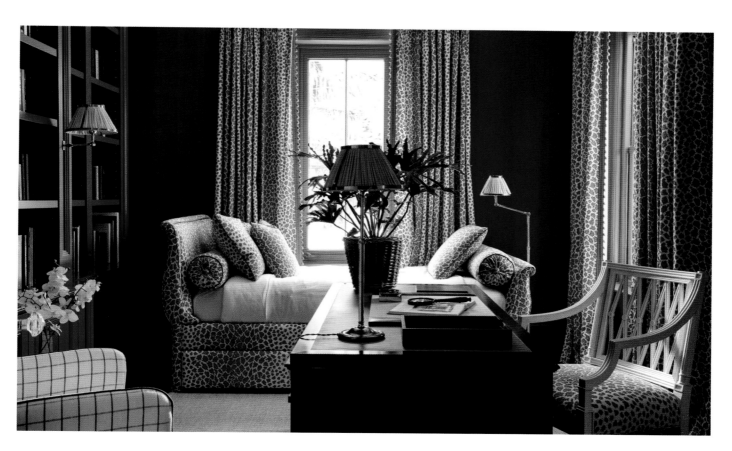

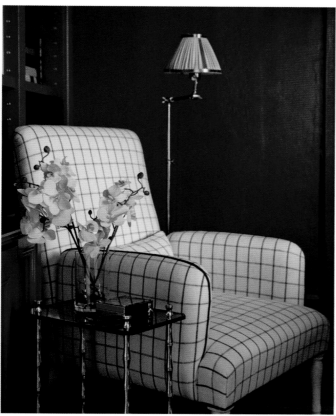

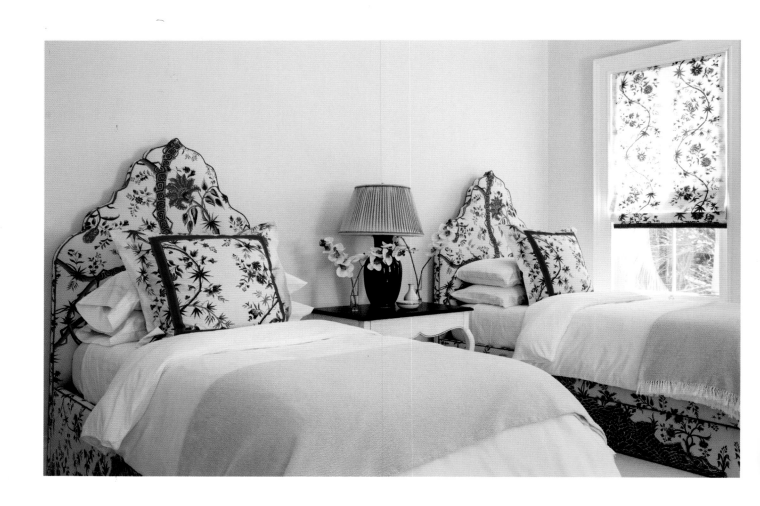

ABOVE: Pierre Frey's Le Grand Genois Panneau Tree of Life fabric took its cues from a seventeenth-century palampore and brings a storied effect to this guest room.
OPPOSITE: The colors in the antique screen are tonally in pace with the room's fabric.

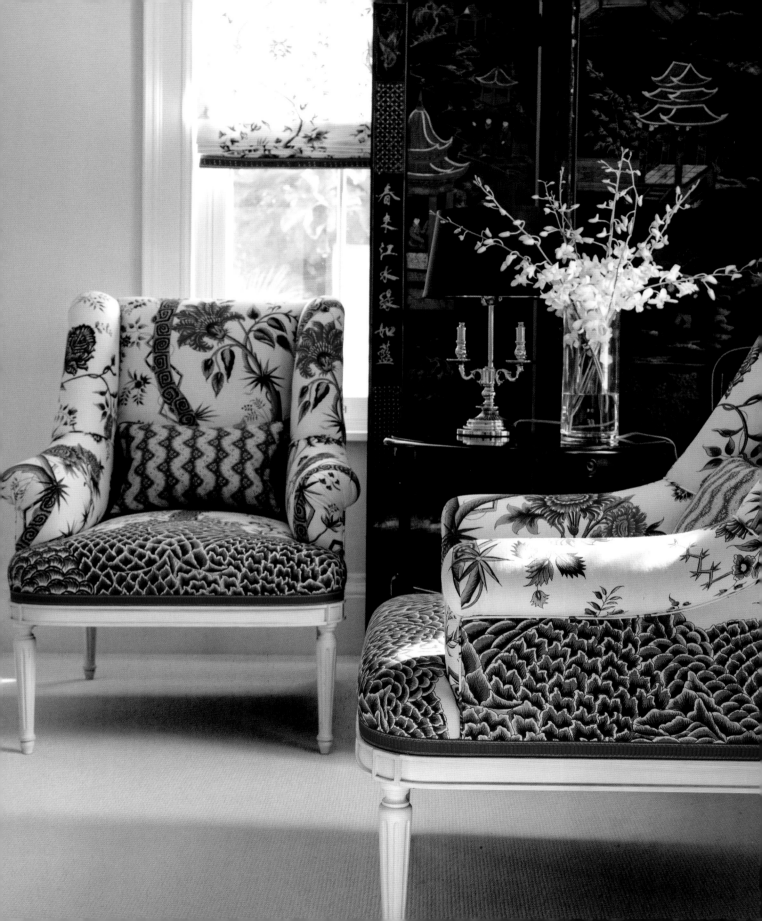

September

LOWCOUNTRY LIVING

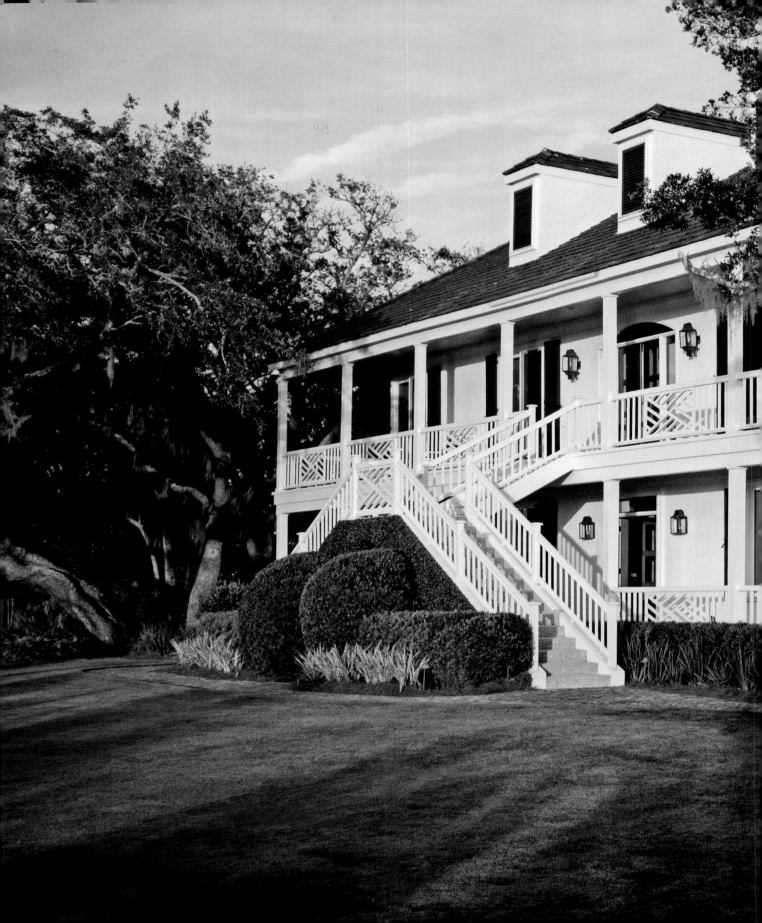

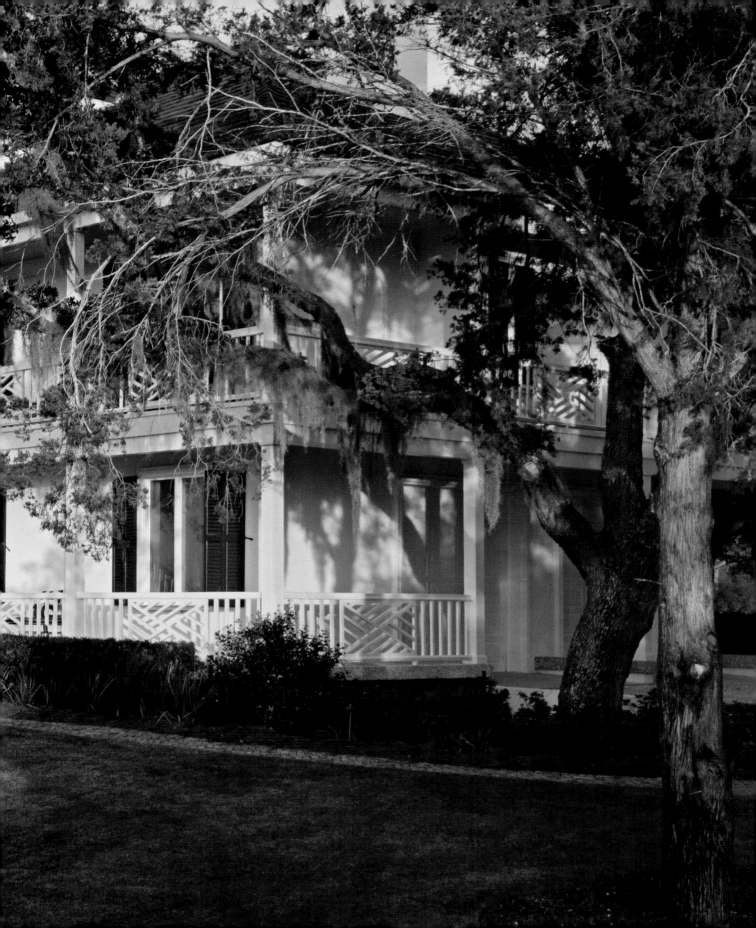

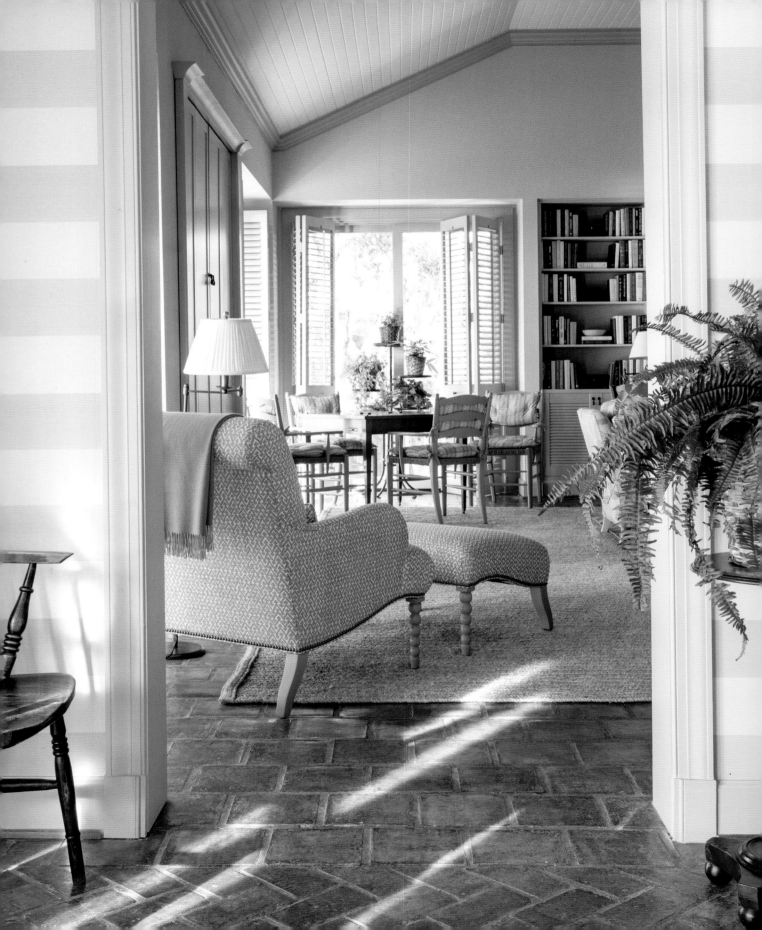

For the uninitiated, the Lowcountry region of Georgia is instantly spellbinding: a place where regal white egrets stand watch over the salt marshes, and Spanish moss drips from centuries-old live oak trees. The pace is slow, and it gets even slower after summer visitors depart. Sometimes in September it feels like time stands still.

Set on Sea Island, the iconic resort that centers around the 1928 Cloister hotel, this existing cottage already took its cues from the region's architectural vernacular. It has proud porches that wrap around the entire structure and provide blessed shade in the summer heat, haint blue (a shade of blue used for centuries to echo the sky and ward off evil spirits) porch ceilings, brick flooring, and a prime overlook of the surrounding wetlands.

We took those marshes as our muse for the interior color palette—soft, pretty turquoises and acidic lime greens—as well as the rustic nature of the fabrics and finishes. All the textural accessories we used here feel like they

PAGE 223: Spanish moss could be the unofficial state plant of Georgia: everywhere and so entrancing. PREVIOUS PAGES: Wraparound verandas and shutters have kept Southerners cooler for centuries. OPPOSITE: Bricks laid in two patterns, a basic stack and herringbone, provide such a historic look that we left much of them exposed. ABOVE: The light on Georgia salt marshes—framed here by boxwoods—shifts beautifully throughout the day.

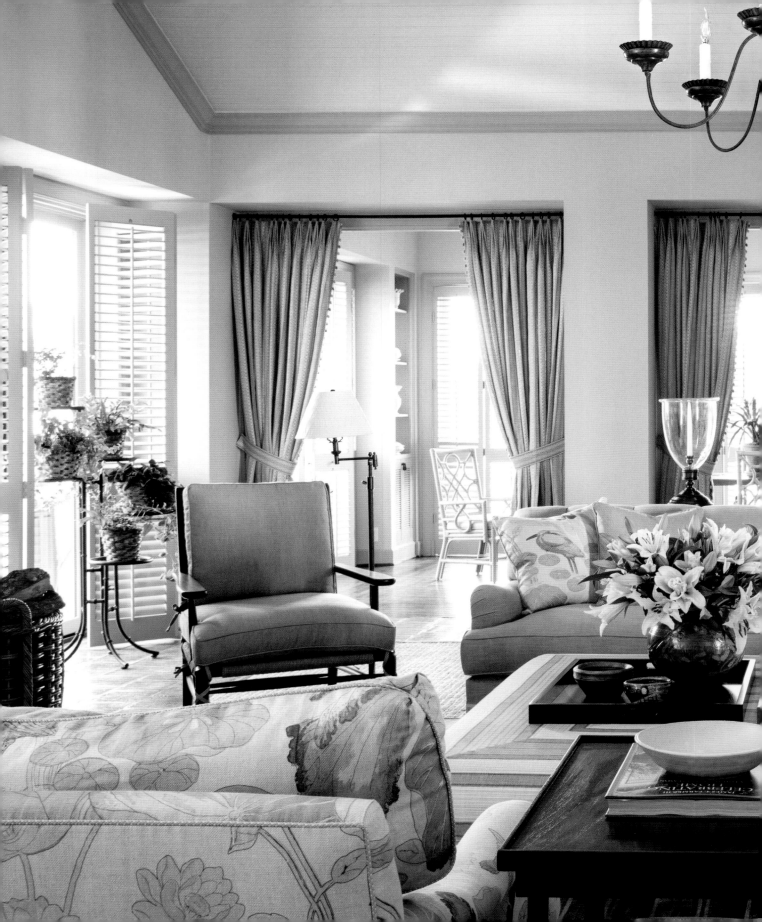

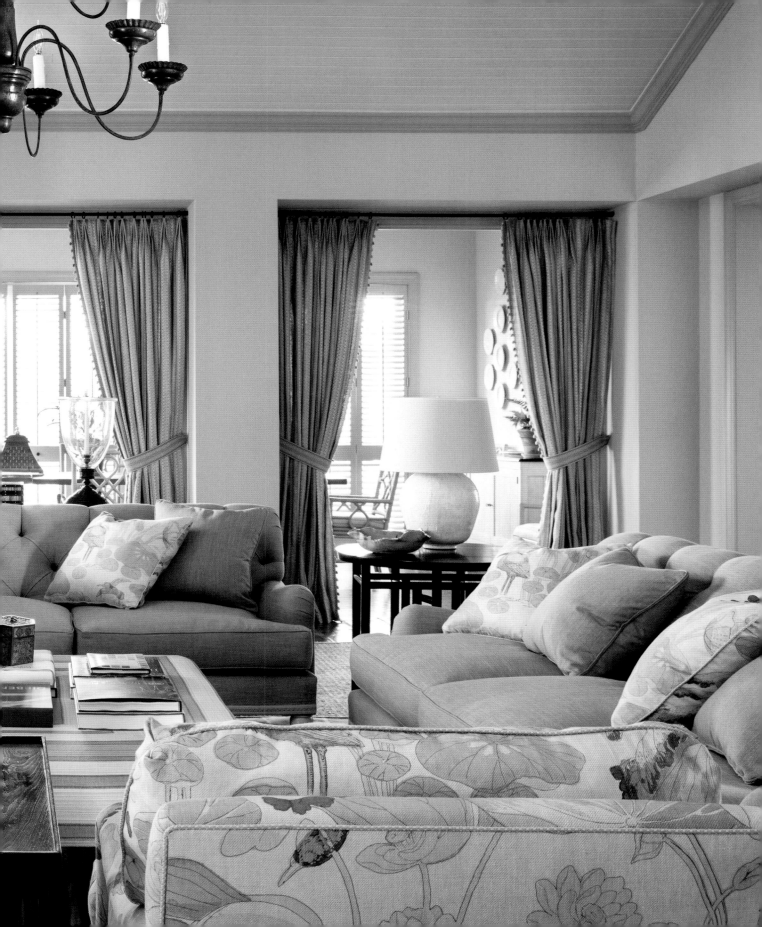

> "In nature, nothing is perfect and everything is perfect.
>
> —*Alice Walker*

speak the same language. We employed natural fibers throughout, as well as American wood antiques and pottery, lush plants, and botanical Audubon prints. As Georgia was one of the original colonies, the colonial era was also a huge inspiration to us. We brought in hurricane glass, tole lanterns, and period-appropriate antiques, but juxtaposed them with modern art pieces to jolt the spaces into the present.

I love the existing shutters on the French doors that span the exterior, especially because of the magnificent, striated light they provide. But they also presented a problem. Without window treatments, a room can easily feel a bit cold. So we cozied up the living space by hanging portieres—panels of fabric that serve as doorway curtains—separating the living and dining rooms with a subtly banded pattern and an effervescent pom-pom trim.

We played a lot with linear choices in this house, an understated nod to the striped way the sunlight pours through the shutters. The foyer is wallpapered in horizontal bands in two shades of blue; we upholstered a mitered stripe into the ottoman and dining room cushions; and we highlighted the beadboard ceilings by painting them a slightly different hue from the walls. It's subtle, but all those lines add just the right graphic touch—and a light counterpoint to the tidal creeks and maritime forests thriving outside every window.

PREVIOUS PAGES: Glass hurricanes and seawater-toned upholstery feel sprung from the region.
OPPOSITE: We used three subtly different shades of blue to highlight the bones of the living room.

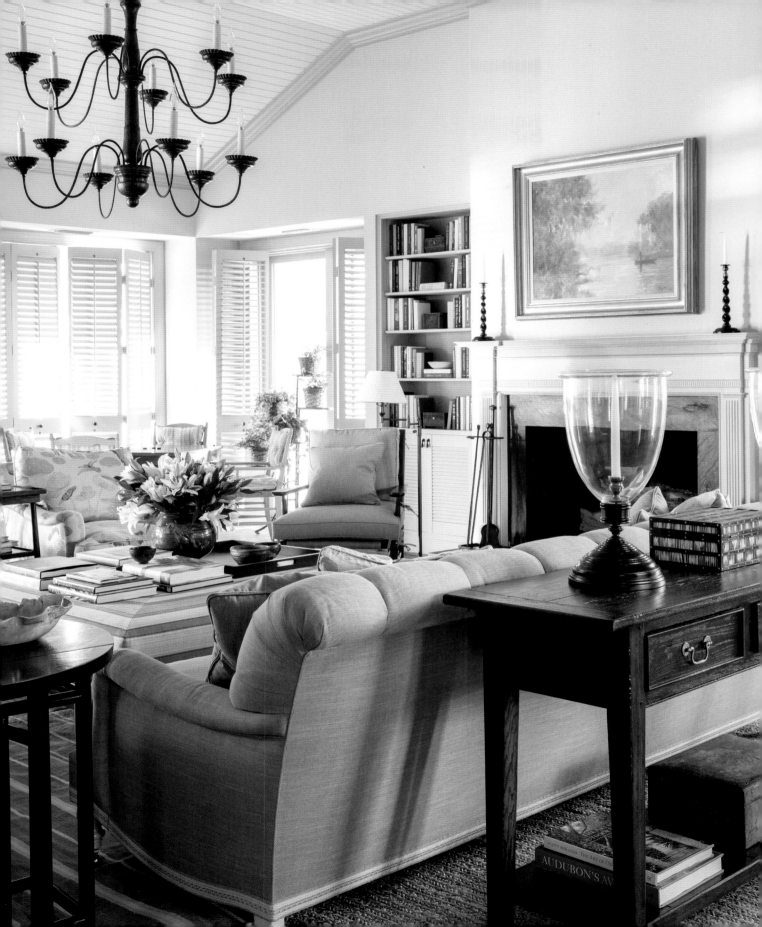

Southern comfort can be found in the grace of the land itself: the soft sands, fragrant magnolia, and light dappled through live oak trees.

CLOCKWISE FROM TOP LEFT: The custom horizontal-striped walls are a subtle reference to the way sunlight flows through the home's shutters. Water lily fabric on linen: cooling at a glance and to the touch. In lieu of a coffee table, a generous miter-striped ottoman with trays allows for tabletop use and a place to put your feet up. Mixing pattern scales keeps the look cozy. Always make room for moments of play. This motif includes herons, among the resident birds often seen out the windows here.

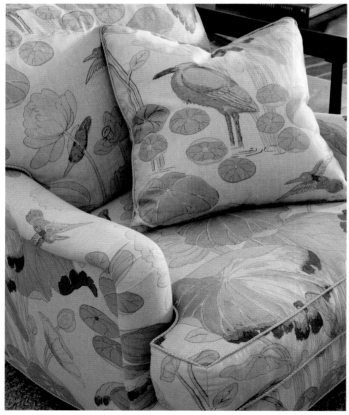

Garden-inspired tole lanterns illuminate both ends of this antique dining table in a soft, warm glow. We kept the color palette limited in this space to put the focus on the views.

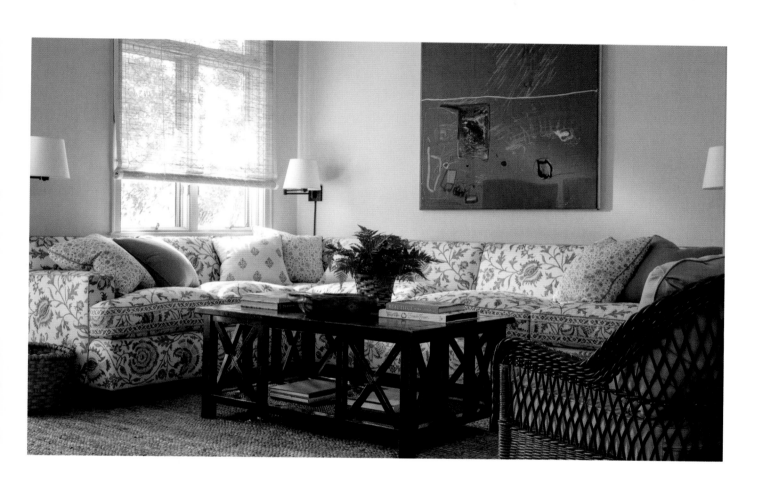

OPPOSITE: A detail from the wallpaper in the powder room captures the dancing reeds of estuary marshlands. ABOVE: We curated this modern art piece to juxtapose perfectly with the deep corner sectional.

"Autumn shows us how beautiful it is to let things go."

Anonymous

OPPOSITE: William Morris's Willow Bough wallpaper, designed in 1887, supplies a classic feel to a corner nook in the laundry room. The white ibis is commonly spotted in Georgian wetlands and coastal marshes.

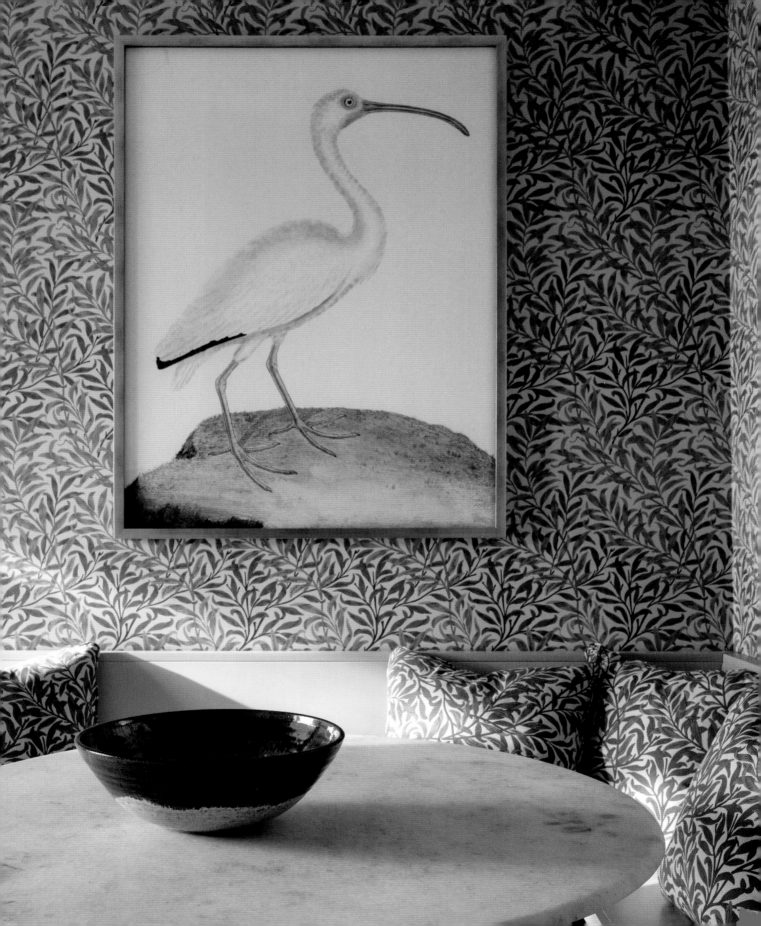

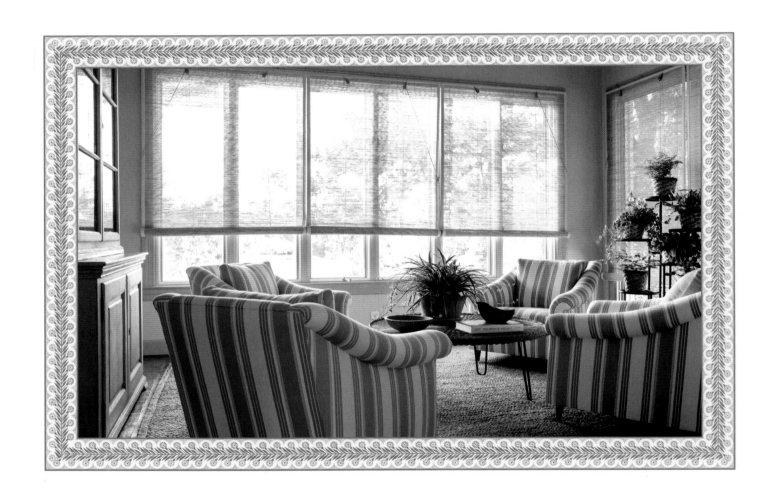

ABOVE: This sitting area off the kitchen has a singular purpose—taking in the great views. Conversation flows in a setup like this, where everyone is cozily ensconced in an armchair; these are upholstered in awning stripes, continuing the stripe and shadow theme that runs throughout the home. OPPOSITE: Ceramic pieces and hand-turned wood bowls alike bring wonderful texture into a living space.

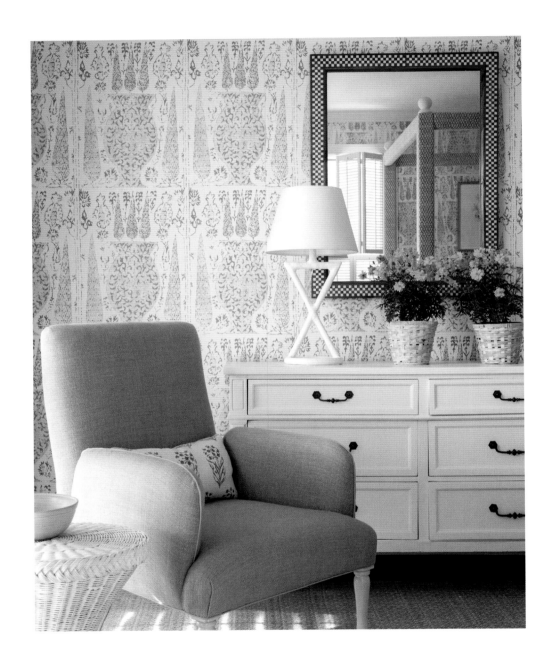

ABOVE: In a state known for the peach, a hint of orange is a natural fit—especially paired with blue and white, as it is in this Penny Morrison block print. OPPOSITE: A four-poster bed creates a room within a room that feels inviting and comforting in a guest space.

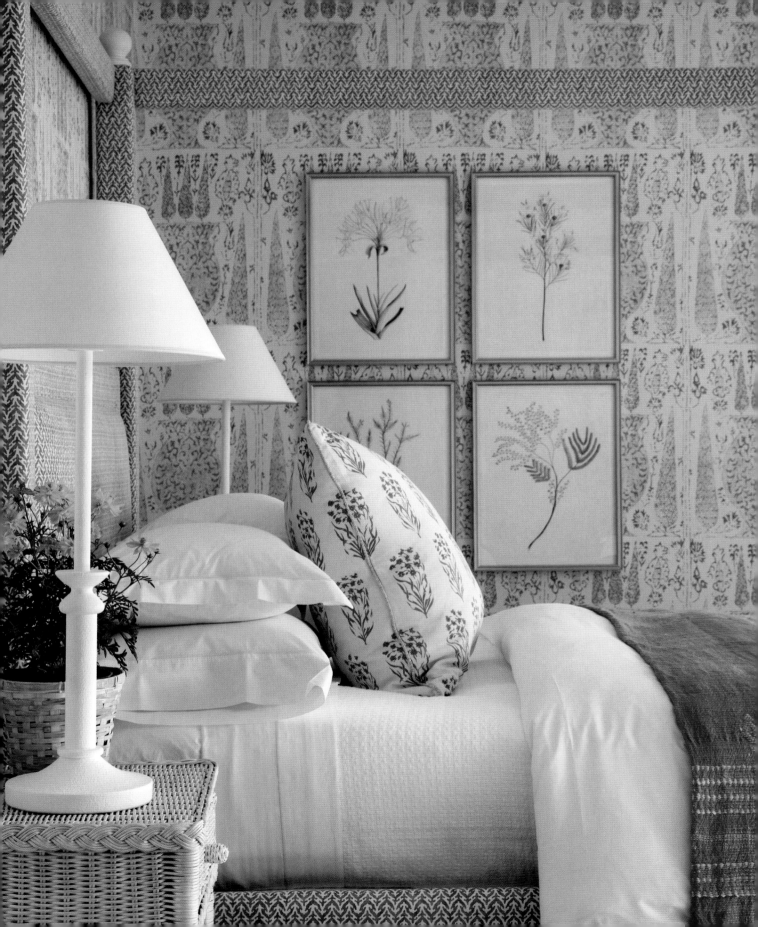

Sunset on the salt marsh.

Handwoven details contrast with the windowpane fabric from Schumacher.

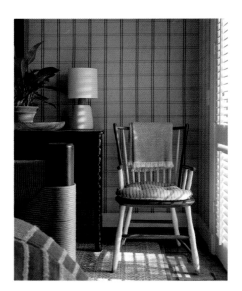

Flaxen and sage green windowpane fabric on the walls reads as classic.

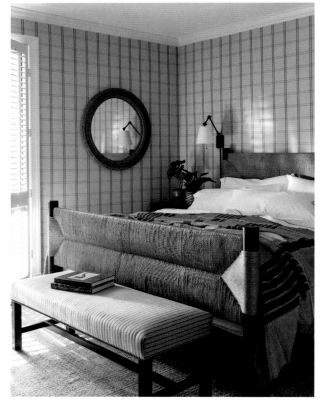

The woven rush on the bed adds texture.

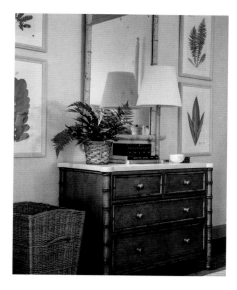

Bamboo furniture is natural by the shore.

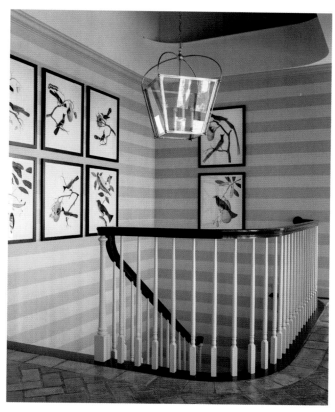

Framed in black, Audubon prints provide a graphic touch.

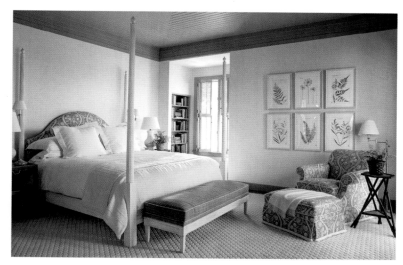

We had a lot of fun with paint in this house; the ceiling here is as green as a coastal pepperbush.

Embroidered fabric in the primary bedroom.

October

AUTUMN MIDWEST CLASSIC

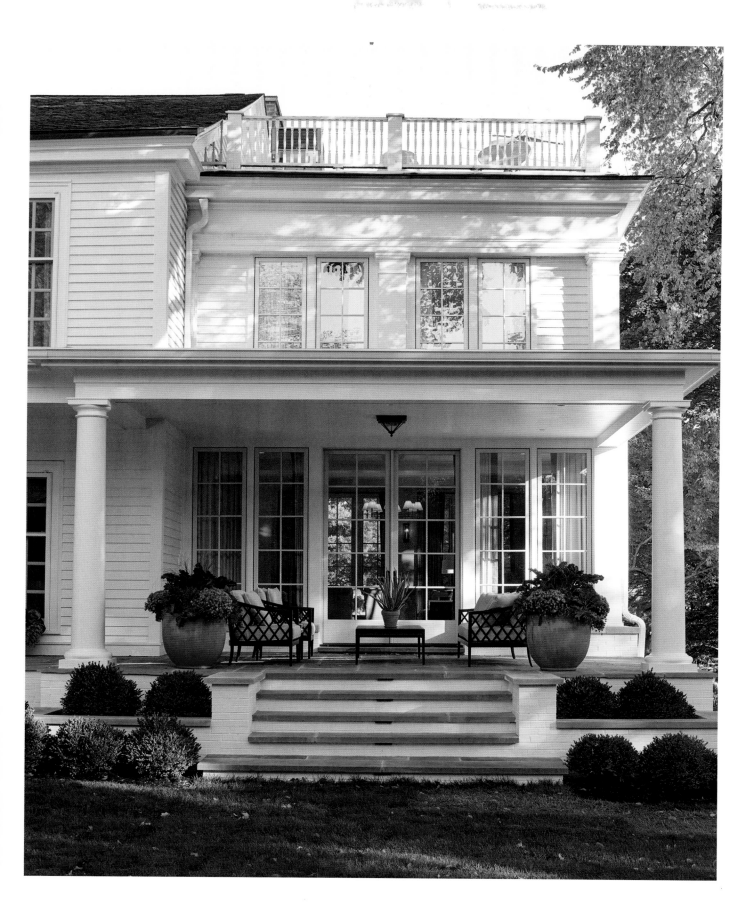

PREVIOUS PAGE: We tried to
stay true to the historic early
1900s architecture of the
house, in the Chicago
suburbs. Pots brimming with
autumnal plantings and
drying hydrangea set a
perfect seasonal tone.
RIGHT: White houses are
so classic—and allow rolling
lawns and landscaping to
look especially vibrant.

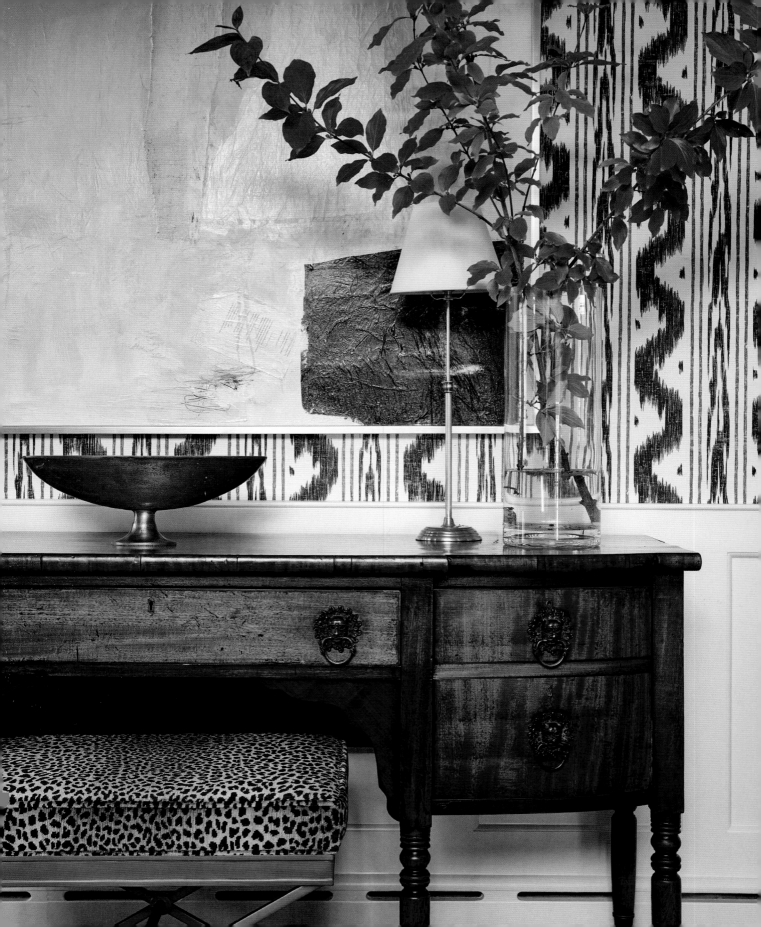

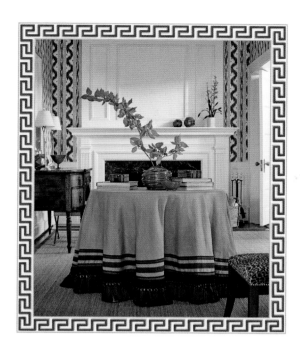

When October descends in the Midwest, there is a new crispness in the air, and the occasional puff of woodsmoke scenting the wind each evening. The leaves on the oak and maple trees turn to crimson reds, caramel, and marigold. It's almost as if nature has tailored its color palette on purpose with one goal: to quickly add warmth to the season.

That word—*tailoring*, defined as making something truly yours in a custom, bespoke way—exactly sums up our approach in this 1900s home in a storybook town on the leafy outskirts of Chicago. We wanted to keep its aura of century-old history and stay true to its deep roots while modernizing and refreshing it for the lovely family that lives there today.

One thing we gravitated to early in the project was the Greek key, which we employed throughout the home. Given its bold, graphic look, the storied motif felt right for this house—it's thoroughly modern and clean at the same

OPPOSITE: We paired the antique English sideboard with a modern stool and contemporary art; the mix mingles the lines between masculine and feminine. ABOVE: We added chocolate brown silk passementeries to the camel hair skirt for the entrance table, which brings elegance and softness. Rich chocolate browns are such comforting, warm hues during the fall.

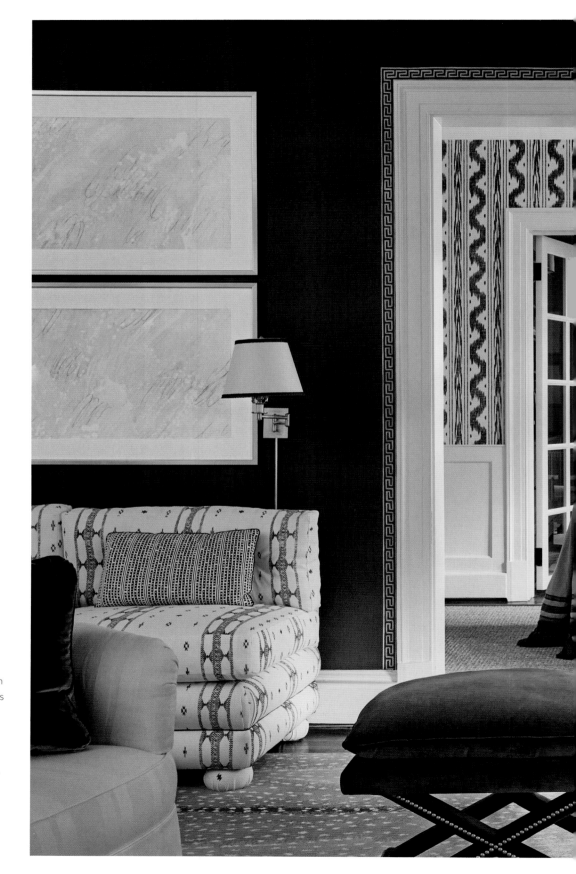

Customizing this series of contemporary drawings meant we could enlarge them to suit the space. Their frames were vital for making a statement and bringing in some gold to add luxury and to play with the room's brass accents. Note the Greek key stenciled border around the doorway; it adds to the tailored, classic feel in the living room, but there's also something modern about it.

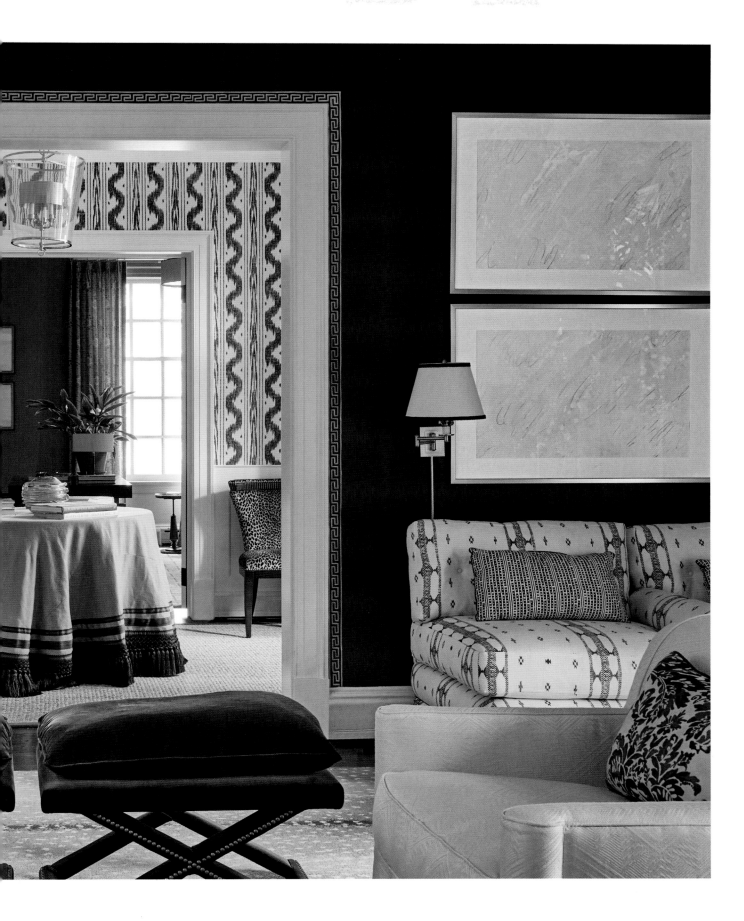

"Autumn is a second Spring when every leaf is a flower."

—*Albert Camus*

time. In fact, that fresh feeling was crucial throughout. To achieve it, we limited the color palette to luxe neutrals: rich chocolate browns, caramels, and steely blues. The upholstery is incredibly tactile, including mohairs, camel hair, supple leathers, and a smattering of animal prints—classic to the core!

We mixed modern pieces and traditional ones, a move that often results in a timeless quality. For example, in the living room, there's a beautiful traditional French chair adjacent to a sleek 1970s brass jardiniere for the tree. In the dining room, delicate Gracie custom wallpaper is juxtaposed against a sculptural modern table. It's all about balance. To that end, you'll notice that when the walls are dark, all the furnishings and art set before them are light—an approach that harkens back to the most ageless spaces of Albert Hadley and Billy Baldwin.

When a young family lives in a traditional home with historic bones like this one, you need to balance the classical architecture with the decor to keep it feeling modern and fresh. That's one design secret that both Hadley and Baldwin perfected: you have to embrace eras of the past and the present to create a truly enduring space, much like the Greek key.

OPPOSITE: We kept the stain on the staircase's newel and handrail but painted the balusters. The goal was to embrace the home's history while also freshening it up for today.

ABOVE: Every room could use a bit of reflection, such as these 1970s brass jardinieres. OPPOSITE: When walls are dark, light furniture and art can supply balance—a move often embraced by designers like Albert Hadley and Billy Baldwin. Antelope carpets are graceful underfoot, with a touch of exoticism.

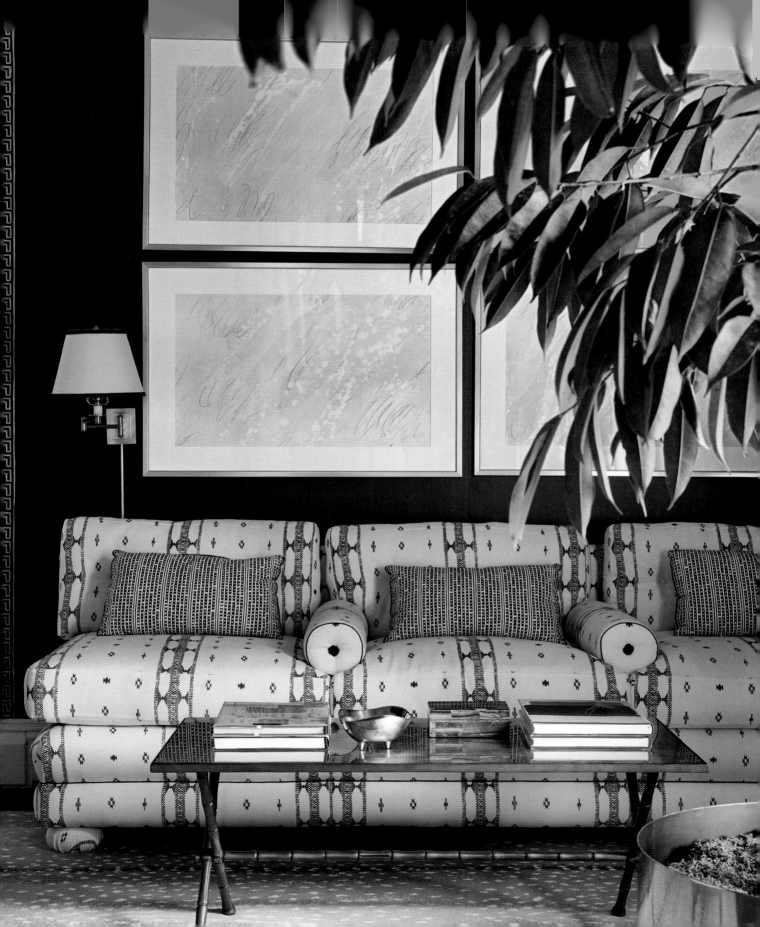

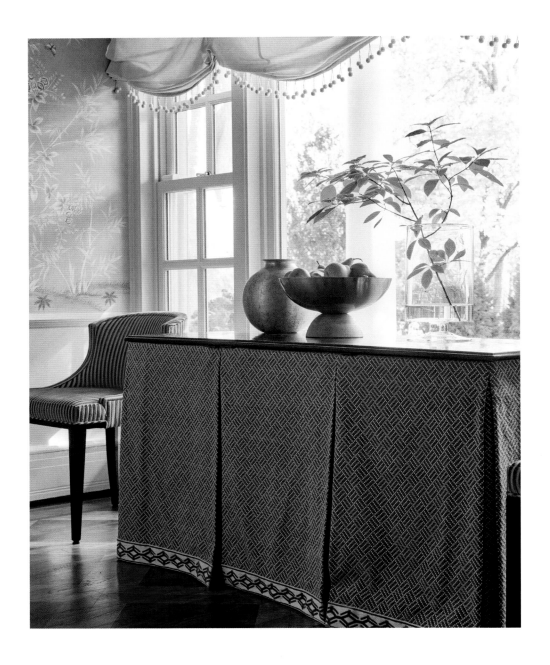

ABOVE: Roman shades with a tassel fringe detail lend a lovely softness in the dining room. OPPOSITE: We gilded the ceiling above the original chandelier, sheathed the walls in custom Gracie wallpaper, and stained the floors with a geometric pattern—and yet it all looks chic and modern with such a sculptural table base.

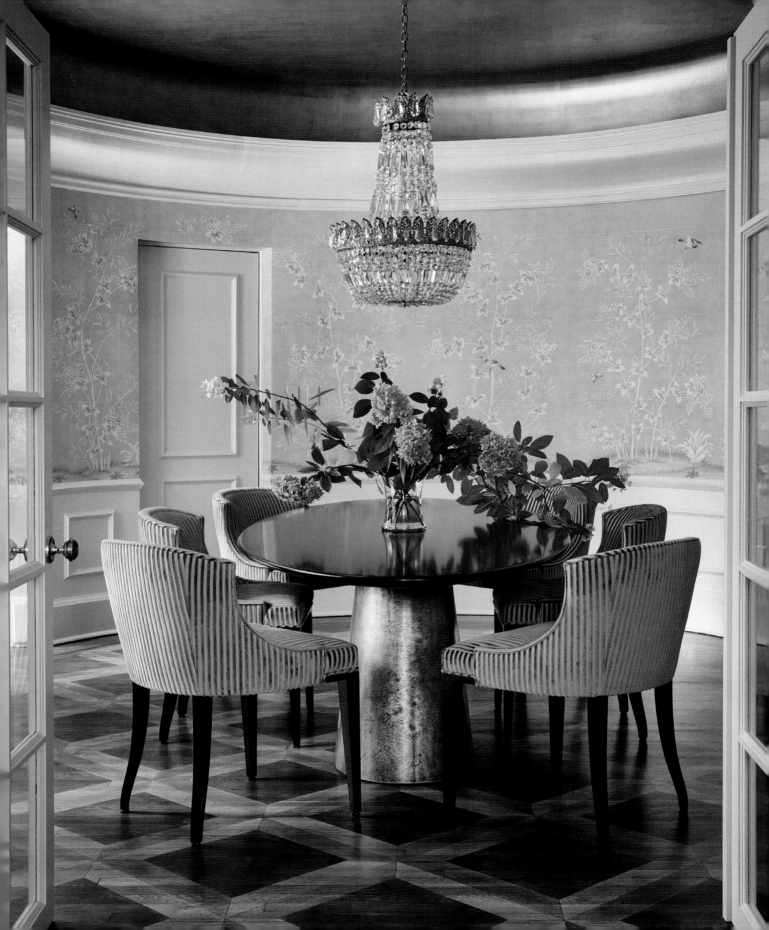

Modern art and well-placed clean lines give this living room a marriage of old and new.

A beveled French mirror brings extra light.

Tailored lattice patterns are not just for spring.

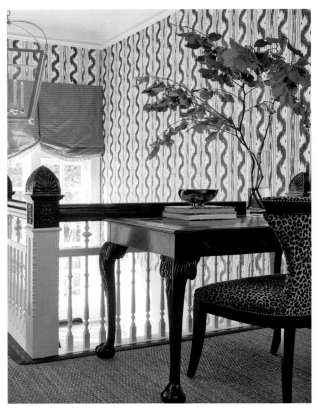

A writing table on the stair landing makes the space functional.

Faded honey hues and layers of neutral patterns are warm and welcoming.

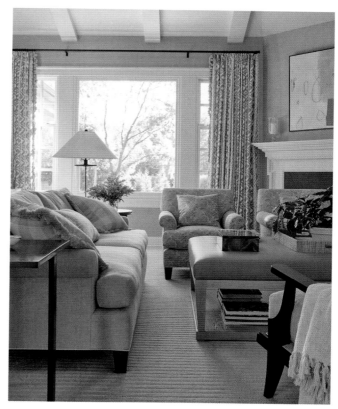

An ottoman top table with shelves beneath is the best of both worlds.

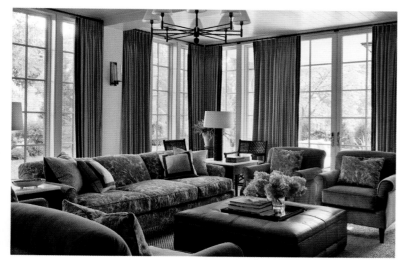

A verdure tapestry inspired the Pierre Frey fabric that grounds the sunroom.

Stone lamps with brass details in the sunroom.

OPPOSITE: Lacquer walls highlight the lines of the existing architecture, such as the Deco-inspired details on the upper shelves that also serve to echo the Greek key. ABOVE: A home office quickly became a jewel box with its lacquered walls and rich strié upholstery, brushed trimmed pillows, and a silk rug.

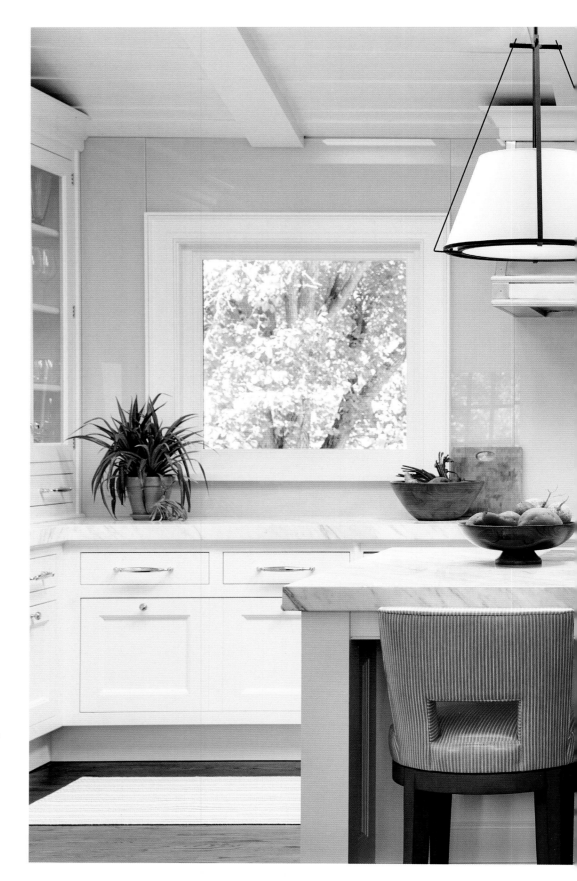

Rather than a standard-issue backsplash, like tile or a slab of marble, we went for the surprising: panels of glass painted on the reverse. It's as reflective as a still pond and manages to let the almost verdigris finish of the range hood pop. The Calacatta gold marble countertops are extra thick at two and a half inches, which lends a centuries-old feeling.

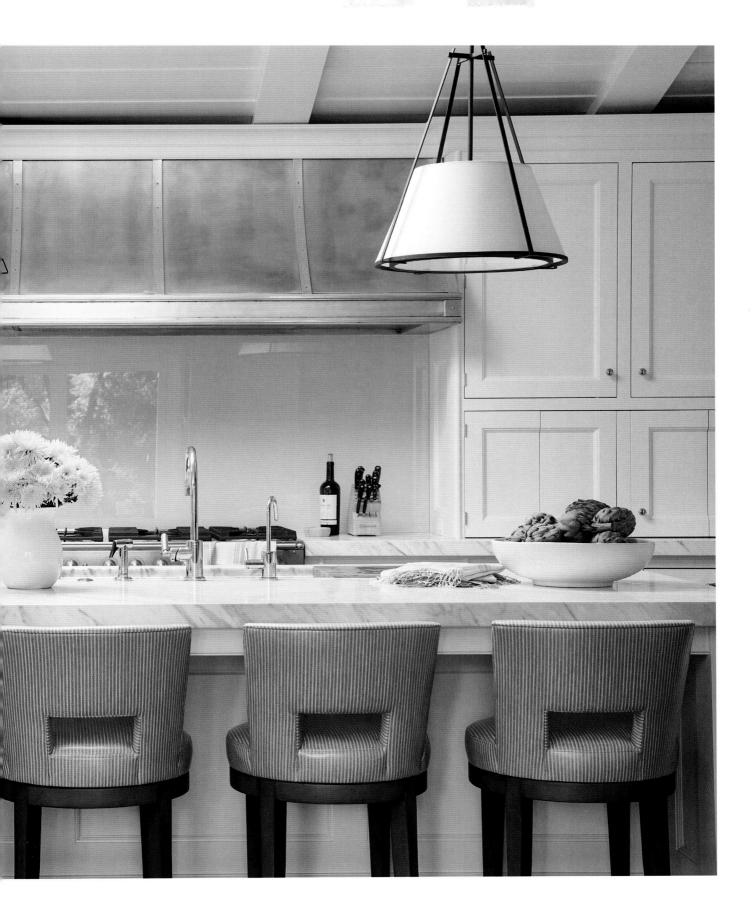

"If you look the right way,
you can see that the
whole world is a garden."

Frances Hodgson Burnett

OPPOSITE: We enclosed this sunroom with windows so that it can act as a
conservatory—a place for plants to flourish on frigid days, and a lovely spot
to sip your tea as the sun streams in. In autumn, the verdant leaves on potted
plants juxtapose beautifully against the changing ones out the windows.

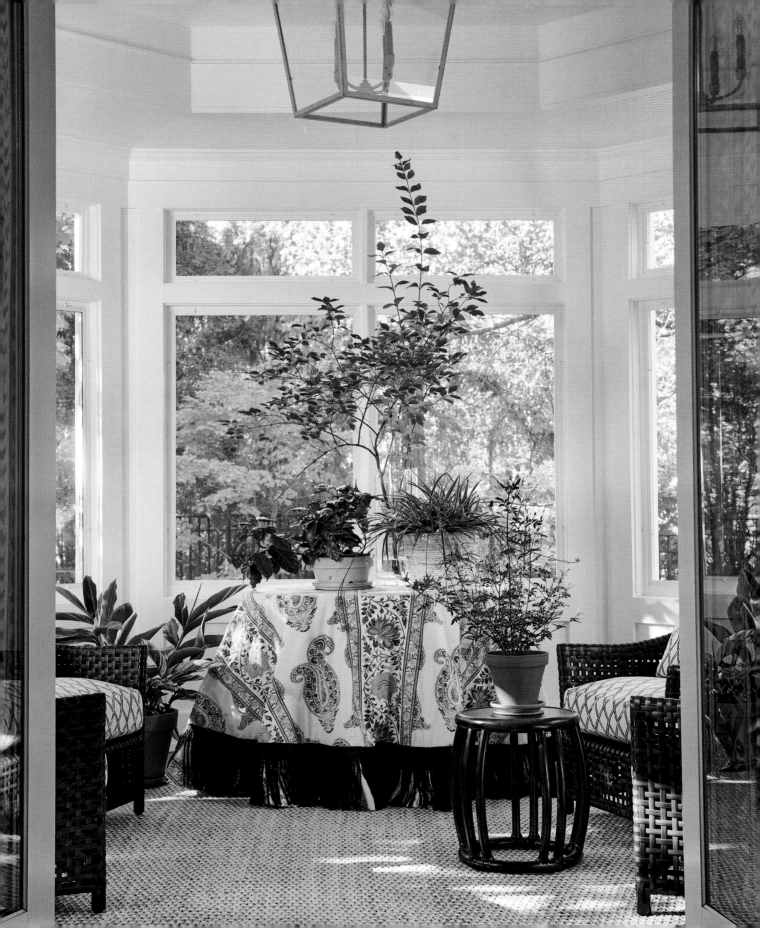

The primary suite was completely reimagined architecturally to make it more functional—adding storage and revamping the bath—but we tried very hard to preserve a historic touch. You'll notice a custom silk trim on the leading edge of the canopy bed panels, a refined touch. They're attached to the bed with loops and covered buttons: a tailored and special detail that elevates the look.

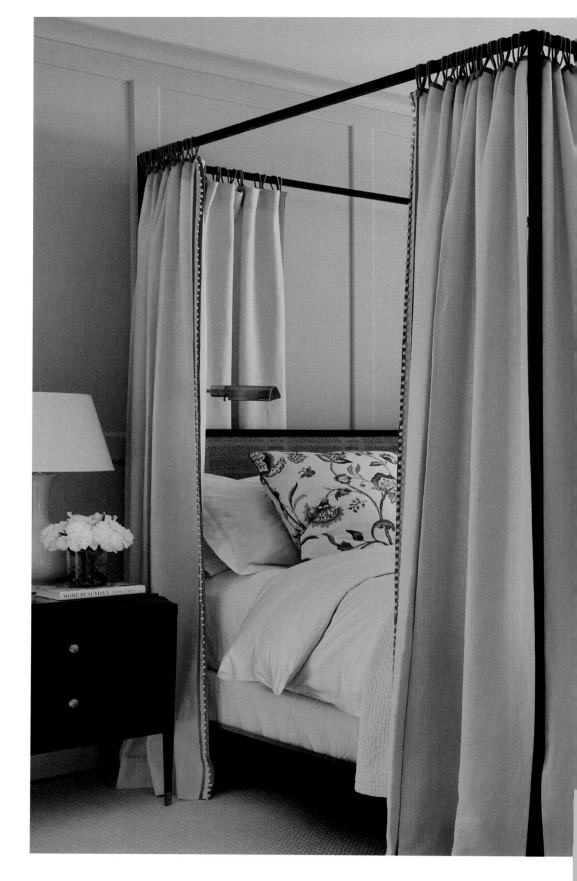

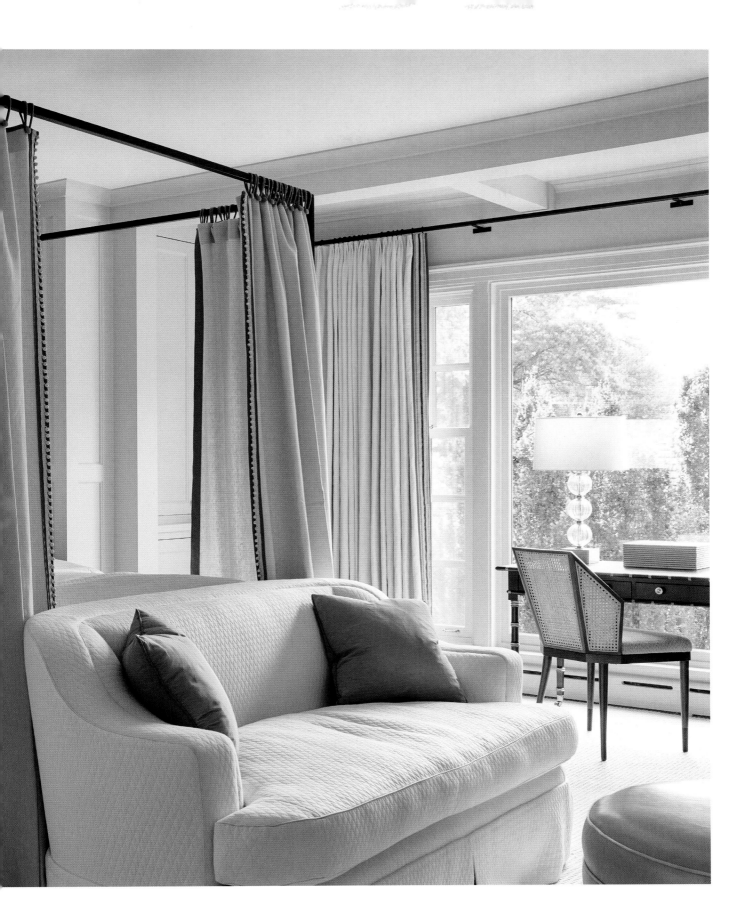

The colors of nature will always be beautiful, like a blue sky on a clear winter day.

CLOCKWISE FROM TOP LEFT: Printed linen paired sumptuously with strié velvet that feels like water. Objets d'art, too, should juxtapose old and new. A good reading chair requires a bolster, ample light, and an ottoman for comfort. This deep soaking tub has a view of the private gardens. The modern geometric chair back pairs prettily with a gilt bamboo desk. We tucked a vanity under the soft daylight of this upper window.

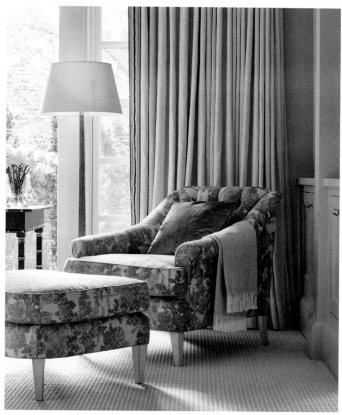
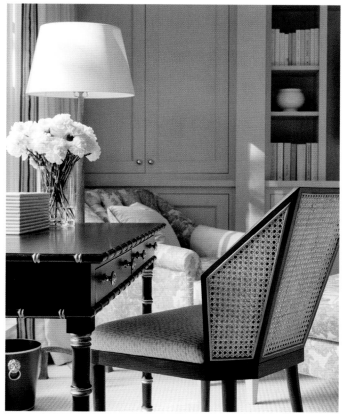

November

ALPINE ELEGANCE

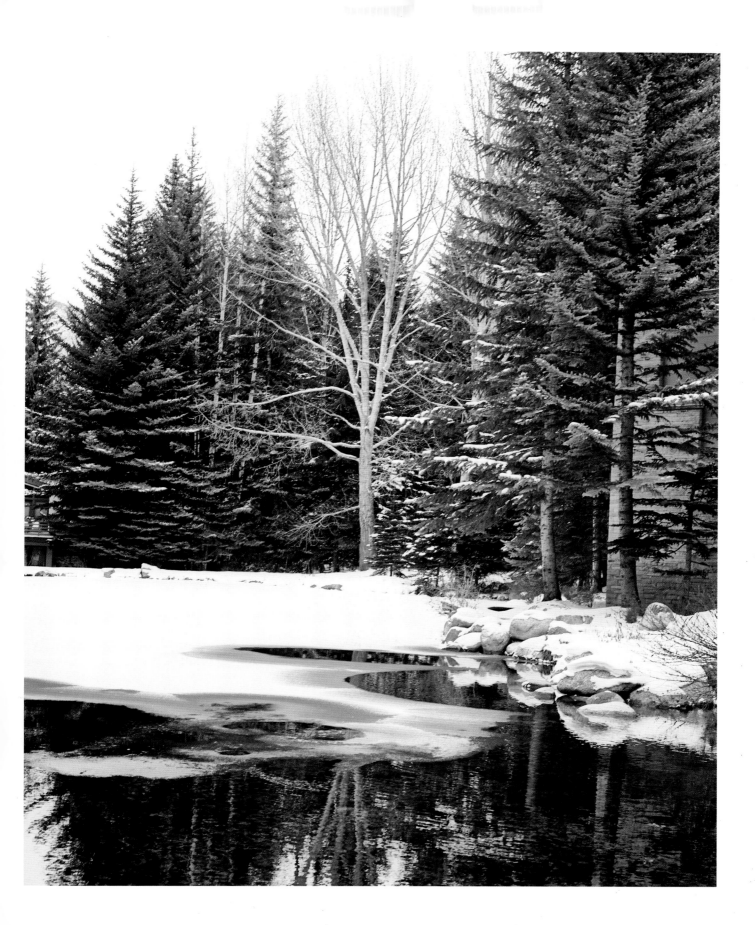

A heavy snowfall is achingly beautiful. Bathed in white, the world feels reborn—like it's been given a fresh start. I've always felt a particular affection for snowflakes themselves, with their symmetrical structure and distinctive, one-of-a-kind shapes that take form as they whirl from the clouds toward the earth.

In Colorado, where this vacation home is, the mountains have already been dusted with snow aplenty by November, their peaks frosted like powdered sugar on a cake. Because the architecture is as modern as it comes, with glacial glass walls and stone that echoes the nearby cliffs, our task in this existing home was mostly an exercise in design. The natural inclination in a house like this is to introduce spare furnishings, like big Belgian linen sofas and trestle tables. But we longed to embrace a level of refinement that only notes of classicism and rare art can provide. We carefully curated custom British pieces and ceramics that show the hand of the maker, giving it all plenty of breathing room.

PREVIOUS PAGE: Evergreen trees are a gift from nature—lush and verdant in all seasons.
ABOVE: Antique tapestries are akin to woven masterpieces: as equally rich and layered as oil paintings, yet even more textural. OPPOSITE: For interiors that will stand the test of time, we paired the existing clean-lined minimalism of the architecture with refined furniture pieces.

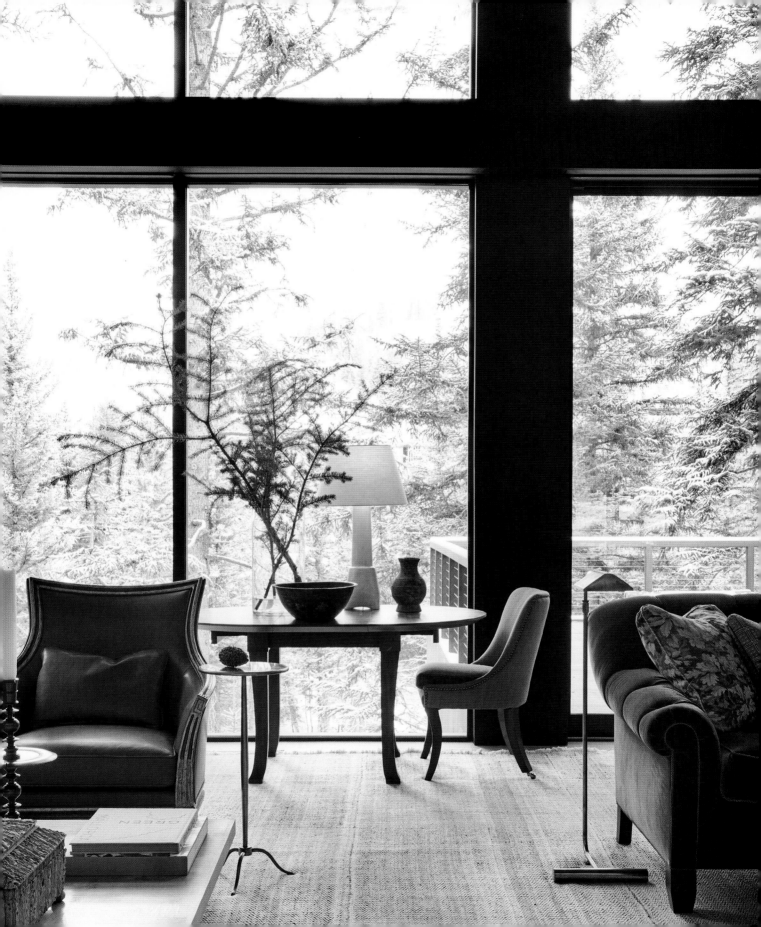

This project was largely an exercise in decorating. We made the modern structure more comfortable and inviting with beautiful textures: tapestries, woods, and a mix of velvets that include mohair, silk, and strié. Many of our fabric hues were pulled directly from the native species in the surrounding mountains, such as Engelmann spruce and aspen leaves in autumn. FOLLOWING PAGES, FROM LEFT: Curating art in the form of pottery (like these pieces from Roman and Williams Guild) was vital because the home was such a clean slate; the touch of human hands provides an artisanal quality. Much of our lighting choices were modern in silhouette, in a burnished brass finish for warmth.

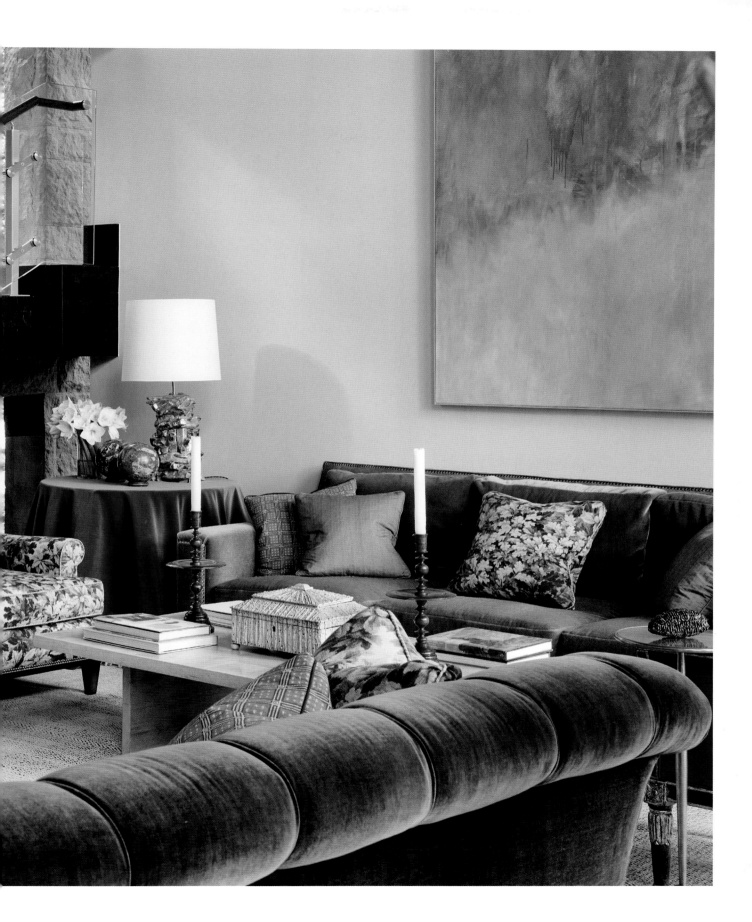

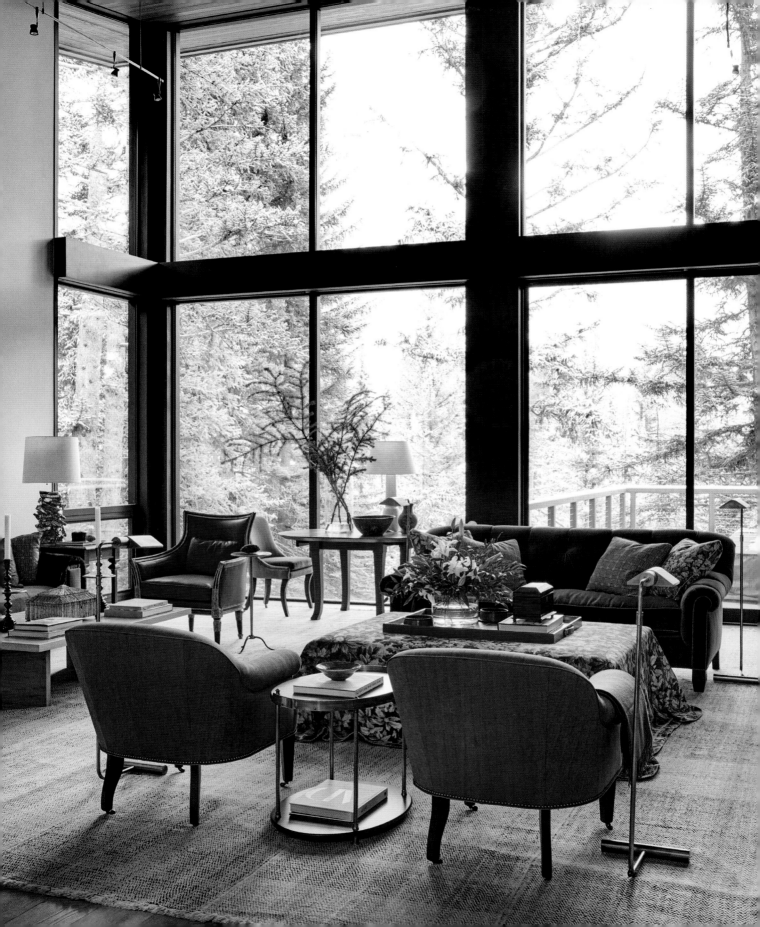

"Every leaf speaks
bliss to me, fluttering
from the autumn tree."

Emily Brontë

OPPOSITE: A velvet sofa is a plush playground for custom pillows
that add interest (these include a subtle strié and tapestry-inspired
fabrics). The contemporary painting by Janet Bruce has so much
depth and also manages to capture the room's color palette.

The Fortuny draperies in the dining room create a quiet envelope for dinner parties. Dark ebonized wood walls ensure the focus is on the views—and one another—while the clients' own Klismos chairs bring in textural warmth and the aura of antiquity. We topped the seats with custom cushions that are velvet on one side and supple leather on the other.

"In every walk with nature one receives far more than he seeks."

—*John Muir*

What would cozy up the clean lines so that all ages would feel welcome and warm? The answer came in an antique Italian tapestry that the home-owner had already collected; it became our North Star. To this we added plush velvets and a mix of woods to lend a luxurious feeling. Early on, we sand-blasted the home's original limestone, which was veering too yellow, so it became more of a biscuit color. Layering in cashmeres, wools, and even faux fur—often in winter whites—brought a certain sumptuousness that's incredibly comforting in the frosty air. Adding a dose of glamour in the form of gilding was imperative: it's synonymous with the glistening of the sun on snow.

We selected a mix of velvets—mohairs, silks, and striés—all in hues culled from the local woodlands. But just like the towering spruce trees and lodgepole pines deep in this crux of the White River National Forest, these are no ordinary greens. They have a bit of blue to them, like a true wintergreen. When the fires are going, and snowflakes flutter down softly beyond the windows, you feel like you're ensconced in your very own snow globe that you never want to leave.

OPPOSITE: Corner banquettes with a view bring comfort to any home. Caramel stripes supply an unexpected touch in the kitchen.

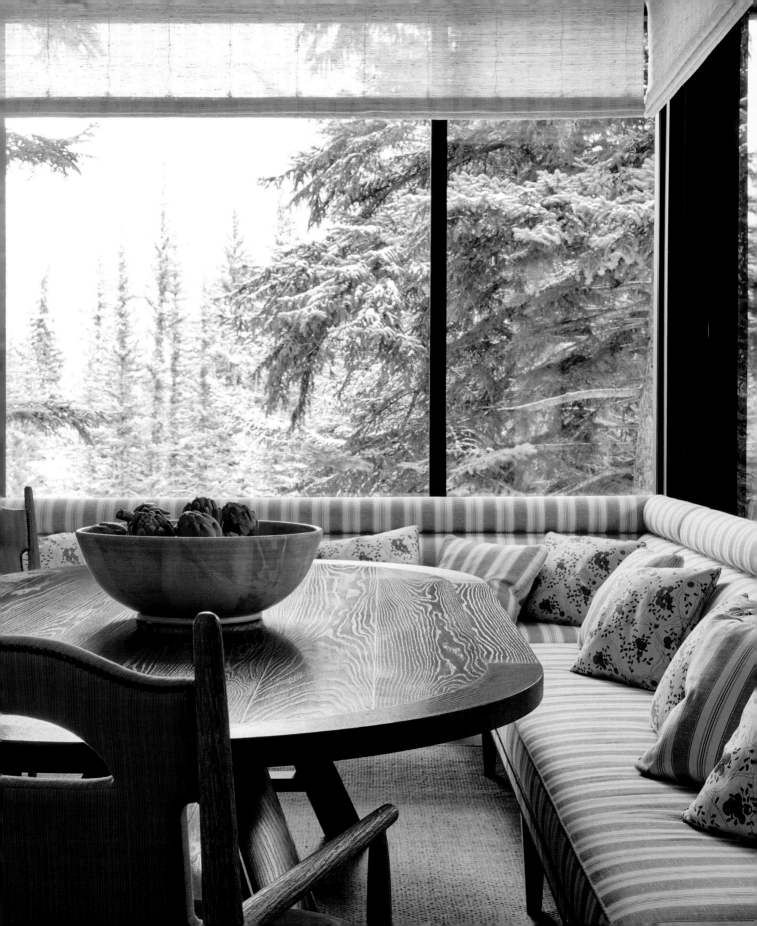

The forest has inspired artists and writers for centuries because it is so inherently soothing: a hushed and happy woodland of towering pines, birdsong, and rambling creeks.

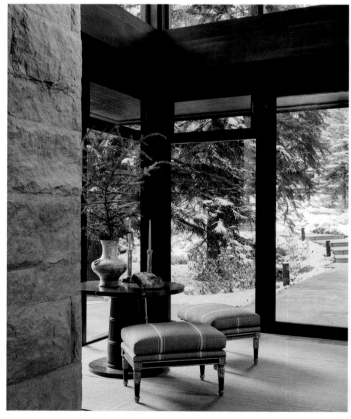

CLOCKWISE FROM TOP LEFT: An antique Italian tapestry. Generous Fortuny draperies add an elegance and luxury to even the most modern of spaces. The sound of the creek is like poetry. Pillows made with Le Manach fabric add texture and color to a guest room. A duo of Louis XVI ottomans nestled under the foyer table are a perfect mix of traditional and modern.

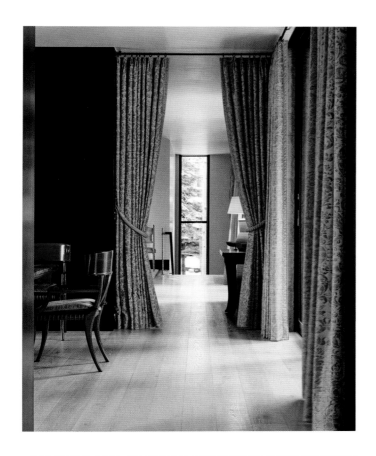

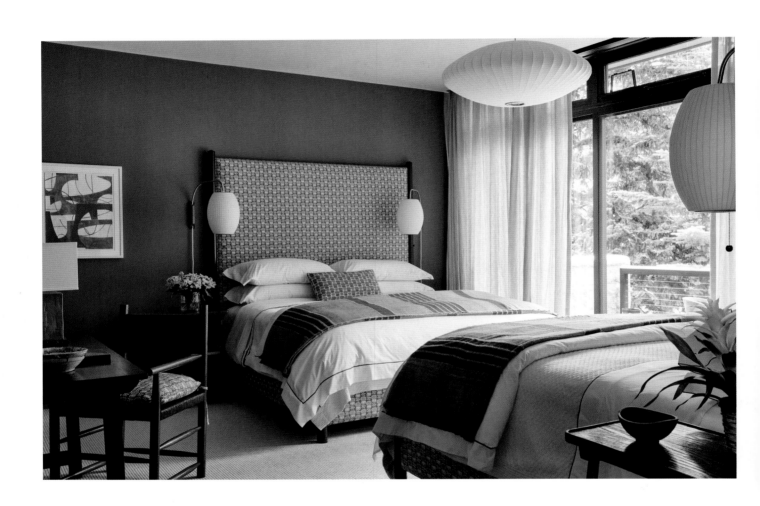

ABOVE: We did something unusual in this guest room, placing the beds end to end. The purpose: everyone wakes up to a window-side view. OPPOSITE: There was a midcentury feeling in the home's existing paper lanterns in the guest room that we liked, so we kept them. We created contrast against their cloud-white hue with the verdant green walls.

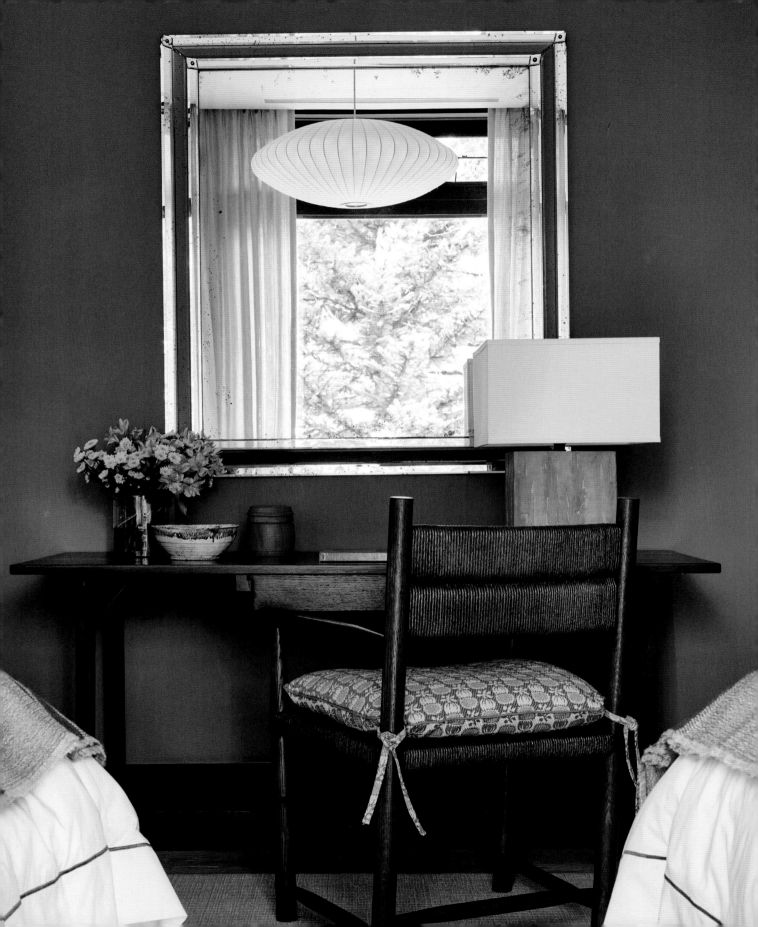

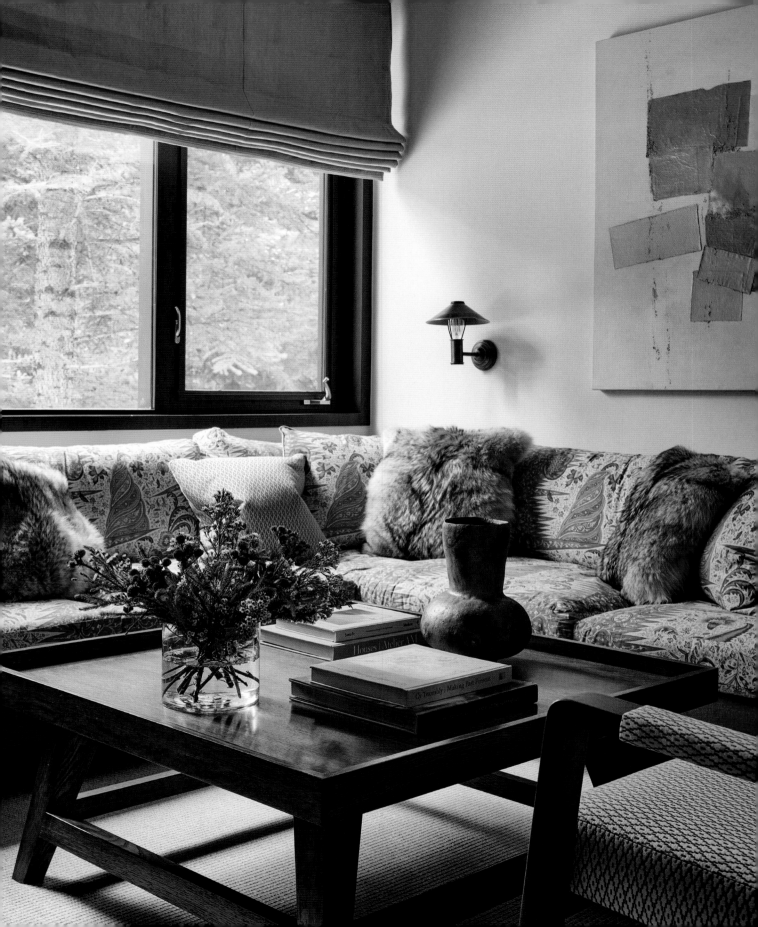

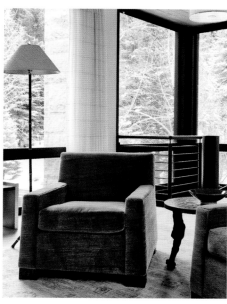

OPPOSITE: Above a corner sectional upholstered in an unexpected combination—Pierre Frey and faux fur—modern art and Roman shades bring breathing room. ABOVE, CLOCKWISE FROM TOP LEFT: Faux fur is practically required in a mountain house. We worked hard to source a pool table that would live up to the artfulness of its setting. Wood grains are some of the most beautiful patterns in nature: you can watch years pass with each new line. Cinnamon-hued mohair takes the chill off.

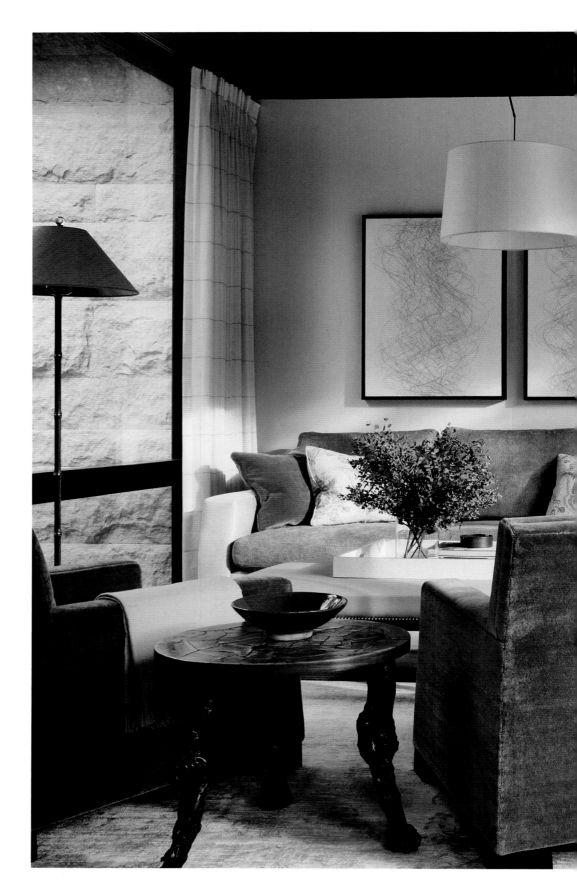

This sitting area just off the primary guest room is all about soft cashmeres and velvets meeting hard metallic edges—and becoming all the more beautiful for it. We sandblasted the interior exposed limestone to make it more neutral in tone, and did the same to the exterior.

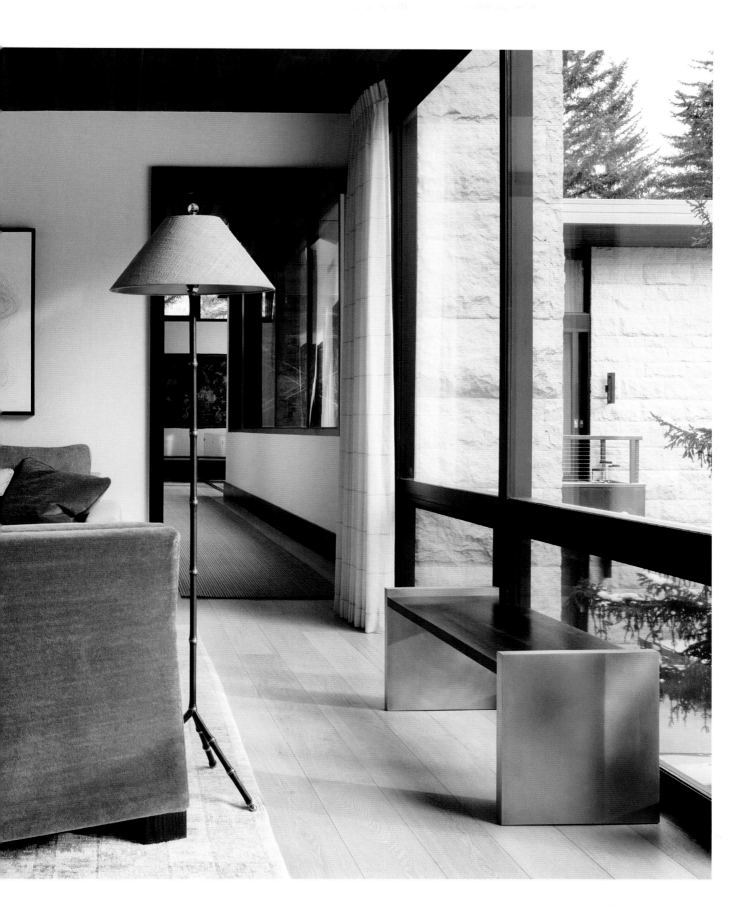

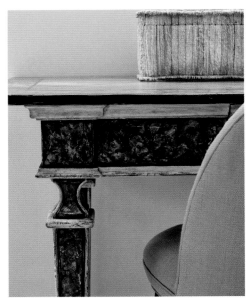

A custom-painted
Italian dressing table.

The colors of the dense
evergreens are
so rich and inspiring.

Geometrics, flora,
and solids: a winning
fabric trio.

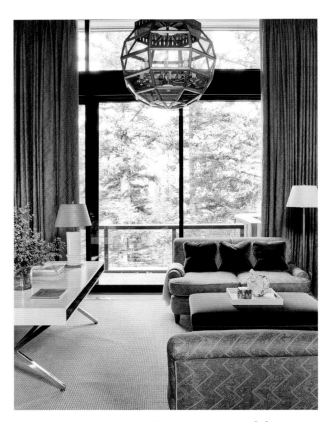

An overscale Collier Webb
globe light in the office.

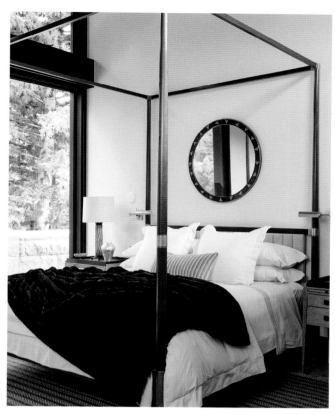

Centering a mirror above a canopy bed's headboard creates a focal point.

Cut velvets and linens from Pierre Frey Le Manach.

Changing shadows transfix from dawn till dusk.

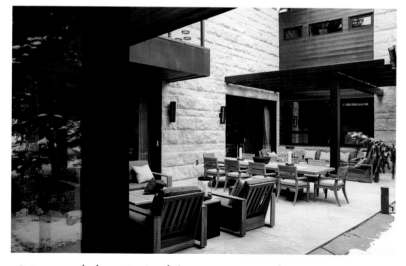

Elegant teak Sutherland outdoor furniture connects seamlessly to the interior aesthetic.

December

MOUNTAIN MAGIC

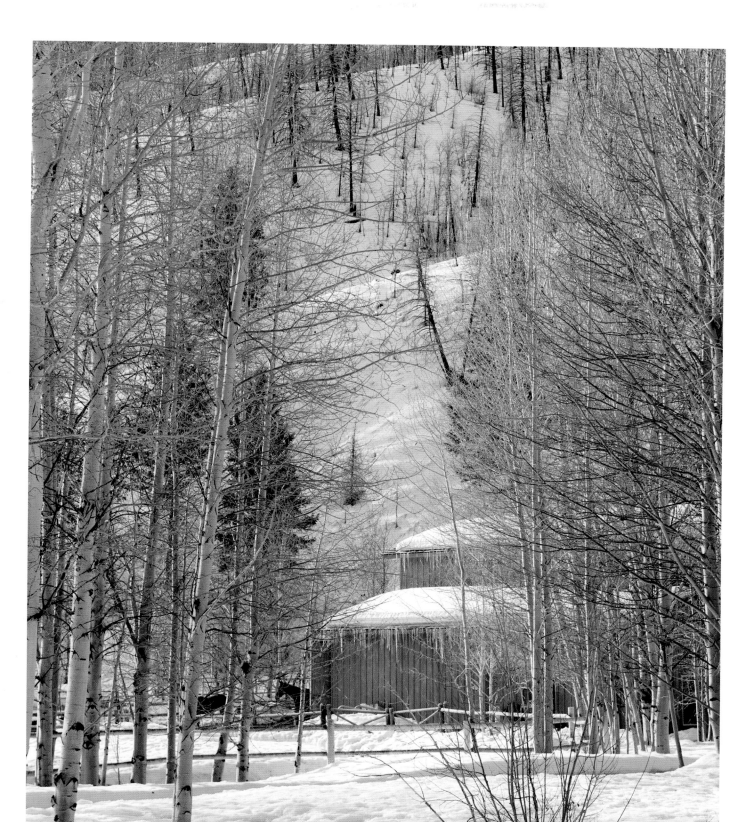

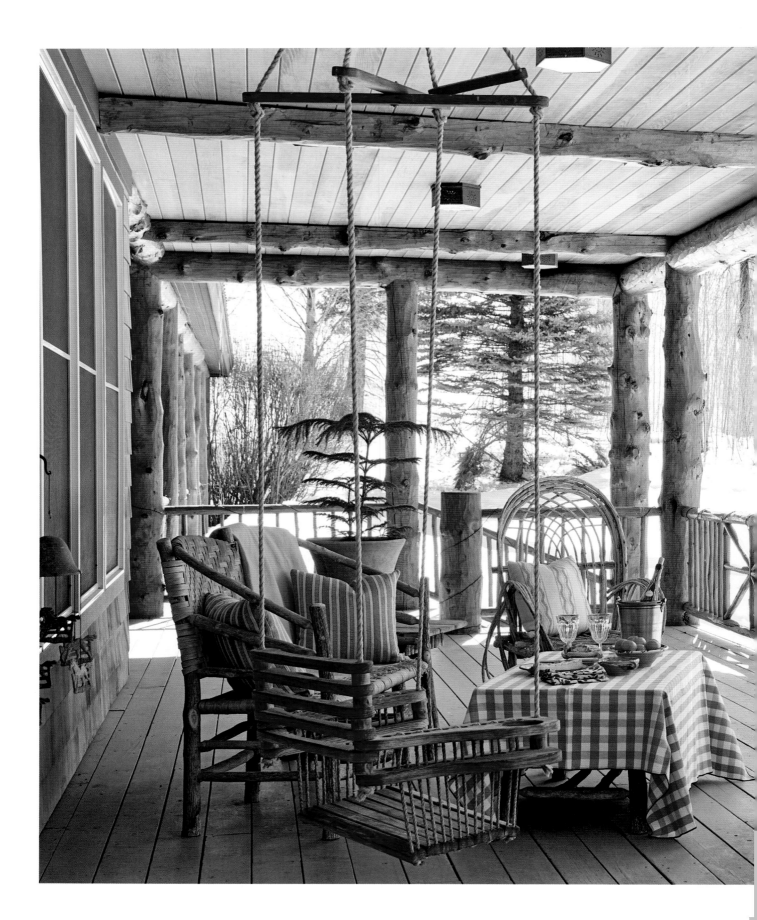

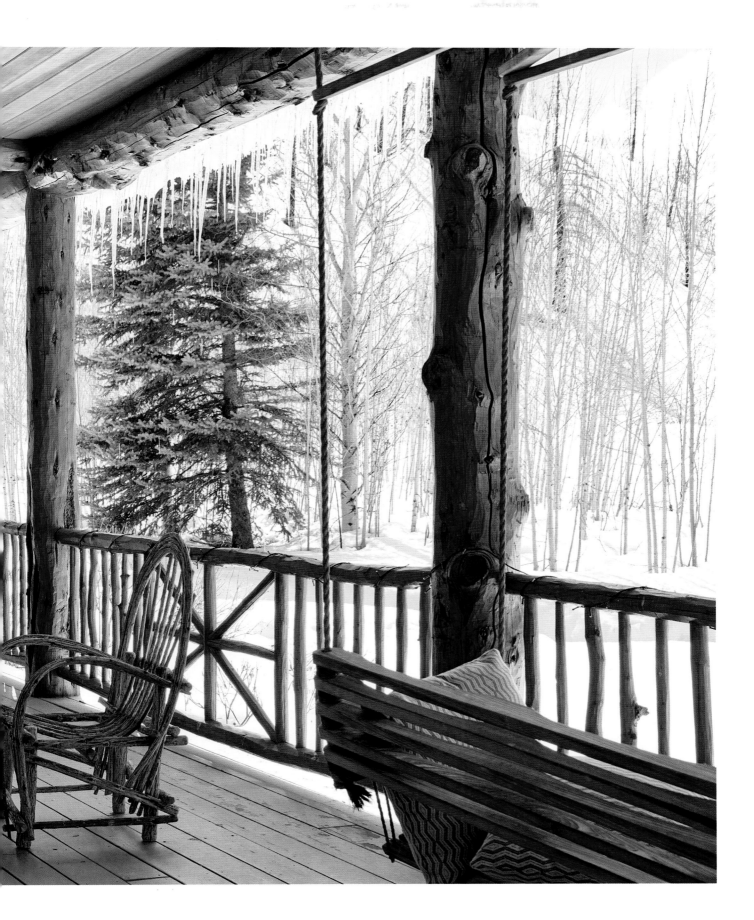

I n the depths of winter, little appeals to me more than a storybook Swiss chalet. When it sits proudly on a sweeping horse ranch near Sun Valley, Idaho, that's all the better. This home already had charm and architectural detail in spades; all the house needed was to be more authentically herself. So we kept the existing twig furniture and stickwork adorning the pass-throughs and balusters, but quickly evicted the theme-y things—the metal moose and tree cutouts—opting instead to help the house embrace her roots.

We wanted it to feel a bit like an alpine lodge in Saint Moritz, bringing in Pierre Frey ikats here and Delft ceramics there. Painting and distressing wood chairs with Swiss details helped balance all the lumber, while adding tassel trim to lampshades and Roman shades supplied delicateness. In the powder room, we hung a fawn-dotted iconic William Morris wallpaper that was inspired by an

PAGE 297: The view through the aspens on this ranch near Sun Valley, Idaho, takes in horses and an icicle-capped barn. PREVIOUS PAGES: Fanback willow chairs and hanging porch swings amplify the sense of wonder at nature. ABOVE: The Adirondack-style home's existing circa 1960s architecture had echoes of Swiss chalet style, which we fully embraced. OPPOSITE: It's amazing what a transformation humble paint can make in an unexpected application. In this foyer, we used colors pulled from Pierre Frey fabrics to set a storybook tone.

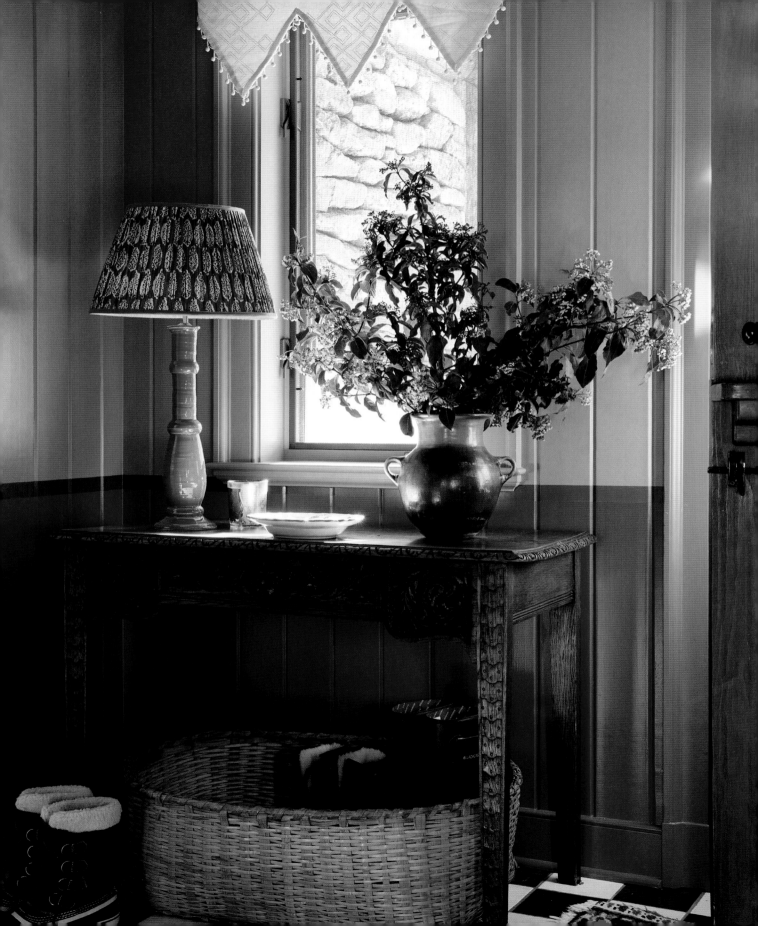

ABOVE, CLOCKWISE FROM TOP LEFT: We laid a checkerboard tile floor in the entrance hall, a centuries-old touch that looks especially fun with the playful paint and Dutch door we installed. Choosing a different color for a door's interior is a simple move with maximum impact. In lieu of installing a chair rail, paint one. Icicles catch the sunlight. OPPOSITE: Within the powder room, a hand-hammered copper sink and antique mirror supply a storied feel in pace with the William Morris wallpaper and Delft tile.

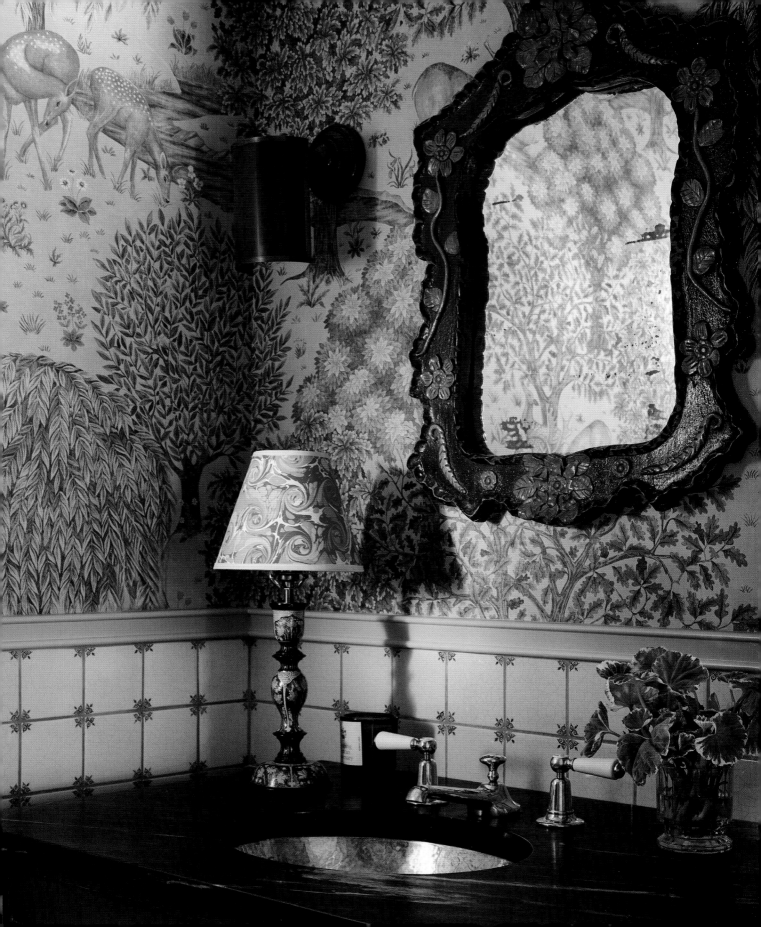

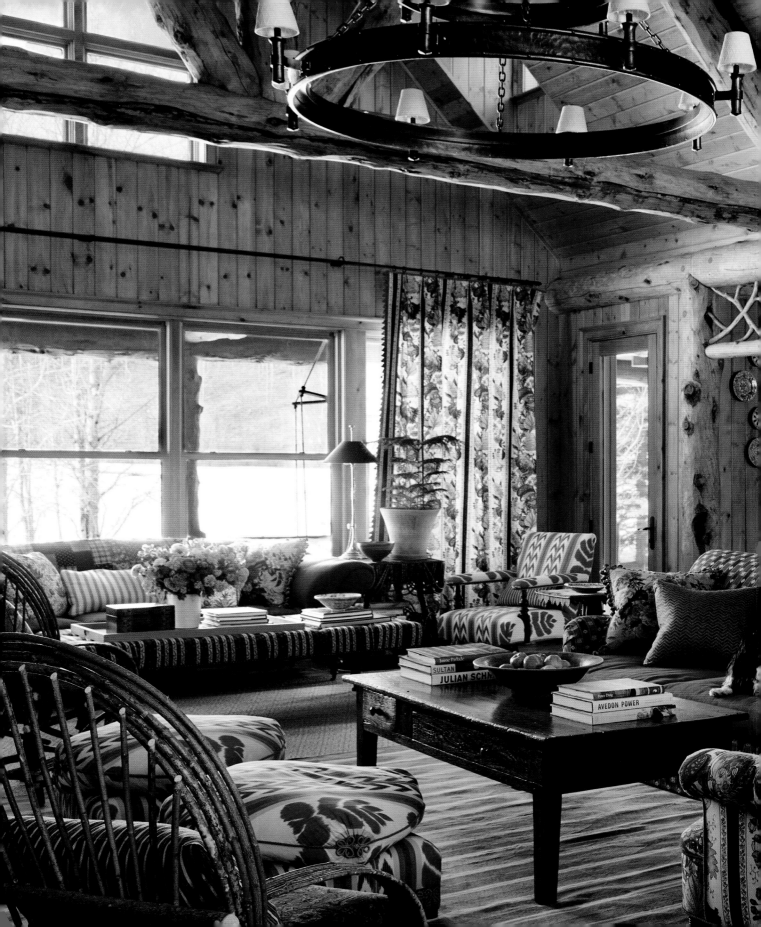

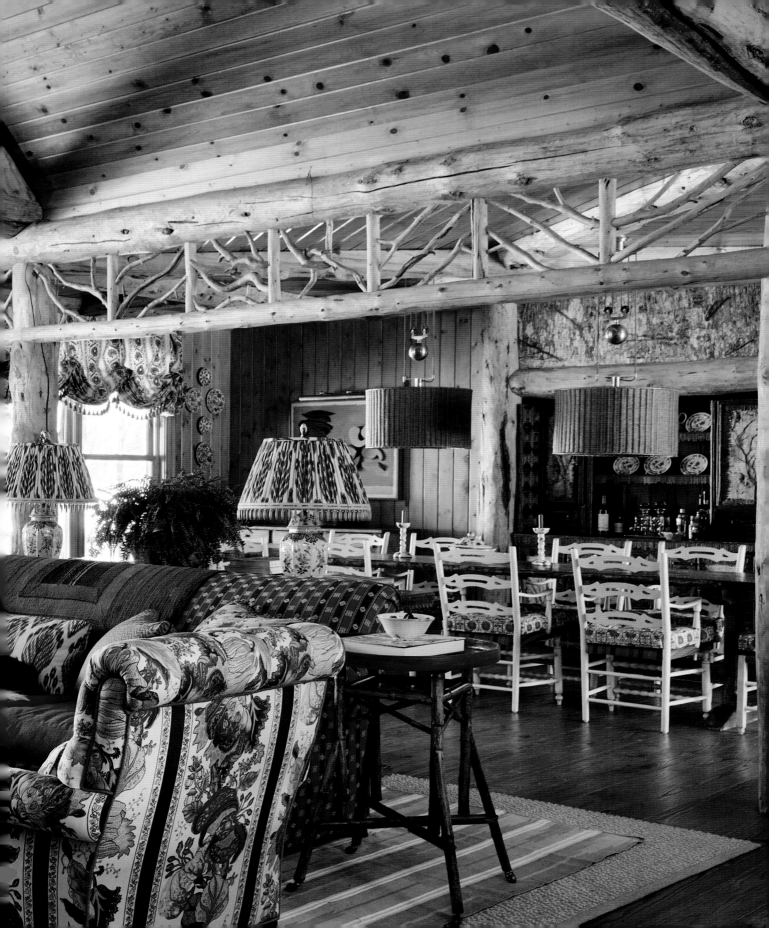

"Nature is the source of all true knowledge."

—*Leonardo da Vinci*

Arras tapestry, *The Brook*, originally woven in 1917. Another pièce de résistance is the mirror over the hearth in the living room, which we had a local artisan make out of the naturally shed antlers of young mule deer and white-tail deer.

In the ski chalets of Switzerland, the decorative gable bands and weatherboards are typically as colorful as a dirndl. So when we designed new millwork, we made it vibrant. The kitchen's tea green cabinets have sky blue interiors to match the Delft tile backsplash; the foyer is a riot of dusty reds with a painted cornflower blue chair rail. Even the Dutch door has a soft, lake-blue stain.

For the children's library, we gave the built-in window nook a fanciful treatment you might find on a train ride through the French Alps: gingham curtains from Colefax and Fowler and hand-printed linen shades. We found so much inspiration for the palette in the tones of the Pierre Frey fabrics. After all, every fairy tale looks better in full Technicolor.

PREVIOUS PAGES: We loved the home's existing twig detailing; it's a mountain version of a transom window. We employed pattern on pattern here, including tons of layered Pierre Frey, to decadent effect, but kept all the color palettes cohesive. Maidenhair and Boston ferns bring exuberant nature indoors. OPPOSITE: We had this fallen antler mirror custom-made; it has the lines of a gilt nineteenth-century Louis Philippe looking glass.

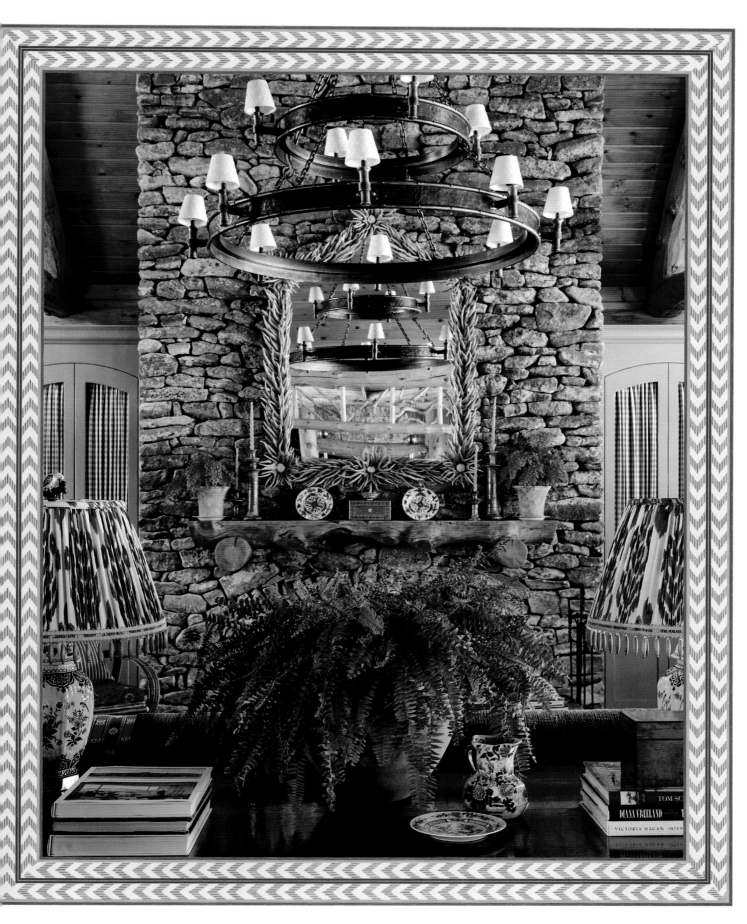

Winter days call for coziness from the floor to the rafters: mixed textiles, taper candles, and always keeping the home fires burning.

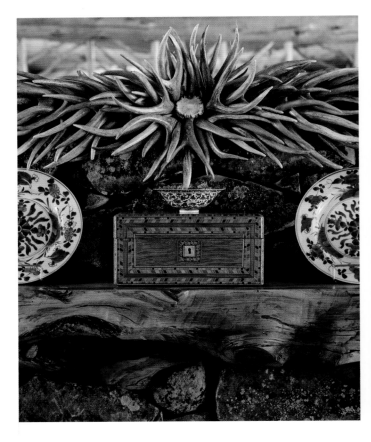

CLOCKWISE FROM TOP LEFT: Layers of blue-and-white ceramics are unexpected. Multiple fabric choices and finishes help a room feel collected over time. The solid sofa seat is what brings the other patterns such life. Delicate maidenhair ferns, rope tapers, and fallen antlers supply a storybook effect inspired by the natural world. An antique quilt and flouncy Roman shade with tassel trim serve to soften up wood-heavy halls. We designed all the millwork in the kitchen. The forged iron pot rack, custom cushions, and Delft tile backsplash bring in a Swiss chalet aesthetic.

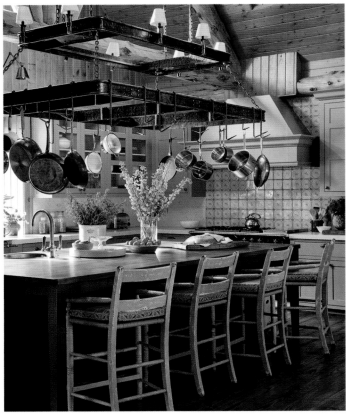

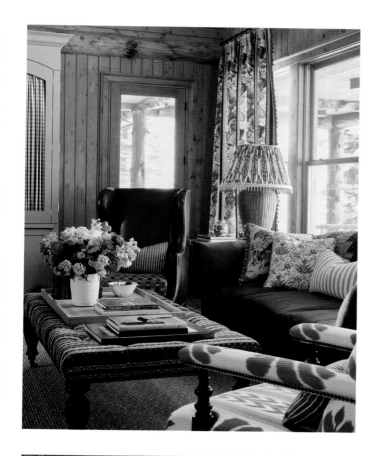
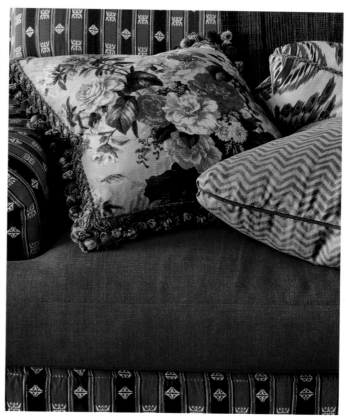

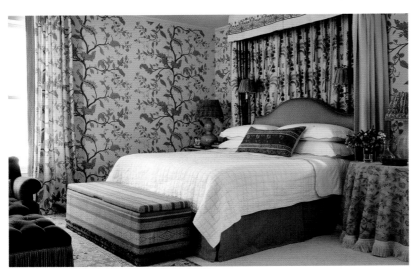

Table skirts, a custom hand-embroidered canopy, and fringe add to the bohemian feeling in this mountain home.

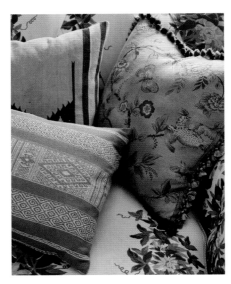

The combination of handwoven indigenous American textiles and florals is unexpected.

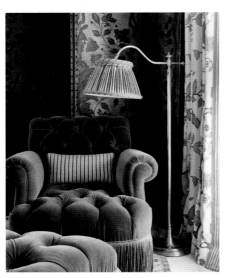

An antique screen is an artful touch in an idle corner.

We lined the millwork with a slimmer version of the curtain trim.

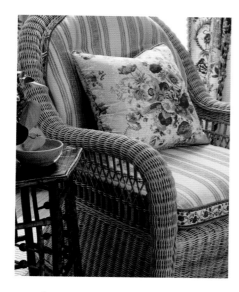

There's a lightness to wicker that's always a welcome sight.

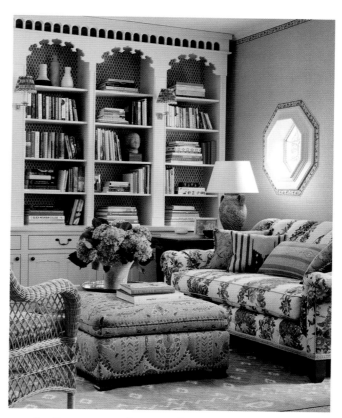

The Moorish built-ins echo the nailhead patterns of the custom ottoman.

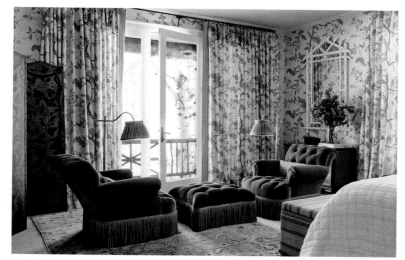

Every primary bedroom can benefit from a conversation area.

A striped seat enlivens a substantial antique desk.

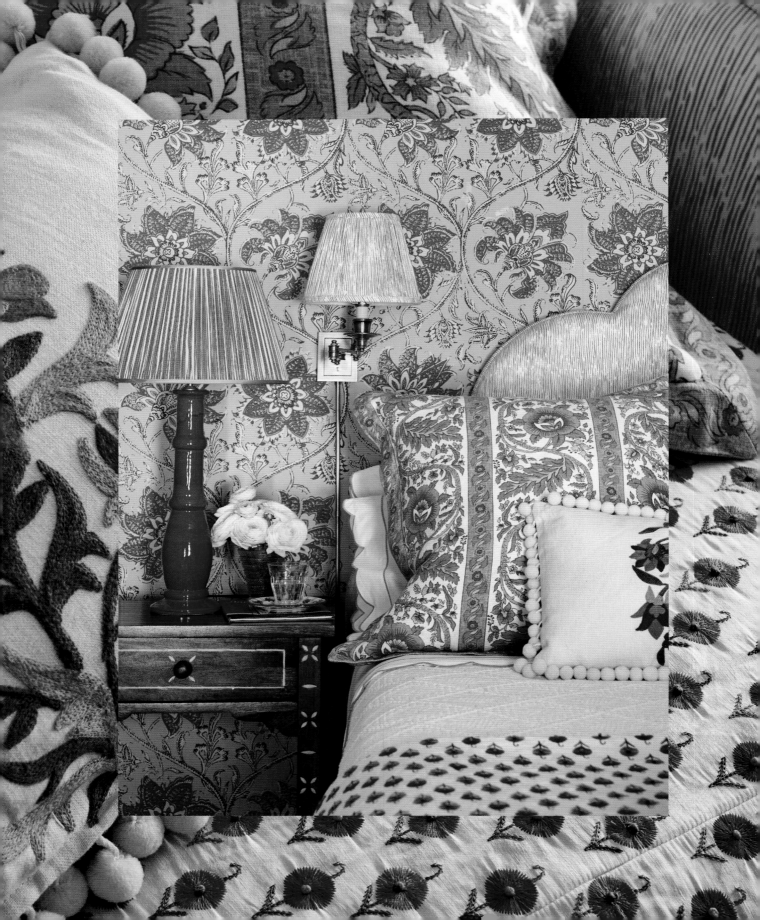

"Where flowers bloom,
so does hope."

Lady Bird Johnson

OPPOSITE: We brought equal parts magic and fantasy to this girl's bedroom with layer upon layer of pink motifs, scallops, and pom-poms. Layered lighting is a must by the bed. We often tuck plug-in sconces on either side of a headboard—they're highly functional and look good.

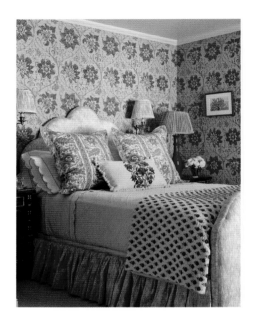
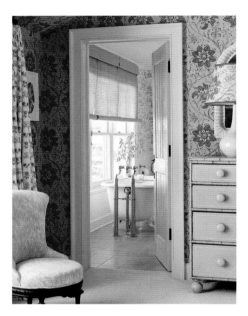
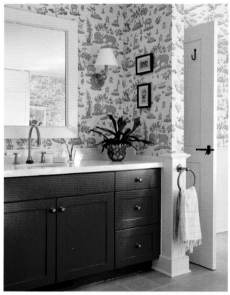
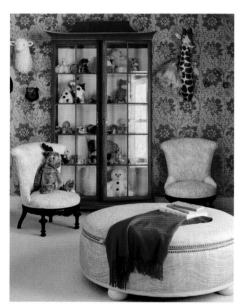

ABOVE, CLOCKWISE FROM TOP LEFT: A daughter's bedroom is awash in pink—all in muted, easy-to-live-with tones. The neutral-on-neutral en suite bath is a calming departure. A chinoiserie curio cabinet has a second life as storage. The Pierre Frey wallpaper in the children's bathroom dances with elephants. OPPOSITE: There's little like a tub with a view.

Homework feels like less of a chore—and more of an adventure—in the children's library. In the tucked-away window nook, the layering of fabrics—checks, stripes on the French mattress, and ikat florals—makes it the perfect magical hideout.

Acknowledgments

The creation of beauty is not a solitary pursuit, and so I must begin these acknowledgments by thanking all of the many artisans, vendors, and workrooms that help make our work at Mark D. Sikes, Inc. so wholly original and authentic. Very little of anything in the homes we design is not somehow treated with a special finish or distinctive design, which makes it one of a kind—and that's all thanks to you. If we can dream it, you can actually do it. I would like to thank some of our amazing partners in this book, including:

DECORATIVE PAINTERS
Mary Meade Evans
Julie Lutjen Lawrence
Joseph Steiert
Valentine Viannay

FREQUENT VENDORS
Peacock Alley
Ken Petersen
Rigo's Custom Furniture
Valley Drapery & Upholstery

MDS CURRENT COLLABORATORS
Chaddock
Chesneys
Hudson Valley Lighting
Modern Matter
Samuel & Sons
Schumacher
Soane Britain
Christopher Spitzmiller
Troy Lighting

STYLIST
Carolyn Englefield

ARCHITECTS
Marc Appleton
B:a Design Group, Inc.
Benevides and Associates Architects
Dailey Janssen Architects
Frank Greenwald
NSPJ Architects
Pencil & Paper Development LLC
Shepherd Resources Inc.
Paul Brant Williger

BUILDERS
Building Blocks Construction
Delamere Building Corporation
Enlighten Home
Gahagan-Eddy Building Company
J5 Construction, LLC
JC Builders
Dave Knecht Homes, LLC
Precise Drafting
Progress 3
Seaside Home Services
Shaeffer Hyde Construction

To my team at Mark D. Sikes, Inc., who has somehow managed to pull off the most exquisite visions for our wonderful clients while having fun: you make it all possible. And finally, to the creative team that helped bring this book to life, including photographer Amy Neunsinger, who so perfectly captures the light; photographers Victor Stonem (who photographed the March chapter) and Stephen Karlisch (who photographed the opener and my portrait); Rizzoli publisher Charles Miers and editor Kathleen Jayes; agent Jill Cohen; designers Doug Turshen and Steve Turner; and writer Kathryn O'Shea-Evans. Thank you.

First published in the United States of America in 2024 by
Rizzoli International Publications, Inc.
300 Park Avenue South
New York, NY 10010
www.rizzoliusa.com

Publisher: Charles Miers
Senior Editor: Kathleen Jayes
Design: Doug Turshen with Steve Turner
Production Manager: Colin Hough-Trapp
Managing Editor: Lynn Scrabis

Developed in collaboration with Jill Cohen Associates, LLC.

Printed in China

2024 2025 2026 2027 / 10 9 8 7 6 5 4 3 2 1

ISBN: 978-0-8478-3011-4
Library of Congress Control Number: 2024933956

Visit us online:
Facebook.com/RizzoliNewYork
Twitter: @Rizzoli_Books
Instagram.com/RizzoliBooks
Pinterest.com/RizzoliBooks
Youtube.com/user/RizzoliNY
Issuu.com/Rizzoli

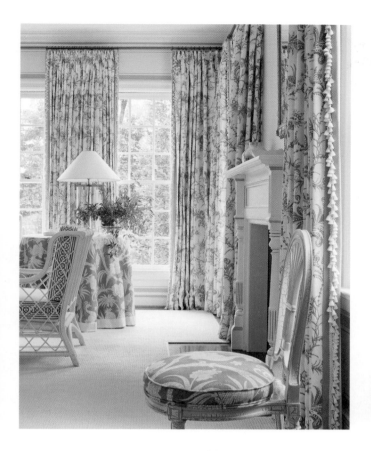
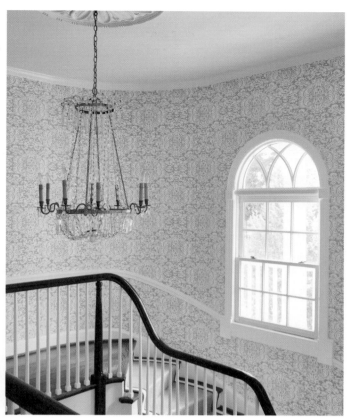

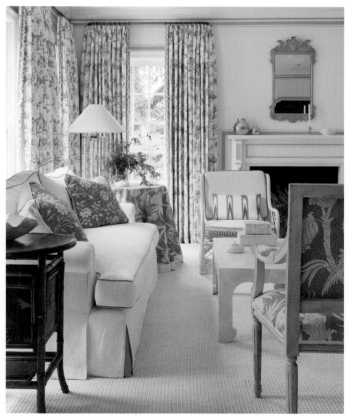